ANDRÉ ACIMAN

HOMO IRREALIS

André Aciman is the author of *Call Me by Your Name, Find Me, Eight White Nights, Out of Egypt, False Papers, Alibis, Harvard Square,* and *Enigma Variations,* and is the editor of *The Proust Project.* He teaches comparative literature at the Graduate Center of the City University of New York and lives with his wife in Manhattan.

ALSO BY ANDRÉ ACIMAN

FICTION

Call Me by Your Name
Eight White Nights
Harvard Square
Enigma Variations
Find Me

NONFICTION

Out of Egypt: A Memoir
False Papers: Essays on Exile and Memory
Entrez: Signs of France (with Steven Rothfeld)
The Light of New York (with Jean-Michel Berts)
Alibis: Essays on Elsewhere

AS EDITOR

*Letters of Transit: Reflections on Exile, Identity,
Language, and Loss*
The Proust Project

HOMO
IRREALIS

HOMO
IRREALIS

THE WOULD-BE MAN
WHO MIGHT HAVE BEEN

Essays

ANDRÉ ACIMAN

PICADOR

FARRAR, STRAUS AND GIROUX | NEW YORK

Picador
120 Broadway, New York 10271

Grateful acknowledgment is made for permission to reprint the following material: "Heaven," from *Boy*, by Patrick Phillips. Copyright © 2008 by Patrick Phillips. Reprinted by permission of The University of Georgia Press.

The Library of Congress has cataloged the Farrar, Straus and Giroux hardcover edition as follows:
Names: Aciman, André, author.
Title: Homo irrealis : essays / André Aciman.
Description: First edition. | New York : Farrar, Straus and Giroux, 2021.
Identifiers: LCCN 2020039386 | ISBN 9780374171872 (hardcover)
Subjects: LCGFT: Essays.
Classification: LCC PS3601.C525 H66 2021 | DDC 814/.6—dc23
LC record available at https://lccn.loc.gov/2020039386

Paperback ISBN: 978-1-250-82928-3

Designed by Gretchen Achilles

Our books may be purchased in bulk for promotional, educational, or business use. Please contact your local bookseller or the Macmillan Corporate and Premium Sales Department at 1-800-221-7945, extension 5442, or by email at MacmillanSpecialMarkets@macmillan.com.

For book club information, please visit facebook.com/picadorbookclub or email marketing@picadorusa.com.

picadorusa.com • instagram.com/picador
twitter.com/picadorusa • facebook.com/picadorusa

1 3 5 7 9 10 8 6 4 2

In memory of Robert J. Colannino.
Rest, my dear and dearest friend.

I'm the gap between what I am and what I am not.

—FERNANDO PESSOA

CONTENTS

INTRODUCTION 5

UNDERGROUND 17

IN FREUD'S SHADOW, PART 1 29

IN FREUD'S SHADOW, PART 2 47

CAVAFY'S BED 63

SEBALD, MISSPENT LIVES 75

SLOAN'S GASLIGHT 89

EVENINGS WITH ROHMER

 Maud; or, Philosophy in the Boudoir 99

 Claire; or, A Minor Disturbance on Lake Annecy 127

 Chloé; or, Afternoon Anxiety 149

ADRIFT IN SUNLIT NIGHT 165

ELSEWHERE ON-SCREEN 187

SWANN'S KISS 195

BEETHOVEN'S SOUFFLÉ IN A MINOR 213

ALMOST THERE 221

COROT'S *VILLE-D'AVRAY* 227

UNFINISHED THOUGHTS ON FERNANDO PESSOA 229

ACKNOWLEDGMENTS 239

HOMO
IRREALIS

Irrealis moods are a category of verbal moods that indicate that certain events have not happened, may never happen, or should or must or are indeed desired to happen, but for which there is no indication that they will ever happen. Irrealis moods are also known as counterfactual moods and include the conditional, the subjunctive, the optative, and the imperative—all best expressed in this book as the might-be and the might-have-been.

INTRODUCTION

Four sentences that I wrote years ago keep coming back to me. I am still not certain that I understand these sentences. Part of me wants to nail them down, while another fears that by doing so I will snuff out a meaning that can't be told in words—or, worse yet, that the very attempt to fathom their meaning might allow it to go into deeper hiding still. It's almost as though these four sentences don't want me, their author, to know what I was trying to say with them. I gave them the words, but their meaning doesn't belong to me.

I wrote them when attempting to understand what lay at the source of that strange strain of nostalgia hovering over almost everything I've written. Because I was born in Egypt and, like so many Jews living in Egypt, was expelled, at the age of fourteen, it seemed natural that my nostalgia should have roots in Egypt. The trouble is that as an adolescent living in Egypt in what had become an anti-Semitic police state, I grew to hate Egypt and couldn't wait to leave and land in Europe, preferably in France, since my mother tongue was French and our family

was strongly attached to what we believed was our French culture. Ironically, however, letters from friends and relatives who had already settled abroad kept reminding those of us who continued to expect to leave Alexandria in the near future that the worst thing about France or Italy or England or Switzerland was that everyone who had left Egypt suffered terrible pangs of nostalgia for their birthplace, which had been their home once but was clearly no longer their homeland. Those of us who still lived in Alexandria expected to be afflicted with nostalgia, and if we spoke about our anticipated nostalgia frequently enough, it was perhaps because evoking this looming nostalgia was our way of immunizing ourselves against it before it sprang on us in Europe. We practiced nostalgia, looking for things and places that would unavoidably remind us of the Alexandria we were about to lose. We were, in a sense, already incubating nostalgia for a place some of us, particularly the young, did not love and couldn't wait to leave behind.

We were behaving like couples who are constantly reminding themselves of their impending divorce so as not to be surprised when indeed it finally does occur and leaves them feeling strangely homesick for a life both know was intolerable.

But because we were also superstitious, practicing nostalgia was, in addition, a devious way of hoping to be granted an unanticipated reprieve from the looming expulsion of all Egyptian Jewry, precisely by pretending we were thoroughly convinced it was fated to happen soon and that indeed we wanted it to happen, even at the price of this nostalgia that was bound to strike us once we were in Europe. Perhaps all of us, young and old, feared Europe and needed at least one more year to get used to our eagerly awaited exodus.

But once in France I soon realized that it was not the friendly and welcoming France I had dreamed of in Egypt. That particular France had been, after all, merely a myth that allowed us to live with the loss of Egypt. Yet, three years later, once I left France and moved to the United States, the old, imagined, dreamed-of France suddenly rose up from its ashes, and nowadays, as an American citizen living in New York, I look back and catch myself longing once more for a France that never existed and couldn't exist but is still out there, somewhere in the transit between Alexandria and Paris and New York, though I can't quite put my finger on its location, because it has no location. It is a fantasy France, and fantasies—anticipated, imagined, or remembered—don't necessarily disappear simply because they are unreal. One can, in fact, coddle one's fantasies, though recollected fantasies are no less lodged in the past than are events that truly happened in that past.

The only Alexandria I seemed to care about was the one I believed my father and grandparents had known. It was a sepia-toned city, and it stirred my imagination with memories that couldn't have been mine but that harked back to a time when the city I was losing forever was home to many in my family. I longed for this old Alexandria of two generations before mine, knowing that it had probably never existed the way I pictured it, while the Alexandria that I knew was, well, just real. If only I could travel from our time zone to the other bank and recover this Alexandria that seemed to have existed once.

I was, in more ways than one, already homesick for Alexandria in Alexandria.

Today I don't know if I miss Alexandria at all. I may miss my grandmother's apartment, where everyone in the family spent

weeks packing and talking about our eventual move to Rome and then Paris, where most members of the family had already settled. I remember the arrival of suitcases, and more suitcases, and many more suitcases still, all piling up in one of the large living rooms. I remember the smell of leather permeating every room in my grandmother's home while, ironically enough, I was reading *A Tale of Two Cities*. I miss these days because, with our imminent departure, my parents had taken me out of school, so that I was free to do as I pleased on what seemed like an improvised holiday, while the comings and goings of servants helping with the packing gave our home the air of being set up for a large banquet. I miss these days perhaps because we were no longer quite in Egypt but not in France either. It is the transitional period I miss—days when I was already looking ahead to a Europe I was reluctant to admit I feared, all the while not quite able to believe that soon, by Christmas, France would be mine to touch. I miss the late afternoons and early evenings when everyone in the family would materialize for dinner, perhaps because we needed to huddle and draw courage and solidarity together before facing expulsion and exile. These were the days when I was beginning to feel a certain kind of longing that no one had explained to me just yet but that I knew was not so distantly related to sex, which, in my mind, I was confusing with the longing for France.

When I look back to my last months in Alexandria, what I long for is not Alexandria; what I long for when I look back is to revisit that moment when, as an adolescent stuck in Egypt, I dreamed of another life across the Mediterranean and was persuaded its name was France. That moment happened when, on a warm spring day in Alexandria with our windows

open, my aunt and I leaned on the sill and stared out at the sea, and she said that the view reminded her of her home in Paris where, if you leaned out a bit from her window, you'd catch a view of the Seine. Yes, I was in Alexandria at that moment, but everything about me was already in Paris, staring at a slice of the Seine.

But here is the surprise. I didn't just dream of Paris at the time; I dreamed of a Paris where, on a not so distant day, I would stand watching the Seine and nostalgically recall that evening in Alexandria where, with my aunt, I had imagined the Seine.

So here are the four sentences that have been giving me so much trouble:

> When I remember Alexandria, it's not only Alexandria I remember. When I remember Alexandria, I remember a place from which I liked to imagine being already elsewhere. To remember Alexandria without remembering myself longing for Paris in Alexandria is to remember wrongly. Being in Egypt was an endless process of pretending I was already out of Egypt.

I was like the Marranos of early modern Spain, who were Jews who converted to Christianity to avoid persecution but who continued to practice Judaism in secret, not realizing that, with the passing of time and generations later, they would ultimately confuse both faiths and no longer know which of the two was truly theirs. Their anticipated return to Judaism once the crisis was behind them never occurred, but their adherence to Christianity was no less an illusion. I was nursing one sense of myself in Alexandria and cradling another in Paris, all the while

anticipating that a third would be looking back to the one I'd left behind once I was settled across the shore.

I was toying with a might-have-been that hadn't happened yet but wasn't unreal for not happening and might still happen, though I feared it never would and sometimes wished it wouldn't happen just yet.

Let me repeat this sentence, the substance of which will appear many times in this volume: *I was toying with a might-have-been that hadn't happened yet but wasn't unreal for not happening and might still happen, though I feared it never would and sometimes wished it wouldn't happen just yet.*

This, like a dead star, is the secret partner of the four sentences that have been giving me so much trouble. It disrupts all verbal tenses, moods, and aspects and seeks out a tense that does not conform to our sense of time. Linguists call this the irrealis mood.

Mine is not simply a longing for the past. It is a longing for a time in the past when I wasn't just projecting onto Europe an imaginary future; what I long for is the memory of those last days in Alexandria when I was already anticipating looking back from Europe on the very Alexandria that I couldn't wait to lose. I long for myself looking out to the self I am today.

Who was I in those days, what were my thoughts, what did I fear, and how was I torn? Was I already trying to convey to Europe pieces of my Alexandrian identity that I feared I was about to shed for good? Or was I trying to graft my imagined European identity onto the one I was about to leave behind?

This circuitous traffic that aims to preserve something we know we are about to lose lies at the essence of the irrealis identity. Whatever it is I am trying to preserve may not be entirely

real, but it isn't altogether false. If I am still today creating circuitous rendezvous with myself, it's because I keep looking for some sort of terra firma under my feet; I have no set anything, no rooted spot in time or place, no anchor, and, like the word *almost*, which I use all too often, I have no boundaries between yes and no, night and day, always and never. Irrealis moods know no boundaries between what is and what isn't, between what happened and what won't. In more ways than one, the essays about the artists, writers, and great minds gathered in this volume may have nothing to do with who I am, or who they were, and my reading of them may be entirely erroneous. But I misread them the better to read myself.

<p align="center">→>-<-</p>

A picture that my father took of me is my last picture in Egypt. I was scarcely fourteen. In the picture I am squinting and trying to keep my eyes open—the sun is in my face—and I'm smiling rather self-consciously, because my father is chiding me and telling me to stand up straight for once, while all I'm probably thinking is that I hate this desert oasis about twenty miles from Alexandria and can't wait to be back and heading to the movies. I must have known that this was the last time I'd ever see this oasis in my life. There is no other picture of me in Egypt after this one.

To me it represents the last instance of who I was two to three weeks before leaving Egypt. As I stand there in my typically reluctant, undecided posture with both my hands in my pockets, I have no idea what we're doing in this desert outpost or why I'm letting my father take my picture.

I can tell my father is not pleased with me. I'm trying to look like the person he thinks I should be—*Stand straight, don't wince, look decisive*. But this is not me. Yet now that I look at the picture, this is who I was that day. I, trying to be someone else or caught ever so awkwardly between who I didn't like being and who I was being asked to be.

When I look at the black-and-white photo, I feel for that boy of almost six decades ago. What happened to him? Whatever did he end up becoming?

He isn't gone. Perhaps I wish he were gone. *I've been looking for you*, he says. *I'm always looking for you.* But I never speak to him; I seldom ever think of him. Yet now that he's spoken up, *I've been looking for you too*, I say, almost by way of a concession, as if I'm not sure I even mean what I've just said.

And then it hits me: something happened to the person I was back then in that picture, to the person staring at the father who is ordering him to stand up straight, adding, as he so frequently did, a cutting "for once," as if to make certain his criticism landed where it hurt. And the more I look at the boy in the picture, the more I begin to realize that something separates me from the person I might have become had nothing changed, had I never left, had I had a different father or been allowed to stay behind and become who I was meant to be, or even wanted to be. It's the person I was meant to be or could have become that continues to rankle in my mind, because it's right there in the picture, but ever so hidden.

What happened to the person I was actually working on becoming but didn't know I was about to become, because one never quite knows that one is indeed working on becoming anyone? I look at the black-and-white picture of someone over

there and am tempted to say, *This is still me.* But it's not. I didn't stay me.

I look at the picture of the boy posing for his father with the sun in his face, and he looks at me and asks, *What have you done to me?* I look at him, and I ask myself: What in God's name have I done with my life? Who is this me who got cut off and never became me, the way I cut him off and never became him?

He has no words of comfort. *I stayed behind; you left,* he says. *You abandoned me; you abandoned who you were. I stayed behind, but you left.*

I have no answers for his questions: *Why didn't you take me with you? Why did you give up so fast?*

I want to ask him who of us two is real, and who is not.

But I know what his answer will be. *Neither of us is.*

<div align="center">+>-<+</div>

When I was last in Nervi, I took a picture of Via Marco Sala, the main, meandering street that connects the small town of Bogliasco to Nervi, south of Genoa. Using my iPhone, I took the picture at dusk, partly because there was something about dusk on an empty, curved road I liked, and partly because there was a strange glow on the pavement. I waited for a car to disappear before taking the picture. Perhaps I wanted the scene to exist outside of time, with no real indication of where, when, or in which decade the picture was taken. Then I posted the picture on Facebook. Someone liked that I had mentioned Eugène Atget and right away took my colored image and turned it into black-and-white, thus giving the photo a pale, early-twentieth-century

look. I hadn't asked anyone to do this, but obviously it was implied somewhere, or someone simply inferred my undisclosed wish and decided to act on it. Someone else then liked what this person had done to my picture and decided to do one better: this time it looked as though the photo were taken in 1910, or 1900, and had acquired now a faint sepia quality. This person had interpreted the original purpose of the picture and given it to me as I had originally desired it. I wanted a 1910 picture of Nervi but didn't know that I was, in my own way, trying to turn back the clock. I got another Facebook friend to reproduce a Doisneau Nervi; another was kind enough to produce a Brassaï Nervi.

I like images of *vieux* Paris. They bring back an old world that disappeared and that I am fully aware may have been quite different from the one photographers like Atget and Brassaï wanted to seize on film. Photographs capture buildings and streets, not people's lives, not their strident voices, their bickering catcalls, their smell, or the stench of the gutters running down filthy streets. Proust: the scents, the sounds, the moods, the weather . . .

What I should have suspected—but didn't know—was that I was taking a picture not so much of a Nervi stripped of all time markers; I was taking a picture of Alexandria as I continue to imagine it at the time when my grandparents had moved there, more than a century ago.

The picture altered on Facebook turned out to reveal the subliminal reason I had taken it in the first place; unbeknownst to me, it reminded me of a mythical Alexandria that I seemed to recall but was no longer sure I'd ever gotten to know. What Facebook had returned to me was an irrealis Alexandria via an

imitation Paris imitating an unreal Alexandria in a small town in Italy called Nervi.

I was no longer the young boy staring out the window with my aunt at an imagined Paris. I was, as I'd predicted even back then, trying to catch a glimpse of the boy staring out to me, except that I felt no more real than he was then. I would never know who he was, locked in Alexandria still staring out to me, just as he will never know who I was or what I was doing that evening on Via Marco Sala. We were two souls longing to connect from across opposite banks.

All I knew after I put away my iPhone was that I would eventually have to go back to Alexandria and see for myself that I hadn't invented what I'd discovered on Via Marco Sala. But going back would never prove anything, just as knowing that wouldn't prove anything either.

UNDERGROUND

seldom read what passes for poetry on posters inside New York subway cars. Usually these poems are no better than Hallmark verses sweetened with dollops of treacle and peppered with just enough irony to flatter the average straphanger.

This time I did read the poem, though: it was a poem about time, or about the redemption of time—I wasn't sure. I read the poem through, wondered about it for a while, and then my mind drifted and I forgot about it. A few days later, there it was again, in another subway car, staring at me, as though still asking something, insisting. So I read it once again and was as intrigued by it as I'd been the first time. I wanted to stop to think about it, partly because its meaning kept teasing and giving me the slip each time I believed I'd seized it, but also because the poem seemed to be telling me something I understood perfectly well but couldn't quite prove I'd actually inferred from the poem itself. Was I projecting onto the poem something I hoped it was saying because I'd been nursing a similar thought myself?

The third, fourth, fifth time I came upon that same poem

in the subway, I felt that something was indeed happening between us and that it had as much to do (a) with the poem, (b) with me, but also (c) with how I kept running into it, to the point that the poem began to acquire an auxiliary meaning that had less to do with itself than with our little romance. On several occasions I even looked for it, expecting to find it, and was mildly disappointed when I couldn't spot it. Indeed, I started fearing it had outlived its time in the subway system and was now being replaced by an ordinary ad.

But I was wrong, and what a joy it was to see it again, waiting for me, hailing me from its end of the car with a winking *I'm over here!* or *Haven't seen you in ages! How have you been?* The joy of reencountering it after fearing I'd lost it began to mean something that was not necessarily irrelevant to the poem itself; both the worry and the joy had wormed their way into the very content of the poem and pollinated it, so that even the history of our nodding acquaintance in the transit system was woven into a poem that was itself about the transit of time.

But perhaps something deeper was going on.

<p style="text-align:center">→>-‹‹-</p>

To understand the poem, I wanted to understand my experience of the poem—from how I felt at our first meeting, which I had started to forget, to the thrill of rereading it whenever I could, down to the state of bafflement it left me in each time I was coaxed to trace its meaning but found myself failing again and again, as though my failure to understand the poem were ultimately its hidden, perhaps its truer, meaning. There were no

external, incidental facts to set aside or dismiss if I wanted to grasp both the poem's effect on me and the person I was upon reading the poem.

The way in which or the place where we land on an art object, a book, an aria, an idea, a piece of clothing we long to buy, or a face we would like to touch—all these cannot be irrelevant to the book, the face, the tune. I even want my first tentative, mistaken readings of the poem to mean something too and not to be forgotten, because misunderstanding, when we feel we've misunderstood a poem, is never entirely our fault but the fault of the poem as well—if *fault* is indeed the right word, which it might not be, since what spurs a fault in reading may be an unintended, undisclosed, subliminal meaning that the poem continues to intimate despite itself, even when it manages to distract us for a moment, a meaning waiting in the wings, forever inferred and yet forever deferred—the suggestion of meaning, a conditional meaning that is simply not quite there or that was once partly there but was later removed either by the poet or the reader and is now a latent, unreal meaning that lies in limbo and is still trying to work itself back into the poem. There is not a single work of art that is not riddled with such fault lines that are constantly asking us to see what's not there to be seen. Ambiguity in art is nothing more than an invitation to think, to risk, to intuit what is perhaps in us as well, and was always in us, and maybe more in us than in the work itself, or in the work because of us, or, conversely, in us now because of the work. The inability to distinguish these strands is not incidental to art; it is art.

What we call meaning, what we call resonance, enchant-

ment, and ultimately beauty, would remain totally unfathomed and silent without art. Art is the agent. Art allows us to reach our truest, deepest, most enduring selves by borrowing someone else's skill, someone else's words, or someone else's gaze and colors; left to our own devices, we wouldn't have the insight, or the comprehensive vision, much less the will or the courage, to enter that place where only art can take us.

Artists see *other* than what is given to be seen in the "real world." They seldom ever see or love places, faces, things for what they in themselves really are. Nor, for that matter, do they even know their impressions of them as they in themselves really are. What matters to them is to see *other* or, better yet, to see *more* than what lies before them. Or, to put it differently: what they reach for and what ultimately touches them is not experience, not the here and now, not what's there but the radiance, the echo, the memory—call it the distortion, deflection, deferral—of experience. What they do with experience *is* and *becomes* experience. Artists do not merely interpret the world to know the world; they do more than interpret: they transfigure the world to see it differently and ultimately to take possession of it on their own terms— even if it is for a short while, before they start the process all over again with another poem, another painting, another composition. It is their mirage of the world that artists long to hold, the mirage that breathes essence into otherwise lifeless places and objects, the mirage they wish to take away with them and leave behind in finished form when they die.

Art seeks not life but form. Life itself, and Earth along with it, is all about stuff, a clutter of stuff, while art is nothing more than the invention of design and a reasoning with chaos. Art wants to let form, simply form, summon up things that were

hitherto unseen and that only form—not knowledge, Earth, or experience—could have brought to light. Art is the attempt not to capture experience and give it a form but ultimately to let form itself discover experience—better yet, to let form *become* experience. Art is not the product of labor; it is the love of labor.

Monet and Hopper weren't seeing the world as it was; they were seeing other than what lay before them, experiencing not what was given but what always felt elusive and strangely withheld and that needed to be invented or restored, imagined or remembered. If they succeeded, it is principally because it didn't matter which of these four it was. Art is the huge negative, the *gran rifiuto*, the everlasting *nyet*—or call it the inability, even the failure, to take things as they are or to accept life as it is, people as they are, events as they happen. Indeed, Hopper said he wasn't painting a Sunday morning or a woman sitting, ever so lonely, on an empty bed; he was painting himself. Similarly, Monet wrote that he was painting not the Rouen cathedral but the air between the cathedral and himself, what he called the *envelope*, the thing that wraps around an object, not the object itself. What interested him was the endless traffic between himself and what he called the *motif* (the subject matter). "The motif," he once wrote, "is insignificant . . . What I want to reproduce is what lies between the *motif* and me." What he wants to represent hovers between the visible and the invisible, between design and raw stuff.

→>·<←

So here is the poem I kept running into in the transit system. It's entitled "Heaven," by Patrick Phillips.

HEAVEN

Patrick Phillips, b. 1970

It will be the past
and we'll live there together.

Not as it was *to live*
but as it is remembered.

It will be the past.
We'll all go back together.

Everyone we ever loved,
and lost, and must remember.

It will be the past.
And it will last forever.

The poet here is remembering a cherished past—let us say, for the sake of simplicity, a love that occurred a while back or long ago but that no longer exists and therefore exists in memory alone. In his ache to hold on to the past, the poet conjures a time in the future when he'll be allowed to return to that past, not the past as it happened and was once lived, but as it's been cradled and cherished and crafted by the mind and a faculty that the poet Leopardi called *le ricordanze*—remembrance as a creative act, the past eternally preserved, eternally held firm, eternally relived, like a Venice that stays forever not as it once

was but as it always longed to be, nothing added, nothing altered, nothing taken, nothing lost. Venice forever, a past that transcends time.

This is not a homogenized, refurbished past cleansed of all incidentals; rather, it is a past that never really was but that continues to pulsate, a past that, even back when it was the past, harbored an unfulfilled wish for a might-have-been version of itself that wasn't unreal for not being.

What the poet is describing is a time in the future when the past will have become an everlasting present. In the words of Virgil, "Perhaps the day may come when we shall remember these sufferings with joy." There is no name for this melding of past, present, and future tenses. Which should not be surprising, since what the poet wishes here is to transcend, to undo, to overcome time altogether and be with all those he ever loved and lost and continues to love and long for. But, then, this is no longer time. This is eternity. This is not life. This is the afterlife. Hence the title of the poem: "Heaven." This is a poem about death. No wonder I've been reading it underground. And the coincidence of reading about death underground surely must mean something too, since coincidence is what confutes and jostles how we attempt to make sense of time, and this is precisely a poem about what will happen when we vanquish time and lie outside of it, beyond time, after time. This is a poem about an eternal future that is an eternal past. Which is the ultimate illusion, the ultimate fiction, the ultimate victory. This is a poem about a place in time that does not exist.

And here we confront the ultimate paradox: to think of ourselves outside of time in this heaven that is past, present,

and future is to think of a time when we won't even be able to think of anything, much less of time or of love. The poem is projecting a time of plenitude and indeed drawing a sense of harmony, redemption, and fulfillment from this projected plenitude, which is supposed to take place in eternity but where the awareness of plenitude, to say nothing of awareness itself, will be impossible to have. The dead are without awareness.

Part of me does not wish to drop the matter here. I want to palpate this imponderable situation, which is why, perhaps, I propose that the best way to grasp the paradox of mind after death is to imagine the opposite scenario. An old man is lying on his deathbed surrounded by his wife, children, and grandchildren, all of whom had brought him much happiness. Naturally he is extremely sad. He says he feels for their sorrow: "Who knows," he says, "your sorrow may last your entire lives, yet I don't want you to feel any. Worse yet, your sorrow makes me very sad, not because I'm the reason for it, but because you are my children and I don't want to see sorrow in your lives. I know how you'll miss me. My room, my desk, my seat at the dinner table. I know how this hurts." But there is also another reason for the dying man's sorrow. "What kills me now is not your sorrow only, but mine as well. I know how much I will miss you. I will miss you as you are all now, I will miss you as you were as children, I will miss you for one hundred days, one hundred years, ten thousand years, forever, because my love never dies, and the worst of it all is that I would rather miss you and ache for you for eternity than think that as soon as I die now I will not even have a brain to know that I ever loved you. I miss you already, because the thought of forgetting or not even having you

in my thoughts is unbearable, is worse than death to me, which is also why I can't stop crying."

Art allows us to think the unthinkable, to posit one paradox after another in the hope of firming up wisps of our lives and feelings by transfiguring them, by giving them a shape, a design, a coherence, even if they are and will remain forever incoherent. Incoherence exists, which is why composition—art—exists. Grammarians called this unthinkable, imponderable, impalpable, fluid, transitory, incoherent zone the irrealis mood, a verbal mood to express what might never, couldn't, shouldn't, wouldn't possibly occur but that might just happen all the same. The subjunctive and the conditional are irrealis moods, as are the imperative and the optative. As defined by Wikipedia—and I quote Wikipedia because the *Oxford English Dictionary* does not house the word—irrealis moods indicate "that a certain situation or action is not known to have happened at the moment the speaker is talking." Instances of irrealis moods in addition to those I've just mentioned are legion.

Most of our time is spent not in the present tense, as we so often claim, but in the irrealis mood—the mood of our fantasy life, the mood where we can shamelessly envision what might be, should be, could have been, who we ourselves wished we really were if only we knew the open sesame to what might otherwise have been our true lives. Irrealis moods are about the great sixth sense that lets us guess and, through art sometimes, helps us intuit what our senses aren't always aware of. We flit through wisps of tenses and moods because in these drifts that seem to take us away from what is around us, we glimpse life, not as it's being lived or was lived but as it was meant to be and should have been lived. I am always looking for what's

not quite there, because by turning my back to what I'm told is all there is, I find more things, other things, many perhaps unreal at first but ultimately truer once I've ferreted them out with words and made them mine. I look at places that no longer exist, at constructions that have long been torn down, at journeys never taken, at the life we're still owed and for all we know is yet to come, and suddenly I know that, even with nothing to go on, I've firmed up something if only by imagining that it might happen. I look for things that I know aren't quite there yet, for the same reason that I refuse to finish a sentence, hoping that by avoiding the period, I'm allowing something lurking in the wings to reveal itself. I look for ambiguities, because in ambiguity I find the nebulae of things, things that have not yet come about, or, alternatively, that have once been but continue to radiate long after they're gone. In these I find my spot of time, my might-have-been life that hasn't really happened but isn't unreal for not happening and that might still happen, though I fear it may not come about in this lifetime.

→>-<←

Today while riding the C train I saw the same poster again. It looks older and yellowed. Clearly, its days are numbered. And yet as I made a point of rereading it—because it's just there waiting to be reread still—it seemed to want to disclose something new, if not something about itself, then something about my seeing it again and thinking back to that time when every line seemed new to me and was still able to mystify me, again and again. I missed those days, the way we might miss our first few days in a grand hotel when we'd get lost in its convoluted

corridors and continue to fail to watch for those reminders that told us we'd yet again taken the wrong turn. And yet, each mistaken corner seemed filled with the thrill of mystery and discovery. The way we might miss the first week of a new love, when everything about the new person seems miraculous, from their habits and cooking, down to the new phone number, which is still difficult to remember and which I don't want to learn for fear that it might lose its luster and stirring novelty.

I want to relive the first reading of the poem, and the second, and third, because a different me is present in each. I want to rediscover the poem from scratch all over again and pretend that these verses, "Everyone we ever loved, / and lost, and must remember," didn't just remind me of something I seem to recognize about my own life but whose cadence I understand only because each of the three verbs folds upon one another ever so neatly and in a manner that suggests I might have written them myself.

I look at the poster of the poem for the nth time and am starting to think that perhaps what I've written about this poem is not quite finished, may never be quite finished, since the meaning I thought I'd captured yesterday has gone into hiding today or couldn't possibly be the correct meaning, though I also suspect it might resurface and prove to be correct in a few days—a chain of events that is not irrelevant to the poem itself—because there is nothing definite about the poem's meaning, because its true meaning is itself a could-be meaning that hasn't really surfaced yet but isn't unreal for not surfacing but might still surface sometime soon, though I fear it did so the first time I read the poem and then never surfaced again.

IN FREUD'S SHADOW,
PART 1

am in Rome again this summer. I am here because I've been
told there is still a chance I might be able to visit Villa Torlonia,
once known as Villa Albani, where I hope to set eyes on what
some claim may be the original statue of Apollo Sauroktonos,
Apollo the Lizard Slayer, conceived by the legendary fourth-
century Athenian sculptor Praxiteles. This is not the first time
that I've come to Italy lured by the possibility of seeing the
statue. But I've failed each time; hence, my guarded skepti-
cism. The Torlonias have always been reluctant to let people see
their villa, even more so their prized antiques, some of which
owe their existence in the villa to the expert hand of Cardinal
Albani's secretary, Johann Joachim Winckelmann, the scholar,
archaeologist, and father of modern art history who lived from
1717 until his murder in 1768. This is my third visit to Rome to
view the statue, and I fear it might turn out to be yet another
fruitless one. I am reminded of Freud, who made a point of visit-
ing Michelangelo's *Moses* whenever he was in Rome and got to
see it each and every time.

Sometimes I like to think that I am retracing Freud's footsteps in Rome—the Hotel Eden, the Vatican Museums, the Pincio, San Pietro in Vincoli. I like the tone of scholarly seriousness that recalling Freud's visits casts on my stay in Rome; it screens what I might really be after here and makes my interest in the city feel less troubling, less urgent, less primal or personal. After seeing the Caravaggios in Piazza del Popolo, I am sitting down at Caffè Rosati and ordering a chinotto. This piazza, after all, is the very spot where an ecstatic Goethe realized he had finally entered Rome.

I am in Rome, but I am not particularly surprised or, for that matter, as rapturous as I had hoped. Perhaps this is just my oblique way of asking Rome to startle me with something new, something forgotten, or with something that might jumpstart the full realization of being back in a city that I know I love, though this love isn't always easy to find and needs to be rummaged for like an old glove lost in a drawer filled with socks. All year long I've been waiting for this morning at Caffè Rosati, where I knew I'd order a chinotto, buy the paper, and let my mind drift to Winckelmann and Goethe and to the statue of Apollo that I still fear I'll never see. Instead, something holds me back and makes me think of Freud, who grew to love Rome and felt at home here. That is how I want to feel. I want to be in the moment, feel that I belong here. But I don't know how that is done. I'm not even sure that I do want to feel I belong here. Something tells me that I'm really here to think of Freud, not of the *Apollo Sauroktonos* or of the Torlonias or of Winckelmann. But I'm not sure of this either. Perhaps I am here because Rome and I have unfinished business dating back to my adolescence.

But then, come to think of it, Freud is not irrelevant to that either.

<p style="text-align:center">→>⸢⸢−</p>

On September 2, 1901, at the age of forty-four, Freud finally arrived in Rome. He had already been to Italy several times and could have visited Rome before but was held back owing to a psychological reluctance that critics and biographers have alternatively called his "Roman phobia" or "Rome neurosis." Freud was well aware that some buried inhibition kept preventing him from visiting a city that, from his early school days, must have occupied a significant portion of his imagination. Young Freud was exceptionally well read and, like so many pupils in Vienna, was not only conversant with the classics and ancient history but enamored with the art of antiquity. He knew its monuments, was spellbound by archaeology, and probably loved everything about Rome and Athens long before visiting either city. And yet we know, as he knew himself, that something stood in his way.

Freud attempted to fathom the reason behind his phobia, but his explanation hardly scratches the surface. Critics and biographers have offered Freudian or pseudo-Freudian interpretations of the man Freud by using material from his correspondence and his *Interpretation of Dreams* to understand what Rome meant to the forty-four-year-old Viennese doctor. Their theories range from the plausible to the contrived to downright psychobabble. Some hold that Freud might have been reluctant to realize his long-cherished dream of reaching Rome because

he had been nurturing the dream for far too long to confront it as anything bordering on the real. A facile non-explanation. Others suggest that he was totally unnerved by the mere thought of so many layers in the history and archaeology of the city. Hardly a better explanation. There are many others.

Perhaps Freud felt unworthy of visiting the idealized capital of Western civilization. Or, being a Jew, perhaps he wavered before visiting the very heart of Christendom, especially after flirting with, but ultimately rejecting, the prospect of converting to Christianity. Or, following in Goethe's tracks, perhaps he preferred Ancient Rome but had no inclination for the modern metropolis, which would have stood in the way of the old. Or perhaps everything about Rome was underscored by disquieting memories of his Jewish father, or by his guilty conscience as a Jew, or by his suspicion that Rome had become a metaphor for something desired that he was not too eager to probe. As he wrote to his friend and colleague Fliess, "My longing for Rome is deeply neurotic . . . a cloak and symbol for several other hotly longed-for wishes." In the words of Freud's biographer Peter Gay, Rome was a "supreme prize and incomprehensible menace," a "charged and ambivalent symbol . . . [standing] for Freud's most potent concealed erotic, and only slightly less concealed aggressive wishes." This is extremely strong language for what might easily have passed for the typical apprehensions of someone thinking of traveling far from his cushy home in Vienna. *Erotic? Aggressive?*

Freud knew that what he was going to discover would be a real city, not some illustrated pop-up book sold to tourists. And perhaps he knew himself well enough to fear that so desired a visit, apart from stirring great joy, might easily be met with

disappointment or, worse yet, with numbness or dismay. Once visited, Rome would no longer hold the allure of a Rome unvisited.

In this Freud was in good company. Goethe had felt a vague sense of bewildered incredulity more than a century earlier when, as a starry-eyed northerner, he finally arrived in Rome. As he writes on November 1, 1786, "I was still afraid I might be dreaming; it was not till I had passed through the Porta del Popolo that I was certain it was true, that I really was in Rome." A few lines later, he adds: "All the dreams of my youth have come to life; the first engravings I remember—my father hung views of Rome in the hall—I now see in reality, and everything I have known for so long . . . is now assembled before me. Wherever I walk, I come upon familiar objects in an unfamiliar world." To complicate things, Freud himself put forward an explanation for his Roman anxiety by examining several of his dreams about Rome. One explanation, which even the more enlightened and canny theorists have swallowed hook, line, and sinker, was the theory of the ambitious and combative Jew trying to right the long history of Jewish oppression in the Diaspora—Freud as conquistador, to use Freud's own words, as triumphant liberator. Another theory put forward by Freud himself is that his allegiance as a Jew was not to Rome, a city whose history from antiquity to the modern age had been intolerant of and cruel to Jews, but to the Carthaginian general Hannibal, a Semite and Rome's nemesis. But this theory is not so persuasive either, particularly since Freud's unquestioned love of classical history, literature, art, and archaeology would have made his loyalty to Carthage rather thin-skinned. After all, Freud, as far as we know, never traveled to Carthage or even expressed a desire to go there. Instead, after visiting Rome that

first time in 1901, he returned at least six more times. He had passed the test, and having passed it once felt free to come back to Rome for the rest of his life. The allegiance to Hannibal feels like a canard, a decoy of sorts meant to throw everyone off the scent, possibly himself included. If anything, both Freud and Hannibal shared one thing in common: not just their Semitic origin or their determination to stand and fight for what they believed in but, as Freud knew so well, when it came to the much-awaited moment, both he and Hannibal stalled outside the gates of Rome. *Hannibal ante portas. Freud ante portas.*

-->-<--

Freud's hesitation reminds me of Goethe's own. "What I want to see," writes Goethe in his *Italian Journey*, "is the Everlasting Rome, not the Rome which is replaced by another every decade." What Goethe means by *Everlasting* Rome isn't clear. Is it the Rome of antiquity, or is it something more elusive yet, not modern, not ancient, not anything, really, but a confluence of all the Romes that have ever existed and will always exist? We'll never know.

There are many Romes. Some belong to different ages and go back twenty-five hundred years, while others aren't old enough to have been given a name yet. Etruscan Rome, Republican Rome, Imperial Rome, paleo-Christian Rome, Medieval, Renaissance, Baroque, eighteenth-century Rome, van Wittel's Rome, Piranesi's Rome, Puccini's Rome, Fellini's Rome, contemporary Rome—and so many, many more. All are so thoroughly different that they couldn't possibly be the same city. Yet each is built into, on top of, under, or against the other, and sometimes with stones stripped and looted from one Rome to build another.

A Roman today doesn't have to know anything about the past or that there are major differences between, say, an ancient Roman called Agrippa and another called Agrippina, but even the most boorish born-and-bred Roman, who's never seen the Forum or the Coliseum or bothered to read Virgil to know why Via Niso and Via Eurialo run into each other, will guess that the streets must have something to do with the past. Everything in Rome has something to do with the past. Antiquity is all over the place, which is another way of saying that time, however one lives one's life in Rome, is the busiest thoroughfare in the city. You cross time even when you're not thinking of time. You touch time the moment you lean on a wall to tie a shoelace and realize that this old, flaking wall was already quite old when men like Goethe, Byron, and Stendhal stood by it and remembered that Winckelmann himself must have touched this very same wall and then rubbed his hands to shake off the same dust that Michelangelo himself must have rubbed against. Everything is old and layered here, and epochs, like throwaway goods in a flea market, are haplessly bundled together, so that you really can't tell one from the other. The new, the modern, the cutting edge always bear traces of the old. It's no different with the people. Romans feel old. Children are wiser than their years, and grown-ups, for all their bursts of ill temper, have learned to make allowances for things you wouldn't put up with anywhere else. Whatever irritated you today already happened once, happens all the time, will definitely happen again. Rome is immortal not because there is so much beauty that no one wishes to see perish but because time is everywhere and nowhere, nothing really dies, and all things come back. We come back. Rome is a palimpsest written over many times.

Freud's description of Rome in *Civilization and Its Discontents* speaks to this in far more eloquent terms. For Freud, Rome is the perfect metaphor for the human psyche and ultimately for the human experience. Nothing stays buried forever, all things resurface, and all ultimately lead into, feed off, and abut others.

In Freud's view, Rome was built layer upon layer, from the oldest crisscrossed "Roma Quadrata, a fenced settlement on the Palatine," to "the . . . federation of . . . settlements on the different hills," to "the city bounded by the Servian wall," and, later still, to "the city which the Emperor Aurelian surrounded with his walls." "Many of the walls still hold up," writes Freud, the lover of antiquity, but "of the buildings which once occupied this ancient area [the visitor] will find nothing, or only scanty remains, for they exist no longer . . . Their place is now taken by ruins, but not by ruins of themselves but of later restorations made after fires or destruction."

Freud must have loved the idea of ruins that are not the original ruins but *ruins of subsequent restorations*—in other words, ruins many times over, reminiscent of Schliemann's multitiered, imbricated city of Troy, built over time, one tier over the other.

But Freud, after seemingly mapping out so stirring a portrait of layered Rome, suddenly changes tack and proceeds to a bolder analogy yet, reminding his reader that "in mental life, nothing that has once been formed can perish." Nothing disappears, nothing is ever pulverized. In his view, moreover, the very notion of sequential tiers, where tier one comes before tier two, and tier two before tier three, is not correct enough, for things do not necessarily simply antedate one another, either in Rome or in the life of the human psyche. Instead of a sequential manner,

Freud proposes an audacious model, suggesting that what was originally present and is now past can continue to survive, not necessarily underneath what is visible but *alongside* its latest incarnation. "What is primitive is . . . commonly preserved alongside of the transformed version which has arisen from it."

This preposition, *alongside*, is key to Freud's Rome. The ancestor lives not below its descendant, or even just alongside its descendant, but—to push the point—the ancestor becomes its descendant. It's as if the original pagan script on a palimpsest not only never disappeared, or continued to exist contemporaneously with the text written over it—it may even overshadow what came after. The later rubs against the earlier, and the earlier talks back to the later.

Freud understood that what comes earlier never disappears but coexists with what comes later. As Freud writes, "Let us, by a flight of imagination, suppose that Rome is not a human habitation but a psychical entity . . . In the place occupied by the Palazzo Caffarelli would once more stand—*without the Palazzo having to be removed* [my emphasis]—the Temple of Jupiter Capitolinus; and this not only in its latest shape, as the Romans of the Empire saw it, but also in its earliest one, when it still showed Etruscan forms and was ornamented with terracotta antefixes. Where the Coliseum now stands we could at the same time admire Nero's vanished Golden House. On the Piazza of the Pantheon we should find not only the Pantheon of today, as it was bequeathed to us by Hadrian, but, *on the same site* [my emphasis], the original edifice erected by Agrippa; indeed, the same piece of ground would be supporting the church of Santa Maria sopra Minerva and the ancient temple over which it was built."

But Freud is uncomfortable with this inspired if chimerical flight of fancy, which seems exaggerated as far as Rome is concerned. The vision of a space untouched by time, where old buildings stand not just alongside newer ones but are embedded in them as well, where ancient Roman monuments that had been plundered of their stones can be nested in the same exact space as latter-day palaces built with those selfsame plundered stones, is a surrealist vision that Freud can't countenance for long. You cannot dismantle the bronze portals of Rome's Pantheon and have them molten to build Bernini's baldachin in Saint Peter's and still expect the Pantheon and Saint Peter's to contain the same bronze parts. Freud is not at all wrong in suggesting that all of Roman history is present in every single instance of the city; he simply cannot visualize—or refuses to visualize—how two buildings can coexist on the same spot.

Freud was fond of the archaeological model and would probably subscribe to the vision of wobbly tectonic plates constantly hurtling against and displacing one another; but the image of multiple time zones cohabiting *alongside* one another is too much for him. And so, the very man who tells his patients to probe their wildest fantasies takes back the whole fantasy: "There is clearly no point in spinning our phantasy any further, for it leads to things that are unimaginable and even absurd. If we want to represent historical sequence in spatial terms, we can only do it by juxtaposition in space: the same space cannot have two different contents." Freud's stratified analogy had served its purpose, and this is where it ends. *No point in taking it any further*, he says.

And yet what Freud had done, perhaps unconsciously, when invoking Rome as a metaphor for the psyche was to tap into

something altogether unthinkable. Not the succession of time zones—which is entirely thinkable—but the collapsing and eventual erasure of temporal zones.

Like Freud's fantasized Rome, where layers of time zones are constantly being reshuffled, the psyche may be likened to a soufflé in the making, where desire, fantasy, experience, and memory are all being *folded* into one another, without sequence or logic or the semblance of a coherent narrative. To paraphrase Julia Child, *folding* is a sort of zigzagging, figure-eight movement of the rubber scraper, which takes the mixture to the top, folds it back toward the bottom, then takes what was just folded at the bottom back to the top again. What was past is present, what will be future is past, and what can never be might return time and time again.

Rome, the eternal landfill, is nothing more than a hodge-podge of constantly reshuffled and refolded tenses: mostly the past tense, marginally the present, and heavily the conditional and subjunctive moods, all merging in a medley that linguists call irrealis moods, that indescribable, counterfactual time zone where we mortals spend most of our days with might-have-beens that haven't really happened but aren't unreal for not happening and might still happen, though we hope—and fear—they both will and never will happen.

Each of these clauses in the previous sentence does not necessarily contradict or dispel the one before or after it but rather seeks to augment it and to *fold* it in by incorporating it in a series of what could easily be called, as in music, a *moto perpetuo* of 180-degree turns and reversals.

Caught between the *no more* and the *not yet*, between *maybe* and *already,* or between *never* and *always,* irrealis moods have

no tale to tell—no plot, no narrative, just the intractable hum of desire, fantasy, memory, and time. Irrealis moods can't really even be written in, much less thought in.

But they're where we live.

The problem with Freud's archaeological analogy is not that he is conflicted about it because it is fanciful but that the analogy itself is simply unwieldy. Things move in time, and things move in space; for the analogy to really work, they have to move on both planes simultaneously—and this Freud, who was by no means averse to counterfactual thinking, dismisses as *fantasy*. Freud simply cannot visualize how perennial place and perpetual time are continuously coincident. Such thinking is not only counterfactual, it is counterintuitive.

Part of the reason for Freud's discomfort with such thinking may be that he is using a spatial metaphor for time, which would be like using an apple metaphor for oranges. Part of it may also be that Freud is unable to think of time without invoking space, but that trying to think of space in that context automatically occludes his very thinking about time.

I suspect, however, that the problem lies elsewhere. Freud may be using an archaeological metaphor, but what is subsumed in his vision of time is not excavation, which is vertical and moves one layer at a time—historically, chronologically, diachronically—but something quite different.

→>-<-←

Irrealis moods speak not the language of psycho-archaeologists but of water dowsers, who understand not excavation but a phenomenon called remanence. Remanence is the retention

of residual magnetism in an object long after the external magnetic force has been removed. Remanence is the memory of something that has vanished and left no trace of itself but that, like a missing limb, continues to exert its presence. The water is gone, but the dowsing rod responds to earth's memory of water.

Unlike excavation, which is vertical and moves down one layer at a time—sequentially—remanence is the pull of something that not only remains hidden, or that has gone underground and may be headed farther underground, or indeed that has altogether disappeared and may no longer exist and perhaps never did exist, but—to add a twist—whose converse, imminence, could just as easily be the pull of something that has not even come into being yet and is still working its way to the surface, into the future. The two gestures of emergence and disappearance happen coincidentally, for remanence and imminence are ultimately not about time, not about past, present, or future, but about the braiding of the three. It is about water that may or may not be underground, that may have dried up or that may be welling up, or both at the same time.

What continues to draw water dowsers is not necessarily the presence of something, nor, for that matter, its absence, but its echo, its shadow, its trace, or, conversely, its incipience, its inchoateness, its abeyance, its larval character. The shadow of the departed and the embryo of something yet unborn sit *alongside* each other. In the language of lithographers, Rome is both the city and its afterimage. It is both the image and the stains on the lithographer's stone long after the prints have been framed and sold, the way fish scales might continue to glisten on the cutting board long after the fish has been sliced open,

cooked, and eaten. Ultimately, Rome is less about time than the inflection of time, the perpetual reflux of time.

Being in Rome is part imagining and part remembering. Rome cannot die, because it never, ever really is. It is the shadow of something that almost was but stopped being but that continues to pulsate and craves to exist though its time either hasn't come yet or is already gone, or is both coming and gone. Rome is pure fantasy. It is not quite there, not quite real, not unreal either, but *irreal*.

➤➤◄◄

What Freud experienced vis-à-vis Rome happened to him again in 1904 when he was finally able to see the Acropolis in Athens. He experienced not disappointment, not even the overwhelming sensation called the Stendhal syndrome, where one is so taken before a great work of art that one collapses. What he felt instead was a cloying something verging on numbness, disjunction, and a sense of alienation. James Strachey's translation of the German word *Entfremdungsgefühl* is *derealization*, the sense, in Freud's own words, that "What I see here is not real." What would have been a source of happiness and fulfillment turns into a form of near apathy, disbelief, and ultimately disturbance. The Acropolis does not speak to him. Nothing could signal his failure to consummate experience more than this inability to confront the real.

"So all this really does exist, just as we learned in school!" thinks a bewildered Freud as he stands for the first time in his life on the Acropolis. He knows that there was never any reason to doubt that the Parthenon existed, but he is nevertheless un-

able to grasp the reality of the experience of being there to prove its existence. It is as if the very mind that stopped itself short of indulging in "spinning [a] phantasy" is now doing the exact opposite and finds itself unable to indulge in reality either.

Visiting a place is not necessarily the experience of it. The real experience is the resonance, the "pre-image," the afterimage, the interpretation of experience, the distortion of experience, the struggle to experience the experience. What we do when we think about experience, even when we don't exactly know what to make of it, is itself already experience. It's the radiance we project onto things and that things radiate back to us that constitutes experience. We bring our phantoms to Rome, and we uncover and read or expect to run into these phantasms, so that in the process Rome ultimately becomes the embodiment of these phantasms, even if we never run into them.

We remember best what could have happened but never happened.

<p style="text-align:center">→>-<←</p>

What does Rome mean to Freud? Is it a stand-in for something else? Is it a jumble of unresolved memories, desires, fears, fantasies, traumas, blockages, repressions, et cetera, all bunched together from babyhood to adulthood, each not just layered on top of the other but existing—to use Freud's apt word—*alongside* the other? Perhaps the question to ask is, how does Freud come up with the most brilliant metaphor in the history of psychology, stating that the psyche, like Rome, is not one thing, that identity itself is not one thing either, but a confluence of many movable and shifty, transient parts that trade places, change

faces, don and doff all manner of masks, lie, cheat, steal from one to give to the other—which is why we don't know who we are or what we want or why we can't find forgiveness for sins we're not even sure we've ever committed?

But still, why Rome? Perhaps Freud selects Rome because, in thinking about the eternal tussle between childhood impulses and their repression in adulthood, his mind must have drifted to Rome, but not just because Rome was a suitable metaphor for a man who was devoted to ancient art and archaeology, or because there was something about him and Rome that suggested repression, *but because his very love of antiquity and archaeology was itself perhaps already a stand-in for his lifelong penchant for buried, shifty, undisclosed, primal, feral stuff,* stuff that, in all likelihood, he had already harnessed and possibly censored by young adulthood. As Peter Gay suggests, not going to Rome was already perhaps an enduring form of censorship. Thinking of Rome in four or so pages of *Civilization and Its Discontents* was unsettling but not necessarily disturbing; it was maybe even pleasurable. Coming up with the idea of Rome as metaphor and toying with Rome's many layers and thinking about layers and going through the motions of unpeeling layer after layer and delving deeper into things with near-clinical precision and dutiful historiographical details might possibly have been a safer and ultimately a secretly libidinous, surrogate pleasure for an unnamed pleasure being deferred.

In this sense, invoking Rome is not only a way of speaking about repressed impulses; it is an oblique way of discussing Freud's own repression by presenting it as a figure of speech, a sort of universal metaphor. Archaeology, and by implication Rome itself, becomes both a mechanism and a metaphor of repression.

Ultimately, the surest way of burying repressed material is by going through the motions of uncovering it. And vice versa.

Freud returned to Rome many times after 1901. Surely, he must have remembered each of his previous visits as he stood in his room at the Hotel Eden overlooking the city, thinking back, not just to a time when he couldn't bring himself to visit Rome, but also ahead to the visits that had yet to come in years to follow. Being the methodical man he was, he would probably chart each visit in his mind, and, like Wordsworth recalling his visits to Yarrow, he too might try to make sense of a Rome unvisited, a Rome visited, and many Romes revisited—the boy Freud in Vienna reading up on Rome, the forty-something Freud arriving there, followed by the older Freud, then father Freud, sick Freud, each one forever eager to keep returning to a city that had come to symbolize so much of his passions and his life's work.

As he keeps revisiting the church of San Pietro in Vincoli to see Michelangelo's statue, he must at some point realize that his foremost yet seldom acknowledged inspiration for his lasting love of art, archaeology, and antiquity was not so much Hannibal but Winckelmann, the father of art history and archaeology, whom Goethe himself had read and who, without ever traveling to Greece, had devoted his life to studying not Greek statues but Roman replicas of Greek nudes. Yet Freud mentions Winckelmann only once. When wondering whether it was Hannibal or Winckelmann who had stirred his longing for Rome, he hastily offers a tortuous explanation justifying why the answer was Hannibal. Winckelmann he does not discuss. Yet Winckelmann's love of the male body had produced a printed work second to none in the annals of art history. Freud does not mention

this either. And even if he had Winckelmann's tomes in mind, still, in the meantime, he had discovered the statue of Moses, and in thinking of Moses, he knew he was also obliquely thinking of himself. It was, in the end, easier to analyze Moses the man and *Moses* the statue than to analyze the analyst himself, easier too, and perhaps safer and—to use Freud's own telling words—less "daring . . . to remain quiet" by analyzing a Jewish hero rather than naked Athenians. However, the language on Leonardo tells us that Freud was not insensitive to Athenian nudes. Thinking of Leonardo, Freud writes:

> These pictures breathe a mysticism into the secret of which *one dares not* penetrate . . . The figures are again androgynous . . . they are pretty boys of feminine tenderness with feminine forms; they do not cast down their eyes but gaze mysteriously triumphant, as if they knew of a great happy issue concerning which *one must remain quiet*; the familiar fascinating smile leads us to infer that it is a love secret. (Italics added)

The analyst had found his double in the city itself—a city that was all layers, all tiers, and thus, essentially, bottomless. Freud fantasized about retiring to Rome and wrote to his wife in 1912 that "It feels quite natural to be in Rome; I have no sense of being a foreigner here." He was echoing none other than Winckelmann himself, who came to love Rome and made Rome his home and who, once in Rome, wrote words that Freud had surely encountered, if not in Winckelmann, then most surely in Walter Pater's assessment of Winckelmann: "One gets spoiled here; but God owed me this."

IN FREUD'S SHADOW,
PART 2

Freud would understand. I long for Rome, but there is always something unsettling, perhaps disturbingly unreal, about Rome. Very few of my memories of Rome are happy ones, and some of the things I wanted most from Rome, Rome just never gave me. These continue to hover over the city like the ghost of unfledged desires that forgot to die and stayed alive without me, despite me. Each Rome I've known seems to drift or burrow into the next, but none goes away. There's the Rome I saw the first time, fifty years ago, the Rome I abandoned, the Rome I came looking for years later and couldn't find, because Rome hadn't waited for me, and I'd lost my chance. The Rome I visited with one person, then revisited with another and couldn't begin to weigh the difference, the Rome still unvisited after so many years, the Rome I'm never quite done with, because, for all its imposing, ancient masonries, so much of it lies buried and out of sight, elusive, transient, and still unfinished, read: unbuilt. Rome the eternal landfill with never a rock bottom. Rome my collection of layers and tiers. The Rome I stare at once

I open my hotel window and can't believe is real. The Rome that never stops summoning me, then throws me back to wherever I've come from. *I am all yours,* it says, *but I'll never be yours.* The Rome I forgo when it becomes too real, the Rome I let go of before it lets go of me. The Rome that has more of me in it than of Rome itself, because it isn't really Rome I come looking for each time but me, just me, though I can't do this unless I seek out Rome as well. The Rome I'll take others to see, provided it's mine we'll visit, not theirs. The Rome I don't want to believe could go on without me. Rome, the birthplace of a self I wished to be one day and should have been but never was and left behind and didn't do a thing to nurse back to life again. The Rome I reach out for yet seldom touch, because I don't know, and may never learn, how to reach out and touch.

Not a speck of me is Roman any longer, and yet once I've emptied my suitcase in Rome, I know that things are in their right place, that I have a center here, and that Rome is home. I have yet to discover that there are, so I'm told, about seven to nine ways to leave my apartment and head down the hill of the Gianicolo to Trastevere, but I am reluctant to learn shortcuts yet; I like the slight confusion that delays familiarity and lets me think I'm in a new place and that so many new things are open and possible. Perhaps what makes me happy these days is that I have no obligations, can afford to do whatever I please with my time, and I love spending my evenings sitting at Il Goccetto, where witty and smart Romans come to while away the hours before heading home for dinner. Some even change their minds while they're drinking, as happened to me a few times, and end up having dinner right then and there. I like this Roman way of improvising dinner when all I'd planned for was a glass of wine.

After wine, sometimes I'll buy a bottle and head back to Trastevere to visit friends. On certain evenings, when I wish to go home, I avoid the bus and go up the hill on foot.

On my way across the Tiber at night I love to see the illuminated Castel Sant'Angelo with its pale ochre ramparts glowing in the dark, just as I love to see Saint Peter's at night. I know that at some point I will reach the Fontanone and stop to stare at the city and at all of its glorious floodlit domes, which I know I will miss soon enough.

I love where I am staying. I have a balcony that overlooks the city. And when I'm lucky, a few friends will drop by, and we'll drink while gazing out at the city by night like characters in a Fellini or Sorrentino film, wondering in silence perhaps what each of us still lacks in life or would want changed, or what keeps beckoning from across the other bank, though the one thing we wouldn't change is being here. To paraphrase Winckelmann, Life owed me this. I've been owed this moment, this balcony, these friends, these drinks, this city for so long.

→>–<←

This could actually be my home. Home, says a writer I've read recently, is where you first put words to the world. Maybe. We all have ways of placing markers on our lives. The markers move sometimes, but some are anchored and stay forever. In my case, it's not words, it's where I touched another body, longed for another body, went home to my parents and, for the remainder of the evening and the rest of my life, would never banish that other body from my mind.

It was a Wednesday evening, and I was just coming back

from a long walk after school. I used to like wandering about the center of the city in the late afternoon, arriving home just in time to do homework. Before taking the bus, I would frequently stop at a large remainders bookstore on Piazza di San Silvestro and, after riffling through a few books, seek out the one I had come for: a thick volume by Richard von Krafft-Ebing, *Psychopathia Sexualis*. There were several hardbound editions of it on sale in that bookstore, and by now I knew the ritual. I would pick one up, sit at a table, and sink into a prewar universe that was beyond anything I could ever imagine. The book was intended for medical professionals and was, as I discovered years later, intentionally obscure, with segments rendered in Latin to discourage lay readers, to say nothing of curious adolescents eager to navigate the uncharted, troubling ocean called sex. And yet as I pored over its arcane and detailed case studies on what was called inversion and sexual deviancy, I was transfixed by its wildly pornographic scenarios that turned out to be unbearably stirring precisely because they seemed so matter-of-fact, so ordinary, so unabashedly cleansed of moral stricture. The individuals concerned could not have seemed more proper, more urbane, more serenely well-behaved: the young man who loved to see his girlfriend and her sister spit in his glass of water before drinking it all up; the man who loved to watch his neighbor undress at night, knowing that the latter knew he was being watched; the timid girl who loved her father in ways she knew were wrong; the young man who stayed longer than he should in the public baths—I was each of them. Like someone who reads all twelve horoscopes in the back of a magazine, I identified with every sign of the zodiac.

After reading Krafft-Ebing's case studies, I would eventually

have to take the 85 bus for the long ride home, knowing that my mother would have dinner ready by the time I was back. Light-headed after so many case studies, I knew I'd eventually suffer from a migraine and that the incipient migraine, coupled with the long bus ride, might trigger nausea. At the bus station was a newspaper and magazine kiosk that also sold postcards. Before boarding the bus, I'd stare at the ones boasting statues, male and female, longingly, then buy one, adding some postcards of Roman vistas to conceal my purpose. The first card I bought was of the *Apollo Sauroktonos*. I still have it today.

One afternoon, after leaving the bookstore, I spotted a large crowd waiting for the 85 bus. It was cold and it had been raining, so once the bus arrived, we all massed into it as fast as we could, hurtling and jamming into one another, which is what one did in those days. I too pushed my way in, not realizing that the young man right behind me was being pushed forward by those behind him. His body was pressed to mine, and though every part of him was glued to me and I was completely trapped by those around us, I was almost sure that he was pushing into me overtly and yet so seemingly unintentionally that when I felt him grab both of my upper arms with his hands, I did not struggle or move away but allowed my whole body to yield and sink into his. He could do with me whatever he wanted, and to make it easier for him, I leaned back into him, thinking at some point that perhaps all this was in my head, not his, and that mine was the guilty, unchaste soul, not his. There was nothing either of us could do. He didn't seem to mind, and perhaps he sensed that I didn't mind either, or perhaps he didn't pay it any heed, the way I too wasn't quite sure I did. What could be more natural in a crowded bus on a rainy evening in Italy? His way of

holding my upper arms from behind me was a friendly gesture, the way a mountain climber might help another steady himself before moving farther up. With nothing else to hold on to, he had grabbed my arms. Nothing to it.

I had never known anything like this in my life.

Eventually, steadying himself a bit, he let go of me. But as the doors of the bus closed and the bus started to sway, he immediately grabbed on to me again, holding me by the waist, pushing even harder, though nobody around us could tell, and part of me was sure that he himself still couldn't tell. All I knew was that he would let go of me once he'd steadied himself and could reach one of the grab bars. I could even tell he was struggling to let go of me, which is why I pretended to stagger away from him, only to lean back, as soon as the bus stopped, to prevent him from moving.

Part of me was ashamed that I'd allowed myself to do to him what I'd heard so many men did to women in crowded spaces, while another part suspected that he knew what we were both doing; but I didn't know for sure. Besides, if I couldn't really fault him, how could he fault me? But I was swooning and doing everything I could not to let him pass. Eventually he managed to slip between me and another passenger, which is when I got a good look at him. He was wearing a gray sweater and a brown pair of corduroys and looked at least seven or eight years older than I was. He was also taller, skinny and sinewy. He eventually found a seat in front of me and, though I kept my eyes on him, hoping he would turn to look back, he never did. In his mind, nothing had happened: crowded bus, people slithering their way between people, everyone almost lurching and holding on to someone else—it happens all the time. I eventually saw him

get off before the bridge somewhere on Via Taranto. A sudden sickness began to seize me. The headache I had feared before stepping into the bus, stirred by the gas fumes, turned to nausea. I needed to get off earlier than I meant to, and I walked the rest of the way home.

I didn't throw up that evening, but when I got home, I knew that something genuine and undeniable had happened and that I would never live it down in my mind. All I had wanted was for him to hold me, to keep his hands on me, to ask nothing and say nothing, or, if he needed to ask, to ask anything, provided I didn't have to talk, because I was too choked up to talk, because if I had to talk, I might have said something right out of the cloying, bookish, fin-de-siècle universe of Krafft-Ebing, which would have made him laugh. What I wanted was for him to put an arm around me in that man-to-man way that friends do in Rome.

I returned to Piazza di San Silvestro many times afterward, always on Wednesdays, read from Krafft-Ebing for a while, stared at the statue of Apollo on display in the magazine kiosk, made sure I wore the same clothes I'd worn on the day I'd felt him lean into me, and at the same hour I saw one crowded bus come after the other, and I waited and kept watching for him. But I never saw him again. Or if I did, I didn't recognize him.

Time had stopped that day.

Now, whenever I come to Rome, I promise to take the 85 bus at more or less the same time in the evening to try to turn the clock back to relive that evening and see who I was and what I craved in those days. I want to run into the same disappointments, the same fears, the same hopes, come to the same admission, then spin that admission on its head and see how

I'd managed in those days to make myself think that what I'd wanted on that bus was nothing more than illusion and make-believe, not real, not real.

When I reached home that evening feeling sick and with a migraine, my mother was preparing dinner with our neighbor Gina in the kitchen. Gina was my age, and everyone said she had a crush on me. I did not have a crush on her. Yet, as we sat together at the kitchen table while Mother cooked, we laughed, and I could feel my nausea ebb. Gina smelled of incense and chamomile, of ancient wooden drawers and unwashed hair, which she said she washed on Saturdays only. I did not like her smell. But, as soon as I let my mind drift back to what had happened on the 85 bus, I knew that I wouldn't have cared what he smelled of. The thought that he too might smell of incense and chamomile and of old wooden furniture turned me on. I pictured his bedroom and his clothes strewn about the room. I was thinking of him when I went to bed that night, but, as I let arousal wash over me, at the right moment, I made myself think of Gina instead, picturing how she'd first unbutton her shirt and let everything she wore slide to the floor and then walk up to me naked, smelling, like him, of incense, chamomile, and wooden drawers.

Night after night, I would drift from him to her, back to him and then her, each feeding off the other and, like Roman buildings of all ages snuggling into, on top of, under, and against each other, body parts stripped from his body were given over to hers and then back to his with body parts from hers. I was like Emperor Julian, the two-time apostate who buried one faith under the other and no longer knew which was truly his. And I thought of Tiresias, who was first a man, then a woman, then a

man again, and of Caenis, who was a woman, then a man, and finally a woman again, and of the postcard of Apollo the Lizard Slayer, and I longed for him as well, though his unyielding and forbidding grace seemed to chide my lust, as though he had read my thoughts and knew that, if part of me wished to sully his marble-white body with what was most precious in me, another still couldn't tell whether what it longed for on Apollo's frame was the man or the woman or something both real and unreal that hovered between the two, a cross between marble and what could only be flesh.

The room upstairs where I fudged the truth each night and dissembled it so well that, without turning into a lie, it stopped being true, was a shifting land where nothing seemed fixed, and where the surest and truest thing about me could, within seconds, lose one face and take on another, and another after that. Even the self who belonged to a Rome that seemed destined to be mine forever knew that, within moments of crossing over to a different continent, I would acquire a new identity, a new voice, a new inflection, a new way of being me. As for the girl I eventually drew to my bedroom one Friday afternoon when we were alone together and found pleasure without love, if she lifted the cloud that was hovering over me ever since the 85 bus, she could not stop it from settling back less than a half hour later.

→>◄←

I have frequently thought about Rome and about the long walks I used to take after school in the center of Rome on those rainy October and November afternoons in search of something I

knew I longed for but wasn't too eager to find, much less give a name to. I would much rather have had it jump at me and give me a chance to say maybe, or hold me without letting go, as someone did on the bus that day, or coax me with smiles and good cheer the way men flirt when they put up a coy front with girls they know will eventually say yes.

In Rome, my itinerary on those afternoon walks was always different and the goal undefined, but wherever my legs took me, I always seemed to miss running into something essential about the city and about myself—unless what I was really doing on my walks was running away both from myself and the city. But I wasn't running away. And I wasn't seeking either. I wanted something gray, like the safe zone between the hand I only wished might touch me somewhere without asking and my hand, which didn't dare stray where it longed to go.

On the bus that evening, I knew I was already trying to put together a flurry of words to understand what was happening to me. I had once heard a woman turn around and curse a man in a crowded bus for being *sfacciato*, meaning impudent, because in typical street urchin manner he had rubbed his body against hers. But now I didn't know which of us had been truly *sfacciato*. I loved blaming him to absolve myself, but I also reveled in my newfound courage and was thrilled by the way I'd struggled to block his passage each time he seemed about to release me to move elsewhere on the bus. I had followed my own impulse and didn't even pretend I was unaware we were touching. I even liked the arrogance with which he had taken me for granted.

All I had at home was my picture of the *Sauroktonos*. Chaste and chastening, the ultimate androgyne, obscene because he

lets you cradle the filthiest thoughts but won't approve or consent to them and makes you feel dirty for even nursing them. The picture was the next best thing to the young man on the bus. I treasured it and used it as a bookmark.

In the end, I went to find the original in the Vatican Museums. But it wasn't what I'd expected. I expected a naked young man just posing as a statue; what I saw was a trapped body. I looked for flaws in his body to be done with him once and for all, but the flaws and the stains I found were the marble's, not his. In the end I couldn't take my eyes off him. I stared not only because I liked what I was staring at but because such stunning beauty makes you want to know why you keep staring.

Sometimes I'd catch something so tender and gentle on the features of the young Apollo that it verged on melancholy. Not a spot of vice or lust or of anything remotely illicit in his youthful body; the vice and lust were in me, or perhaps it was just the start of a kind of lust that I couldn't begin to fathom because it was instantly muffled by how humbled I felt each time I stared at him. *He does not approve of me, yet he smiles.* We were like two strangers in a Russian novel who, before being introduced, have already exchanged meaningful glances.

But then, I remembered, the candor would gradually dissipate from his features, and something like an incipient look of distrust, fear, and admonition would settle there, as though what he expected from me was remorse and shame. But it's never so simple: admonition became forgiveness, and from clemency I could almost behold a look of compassion, meaning, *I know this isn't easy for you.* And from compassion, I was able to spot a touch of languor behind his mischievous smile, almost a

willingness to surrender, which scared me, because it asked me to confront the obvious. *He's been willing all along, and I wasn't seeing it.* Suddenly I was allowed to hope. I didn't want to hope.

→>←←-

Today, after being in Rome for a month almost, I am taking the 85 bus. I will not catch it somewhere along its long route, which might be easier for me, but will take it where the terminal used to be fifty years ago. I will get on the bus at dusk, because this is when I used to take the 85 bus, and I will ride it all the way to my old stop, get off, and walk down to where we used to live. This is my plan for the evening.

I expect that my return may not bring me much pleasure. I never liked our old neighborhood, with its row of small stores that peddled overpriced merchandise to people who are almost all now pensioners or young salesclerks who live with their parents, smoke too much, and cradle large hopes on meager incomes. I remember hating the square balconies jutting out like misbegotten shoeboxes from ugly, squat buildings. I'll walk down that street and ask why I always want to come back, since I know there's nothing I want here. Am I returning to prove that I've overcome this place and put it behind me? Or do I return to play with time and make believe that nothing essential has really changed, either in me or in the city, that I am still the same young man and that an entire lifetime has yet to be lived, which also means that the years between me-then and me-now haven't really happened, or don't really matter and shouldn't count, and that, like Winckelmann, I am still owed so much?

Or perhaps I'll come back to reclaim a me-interrupted.

Something was sown here, and then, because I left so soon, it never blossomed but couldn't die. Everything I've done in life suddenly pales and threatens to come undone. I have not lived my life. I've lived another.

And yet, as I walk around my old neighborhood, what I fear most is to feel nothing, touch nothing, and come to grips with nothing. I'd take pain instead of nothing. I'd take sorrow and think of my mother still alive upstairs in our old building rather than just walk by, probably with some degree of haste, eager to catch the first taxi back to the center of Rome.

I get off the bus at my old stop. I walk down the familiar street and try to recall the evening when I came so close to throwing up. It must have been in the fall—same weather as to-day. I walk down the same street again, see my old window, pass by the old grocery store, imagine my mother miraculously still upstairs preparing dinner, though I see her now as she was re-cently, old and frail, and finally, because I want to arrive at this thought last, I pass by the refurbished film theater where some-one came to sit next to me once and placed a hand on my thigh while I took my time before acting shocked when all I wanted was to feel his hand glide ever so softly up my leg. "What?" I had asked. Without wasting a second, he got up and disap-peared. *What?*, as if I didn't know. *What?*, to say, tell me more because I need to know. *What?*, to mean, don't say a thing, pay no mind, don't even listen, don't stop.

The incident never went anywhere. It stayed in that movie house. It's in there now as I'm walking past it. That hand on my thigh and the young man on the 85 bus told me there was something about the real Rome that transcended my old, safe, standby collection of postcards of Greek gods and of the teasing

boy-girl Apollo who'd let you stare at him for however long you pleased, provided it was with shame and apprehension in your heart, because you had infringed upon every curve of his body. I used to think at the time that, however disturbing the impact of a real body was against mine, the weeks and months ahead might cast a balm and quell the wave that had swept over me on the bus. I thought I would eventually forget, or learn to think I'd forgotten, the hand I'd let linger on my bare skin for a few seconds more than others my age might have allowed. Within a few days, a few weeks, I was sure the whole thing would blow over or shrink like a tiny fruit that falls to the ground in the kitchen and rolls under a cabinet and is discovered many years later when someone decides to redo the floors. You look at its shriveled, dried shape, and all you can say is, "To think that I could have eaten this once." If I didn't manage to forget, then perhaps experience might turn the whole incident into the insignificant thing it was, especially since life would eventually unload so many more gifts, better gifts that would easily overshadow these fragments of near nothings on a crowded Roman bus or in an ugly neighborhood theater in Rome.

We remember best what never happened.

I've gone back to the Vatican Museums to see my Apollo who is about to kill a lizard. I need special permission to see the wing where he stands. The public is not allowed to see him. I always pay homage to the *Laocoön and His Sons*, and to the *Apollo Belvedere*, and to the other statues in the Pio Clementino wing, but it was always the *Apollo Sauroktonos* I longed for and put off seeking. The best for last. It's the one statue I want to revisit each time I'm in Rome. I don't have to say a word. He knows—by now he surely must know, always knew, even back then when

he'd see me come by after school, knowing what I'd done with him.

"Have you never tired of me?" he asks.

"No, never."

"Is it because I'm made of stone and cannot change?"

"Maybe. But I too haven't changed, not one bit."

How he wished he could be flesh, just this once, he used to say when I was young. "It's been so long," he says.

"I know."

"And you've grown old now," he says.

"I know." I want to change the subject. "Are there others who've loved you as much?"

"There'll always be others."

"Then what singles me out?"

He looks at me and smiles. "Nothing, nothing singles you out. You feel what every man feels."

"Will you remember me, though?"

"I remember everyone."

"But do you feel anything?" I ask.

"Of course, I feel. I always feel. How could I not feel?"

"For me, I mean."

"Of course for you."

I do not trust him. This is the last time I see him. I still want him to say something to me, for me, about me.

I'm about to walk out of the museum when my mind suddenly thinks of Freud, who surely must have come to the Pio Clementino with his wife or his daughter or with his good friend from Vienna then based in Rome, the curator Emanuel Löwy. Surely the two Jews must have stood there for a while and spoken about the statue—how could they not? And yet

Freud never mentions the *Sauroktonos*, which he must have seen both in Rome and in the Louvre during his student days. Surely he must have thought about it when writing about lizards in his commentary to Jensen's *Gradiva*. Nor does he mention Winckelmann except once, Winckelmann who, himself, surely must have seen the original bronze version of the statue every day during his tenure in Cardinal Albani's home. I know that Freud's silence on the matter is not an accident, that his silence means something peculiarly Freudian, just as I know he must have thought what I myself thought, what everyone seeing the *Sauroktonos* thinks: "Is this a man who looks like a woman, or a woman who looks like a man, or a man who looks like a woman who looks like a man?" So I ask the statue, "Do you remember a bearded Viennese doctor who'd sometimes come alone and pretend he wasn't staring?"

"A bearded Viennese doctor? Maybe." Apollo is being cagey again, but then, so am I.

But I remember his final words. They were spoken to me once, and he repeated the exact same ones fifty years later: "I am between life and death, between flesh and stone. I am not alive, but look at me, I'm more alive than you are. You, on the other hand, are not dead, but were you ever alive? Have you sailed to the other bank?" I have no words to argue or reply with. "You found beauty but not truth. You must change your life."

CAVAFY'S BED

I t's my first Palm Sunday in Rome. The year is 1966. I am fifteen, and my parents, my brother and I, and my aunt have decided to visit the Spanish Steps. On that day the Steps are filled with people but also with so many flowerpots that one has to squeeze through the crowd of tourists and of Romans carrying palm fronds. I have pictures of that day. I know I am happy, partly because my father is staying with us on a short visit from Paris and we seem to be a family again, and partly because the weather is absolutely stunning. I am wearing a blue wool blazer, a leather tie, a long-sleeved white polo shirt, and gray flannel trousers. I am boiling on this first day of spring and dying to take off my clothes and jump into the Roman fountain—the Barcaccia—at the bottom of the Steps. This should have been a beach day, and perhaps this is why the day resonates with me so much.

Two years before, in 1964, we were probably celebrating Sham el Nessim, the Alexandrian spring holiday, which for many of us usually marked the first giddy swim of the year.

But in Rome at the time I am not thinking of Alexandria at all. I'm not even aware that there might be a connection between Rome, this eruption of beach fever, and Alexandria. The yearning to jump into a body of water and drink it whole, and always that search for shaded areas, away from the blazing sun—these are what my body wants, now that the wool I'm wearing is unbearable.

After our long walk on the Pincio, we come back down the Steps and stop to buy a juice and a sandwich each in a small corner bar on Via della Vite. The bar has turned off its lights to keep the premises cool. It feels good inside. I like my sandwich simple, containing only coleslaw.

A used bookstore right next to the Keats-Shelley House by the Spanish Steps happens to be open that day. My father and I do what we always do when we're together: we look for books I should read. He points out a used copy of Chekhov's short stories, but I want to read *Olivia*. So we buy *Olivia*. He read it in French, he says, and promises it will certainly offset the Dostoyevsky I've been devouring that entire year. My father has definite opinions about books. He dislikes current writers, dislikes the bare rag-and-bone shop of the heart; anything that smacks of the immediate world around us turns him off. Instead, he likes his literature a touch dated—say, by thirty to forty years. I understand this. Everyone in the family feels a bit dated and out of sync with the rest of the real, here-and-now world. We like the past, we like the classics, we don't belong to the present.

A week later, my father is already back in Paris. It's Saturday, and I am back on Piazza di Spagna, this time alone. Many of the flowerpots have already been removed, though there are a great many still. I don't want to go home, so I hang around the

Spanish Steps. At around twelve or so, I stop at the same bar and buy a coleslaw sandwich, as I'd done the week before. I also buy a book that I know my father would approve of: the short stories of Chekhov. Past one o'clock, the area begins to empty, and all the stores are closed. I am sitting on the warm Spanish Steps and am peacefully reading. I am, of course, not really focusing on the story; what I am longing for is a whiff of a marine breeze; I want to be transported back to last week and to that feeling of well-being and plenitude that had suddenly erupted in our lives without warning or explanation on Palm Sunday.

For a month or so after that day, every Saturday I would buy a book and a coleslaw sandwich and begin reading on the Spanish Steps. I still do not make the connection with Alexandria during that period. I don't even make it when, exactly a year later, around Palm Sunday once again, I finally decide to buy the first volume of Lawrence Durrell's *Alexandria Quartet.* I am alone that day, and the memory of the previous year's Palm Sunday hovers over the day like an illusion of a day spent not on these Spanish Steps but at the beach in Alexandria. I like this shadow memory.

Half a century later the meaning of these ritual weekly errands to the Spanish Steps is somewhat clearer: part longing for a larger, happier, secure household, and part yearning for an Alexandrian world that was entirely lost. What I wanted by myself in 1967 was the family outing in 1966, though the 1966 outing mattered because it held wisps of Alexandria in 1964.

Alexandria eventually came to me one afternoon as I lay in bed reading *Justine.* I liked to read in the afternoon and welcomed those precious minutes when a band of sunlight, reflected from a window across the courtyard, would settle on my

bed. It was then that I fell upon a list of familiar names of Alexandria's tramway stations: "Chatby, Camp de César, Laurens, Mazarita, Glymenopoulos, Sidi Bishr," and, a few pages later, "Saba Pasha, Mazloum, Zizinia, Bacos, Schutz, Gianaclis." And then I just knew. I had not invented Alexandria. And just because I was never going to see it again didn't mean that it was dead and expunged from our planet. It was still there, and people still lived in it, and, contrary to what I'd led myself to think, I didn't hate it, it was not ugly, there were people and things I still loved there, places I still longed for, foods I would give anything to savor one morsel of, and the sea, always the sea. Alexandria was there still. I just wasn't.

But I already knew it wasn't the same Alexandria; my Alexandria no longer exists. Nor does the Alexandria that E. M. Forster knew during the First World War, nor the Alexandria that Lawrence Durrell made famous after the Second World War. Their Alexandrias are all gone. And as for the city I grew up in in the 1950s and early '60s, it too no longer exists. Something else lies on Egypt's Mediterranean coastline today, but it's not Alexandria. E. M. Forster, the author of the classic guidebook to Alexandria, lost his way in the streets of the city when he returned before writing the third preface to his *Alexandria: A History and a Guide*. Durrell might never have gotten lost down some of its sinister lanes, but he certainly wouldn't recognize the Alexandria of the *Quartet* one bit—and for good reason: that Alexandria never really existed in the first place. But then, Alexandria was always the child of fancy. Durrell, like C. P. Cavafy, saw another Alexandria, his Alexandria. Many artists have recreated their city and made it theirs forever: Matisse's Nice, Hopper's New York, Fellini's Rome, Joyce's Dublin, Svevo's Trieste,

Malaparte's Naples. As for me, I could still take a walk in Alexandria today and never get lost; however, the character of Alexandria has so thoroughly changed in the five decades I'd been away that what I found there, when I finally did go back thirty years after leaving, unhinged me completely. This was not the place I had come looking for. Whatever this was, it was not Alexandria. Where today's Alexandria is headed is anyone's guess, though I shudder to speculate.

Cavafy, the ultimate Alexandrian, gave us an Alexandria that was already not quite there in his own lifetime. It kept threatening to disappear before his eyes. The apartment where he had made love as a young man had become a business office when he went to revisit it years later; and the days of 1896, of 1901, 1903, 1908, 1909, once filled with so much eros and forbidden love, were already gone and had become distant, elegiac moments that he remembered in poetry alone. The barbarians, like time itself, were at the gates, and everything would be swept in their wake. The barbarians always win, and time is hardly less ruthless. The barbarians may come now or in one or two centuries, or in a thousand years, as indeed they had come more than once centuries earlier, but come they will, and many more times after that as well, while here was Cavafy, landlocked in this city that is both the transitional home he wishes to flee and the permanent demon that can't be driven out. He and the city are one and the same, and soon neither will exist. Cavafy's Alexandria appears in antiquity, in late antiquity, and in modern times. Then it disappears. Cavafy's city is permanently locked away in a past that refuses to go away.

As for the old Alexandria of Alexander the Great, of the Ptolemies, of Caesar and Cleopatra, of Callimachus, Apollonius, of

Philo and of Plotinus, and, let's not forget, the Alexandria of the great library, well, it perished many times over and, from the evidence available today, might as well never even have existed. Stones and shards, scraps and fragments, layers and tiers. The Alexandria of these ancients, like Cavafy's Alexandria or like mine, just happens to have been *in* Alexandria and, strange to say, happens to be called Alexandria too, and, coincidentally enough, some of its streets still run along the same lines that the founders of the city laid down more than two thousand years ago. But it's not Alexandria.

There have been many Alexandrias. Egyptian, Hellenistic, Roman, Byzantine, Ottoman, colonial—each pluralistic: multiethnic, multinational, multireligious, multilingual, multi-everything, or, in the unforgettable words of Lawrence Durrell in one of his more whimsical moments, a city of "five races, five fleets and more than five sexes." But he also branded it a "moribund and spiritless backwater . . . a shabby little seaport built upon a sand reef."

Yet Alexandria is more than a place, more than an imbrication of layers and tiers, more than an idea, more than a metaphor, even. Or maybe it's just that: a self-perpetuating, self-consuming, self-regenerating idea that won't go away, because it's already gone away, because it never really existed in the first place, because it's still struggling to come into being, and we're too blind to see this.

Alexandria is an invention. It is totally man-made, artificial, the way St. Petersburg is entirely man-made and, therefore, unnatural. A man-made city does not sprout; it is pulled out of sludge and then shaken into existence. Because it is a graft, it never feels secure in its place, never belongs. It is on

borrowed time, and the ground on which it's built comes from scrounged landfills and stolen earth. Which is why, perhaps, like all newly wealthy cities, Alexandria was always splendiferous and extravagant—to forget it stood on shaky ground, for nothing bound it to earth. You could not swear on the ground you stood on, because the ground you stood on was never really firmly there, nor was it ever divinely yours to be sworn on in the first place. A transitional identity cannot even swear on anything, because it is transcendentally divided, homeless, and, hence, transcendentally disloyal. Which is also why no one had convictions in Alexandria, and any oath, like truth, was always a shifty business. Alexandria borrowed belief systems and robbed traditions from its neighbors because it had none of its own to pass on, though it almost always perfected the things it adopted; its great contribution was not always invention, but reinvention. Under the Ptolemies it stole every book it could lay its hands on, the way it appropriated and then promoted the knowledge it found in them. It borrowed nationalities, borrowed workers, borrowed legacies, borrowed languages, borrowed, borrowed, borrowed, but was never one thing in one place, which is why it is the only spot in the history of mankind that not only understands but that feeds on and ultimately prescribes paradox in its charter. It won't be shocked when church and brothel share the same roof, because it knows that prophet and street hustler, priest and poet, are not just easy bedfellows, they are one and the same person. Wealth, pleasure, intellect, and God—that's what Alexandria added up to; or, in the words of Auden about Cavafy, "love, art, and politics." How these three managed to cohabit without tearing one another apart can be explained by one word only: luck. And luck never lasts—like the library,

which burned down many times over, like Hypatia, who died of a thousand cuts. It never lasts, because it cannot last. Cavafy, a Greek born in the Ottoman Empire, living in British colonial Egypt, knew all about barbarians at the gate and all about luck running out. The barbarians came to Byzantium bearing a cross once. Two centuries later they came bearing the crescent. Byzantium never stood a chance. Alexandria didn't either.

Which is why in my time, and slightly before my time, all Alexandrians had permanent homes elsewhere, held two nationalities, and boasted at least four mother tongues. Everyone was mixed. This was true in antiquity, and it was true in the last century. Alexandria was provisional in every sense of the word, the way truth is provisional, home is provisional, pleasure and, of course, love are provisional. There is no other way. Those who believed that Alexandria was here to stay were not Alexandrians. They were the barbarians.

Alexandria is unreal. You watch it go away. You know it will. You wait for this. You anticipate the end and already know you'll remember you anticipated it when that day comes. There is no present tense in Alexandria. Time's covenants were always broken here. However you look at things, everything always already happened, will happen, might, could, should happen. You never planned for next year; that was being presumptuous. Instead, you planned to remember. You even planned to remember planning to remember.

Caught between remembrance and anticipated memory, the present tense always played an elusive minor part in a deafening symphony of verbal tenses and moods. We lived counterfactual lives in a medley of "timescapes." Once again, irrealis moods:

part conditional, part optative, part subjunctive, part nothing. You fantasized a future without Alexandria before even leaving Alexandria, the way you already knew you'd remember rehearsing a preemptive sense of nostalgia for Alexandria while you were still living there.

When Cavafy steps into the room where he made love in his younger days, he is neither here nor there. He watches the cast of the afternoon sun spread over where he remembers there was once a bed, and he is almost certain that he knew, already back then in his younger days, that he'd think of these dear hours in the afternoon many, many years hence. This is, this was, will always be, the real Alexandria. Cavafy never says this. But I do. Otherwise the poem means nothing to me. Here it is in my free translation:

THE AFTERNOON SUN

This room, how well I've known it.
Now it and the one next door are rented out
as business offices. The whole house
is home to brokers, merchants, companies.

This room, how familiar it still is.

Near the door here was the couch,
in front of it, a Turkish carpet,
nearby a shelf that held two yellow vases.
To the right, no, opposite, a closet with a mirror.
In the middle, the table where he wrote;

and the three large wicker chairs.
Next to the window was the bed
where we made love so many times.

This poor furniture is nowhere now.
Next to the window, the bed
which the afternoon sun touched midway.

. . . At four o'clock one afternoon we parted
for just a week . . . But alas,
That week lasted forever.

Cavafy would never have walked into the old room and just
thought, here was a bed once, here a chest of drawers, here sun-
light across our bed. This is not the complete thought. What he
thinks of and is unable to say is: I never thought I'd be back here
remembering these afternoons when my body and his lay coiled
together in this very spot. But that's not true. I know I thought
this, surely I did, and if I didn't, then let me imagine that, as we
lay on this bed, exhausted from our lovemaking, that I already
had a presage I'd come back here decades later looking for this
younger self who surely would have earmarked this moment so
that I'd recover it as an older man and feel that nothing, nothing
is ever lost, and that if I should die, then surely this rendezvous
with myself will not have been in vain, for I've inscribed my
name in the hallways of time as one writes one's name on a wall
that has long since been torn down.

The present hardly exists for Cavafy. It hardly exists, but
not because Cavafy was too prescient to the ways of the world
not to foresee that he'd remember the past before the future

had occurred, or because his writing is punctuated by competing temporal zones, but because the real, inhabited zone of his poetry has literally become the transit between memory and imagination back to imagination and memory. The reflux is where things happen. In Cavafy, intuition is counterintuitive, and impulses are thought-tormented, and the senses are too canny not to know that something like disquiet and loss always await lovemaking. The grasp on things is always, always tentative and counterfactual. Cavafy the lover would not have written this poem as a nostalgist, but as someone who was, as he is in so many of his poems, already awaiting nostalgia and therefore fending it off by rehearsing it all the time.

Being in Alexandria is part imagining being elsewhere and part remembering having imagined this. Alexandria cannot die and doesn't let go, because it never really is, or if it is, it is never itself long enough. It is the shadow of something that almost was but stopped being yet continues to pulsate and craves existence though its time hasn't come yet but could just as easily have already come and gone. Alexandria is an irrealis city, always apprehended but never fully discovered, always adumbrated but never really touched, an Alexandria that, like Ithaca or Byzantium, has always been and will always never be quite there.

I was aroused and thrilled while discovering Durrell's sensuality. Who knew that I'd lived in a city where such things happened, things I dreamed of and thought of all the time but needed to see in print to realize they were not just airy, schoolboy fantasies? They would have been at hand's reach in Alexandria. All I should have done was ask our driver, who was the most open-minded man I knew in Egypt, to tell me where I could find those pleasures Durrell seemed to know so much

about. Some open-minded relatives would have helped me find these pleasures, since they too knew all about them. There were stores where I could walk in and, like Cavafy's narrator, ask about the quality of the cloth and allow my hand to graze the salesclerk's hand. There were women who stood on the same sidewalk in the evening who I wished would turn their gaze on me, though I was just a young fourteen-year-old then. And there were men too who threw the most feral glances at me that both scared and troubled me and that I would be tempted to return, because mine would surely lead to nothing. This was a city I'd just begun to know before leaving, and now that it was too late, I was suddenly discovering it in Rome—Rome, whose Spanish Steps and bookish errands and coleslaw sandwiches on Saturday afternoons were nothing more than poor stand-ins for a city and a way of life forever lost. In my room in Rome, and with Durrell and Cavafy as guides, block by block, tram station after tram station, I began reinventing a city I knew I was already starting to forget and could kick myself for not having studied better to anticipate the day when I'd look back from Italy and remember so little.

SEBALD, MISSPENT LIVES

t was late in the fall of 1996, and I was, as usual, getting ready to leave my office and head to the subway. I usually take the B train, but on that evening my colleague decided to drive me, perhaps because he had started to tell me about his father, who had just died, and, with the minutes ticking, offered to drive me all the way to 110th Street. I'd heard he was shaken by his father's death, but I also knew he was keeping it to himself. Late that afternoon, while walking past his open door, I had caught him standing in his office, with his back turned to me, gazing out at the leafless trees in a stance so aimless and unguarded that he reminded me of those frozen characters in Edward Hopper's paintings who are forever staring out their window at basically nothing at all. I chose to walk by without disturbing him. He was, I was sure, thinking of his father, and I felt for him. But after slipping by his door, I decided to take a few steps back and peered into his office. "You OK?" I finally asked. He looked at me, then smiled, aware of my hesitation. "Me OK," he replied. Then, with one thing leading to the other, he opened up and

told me a great deal about his father while driving me home. I'll never forget the story.

After being married all his life, his widowed father found the courage one day to reach out to a woman he had loved in high school, more than fifty years before. She too had been recently widowed, which he knew, since all through their married lives each had been keeping secret tabs on the other. The two were not a whit less in love than when they were high school sweethearts. I asked my colleague whether he had known about his father's first love. No, no one even suspected. The man had been a devoted and faithful husband all of his married life, the perfect family man, and a model Orthodox Jew. And yet, I said, he must have lived with this big, gaping hole in his heart, despite the wife he must have cherished, the children he loved, the circle of friends that had gathered around him, and the business he'd built up. All exemplary, he added. And yet . . . , he said. The two needed to do a lot of catching up. Yes, but while a part of them might certainly have wished they'd stuck together and not been married to the wrong partners—and his mother was the wrong partner, as he later found out from his father's letters and journals—another part, while grateful for their final reunion, could not help thinking of the life they'd missed out on, of all the years spent apart, and of how impossible it would be now to even attempt to make up for lost time. Could one ever banish the thought that one has led the wrong life? How could one be happy when faced with daily reminders of so many wasted years?

He mused aloud about the matter for a while when he parked the car outside my home. When he'd last seen his

father, they were like lovebirds together, he said. They were so grateful for this second go at life that they took what they could and enjoyed the present without regrets, because all they had was the present. No point thinking of the years behind them, and certainly no point thinking of the future. "But under those conditions," I said, "I wouldn't know how to live in the present only. My mind would be constantly tossing and turning back and forth in time, like someone trying to fit into clothes he wore decades earlier, or trying on hand-me-downs worn by a very fat uncle. I'd probably end up ruining the small gift given me in my final years."

As my colleague was not reluctant to observe, "My father lived the wrong life, you see, yet I am the product of that wrong life." He smiled.

The candor with which he described his father's life disturbed me. Was there such a thing as a wrong life? I asked.

He looked at me. Yes, there was, he said, and went no further.

But if I was interested in reading about misspent lives, he said, perhaps I should pick up W. G. Sebald.

This was the first time that I'd ever heard of Sebald. Had it not been for that car ride that evening, or for that conversation about my colleague's father, chances are I would have discovered Sebald under entirely different circumstances and, in light of those circumstances, given him a reading totally unlike the one that followed this conversation.

I bought *The Emigrants* that same evening at a Barnes & Noble on the Upper West Side and was unable to put it down. Most people read Sebald in light of the Holocaust. I read him in the key of misspent lives.

On finishing W. G. Sebald's *The Emigrants* a few days after the car ride, I could not stop thinking of the last of the four tales in the book. Here, the grown Max Ferber, who as a boy was shipped off to Manchester from Germany without his parents, has had a relatively successful life as an artist in England, his adoptive home, but he is permanently scarred because of what the Nazis had done to his mother. Life after the Holocaust was, as the French call it, not a *vie*, but a *survie*, not living, but surviving. The road originally intended was never traveled. What took its place was a makeshift path, which one would still have to call a life, and maybe even a good life, but it was never going to be the real life. Cut short, this might-have-been life didn't necessarily die or wither; it just lingered there, unlived and beckoning. Tree stumps don't always die, but they no longer thrive; it's the offshoots that do the work of the tree.

The parallels between my colleague's father and Max Ferber were compelling. Both men ended up living lives that always felt partially misspent: one with the wrong spouse, the other in the wrong country, with the wrong language, the wrong people. Both made the best of what they were given. But the similarities between Sebald's characters and Sebald's own life are equally striking. Sebald was himself a German who had been living and teaching at a university in England since the 1960s—not an exile but an expatriate who, in so many intangible ways, remained a displaced soul. He was not Jewish, but he seemed to write about individuals who were Jewish or had close ties to those Jews whose lives had been so thrown off course by the war, by loss, horror, exile, or, to use Sebald's term, by transplantation, that it was no

longer clear to them not just where or why but how, exactly, they belonged on this loose bolide called planet Earth, or whether *"belongingheit"* could ever be applied to them again, because this too was true: they had no notion of where they stood vis-à-vis this ungraspable other thing called time. Was time fast-forwarding or turning back on them, or was it simply standing still, year after year after year, until it ran out? Or, to look at things differently, were they out of step with time, because time's covenants no longer held for them? These survivors too looked out of windows with despair and melancholy in their eyes, wearing that glazed and vacant stare that tells you that, without dying, they have in fact outlived their time. They're not ghosts, but they are not of us. "And so they are always coming back to us, the dead," he writes— words Sebald repeats in one way or another in almost everything he writes. It bespeaks his inability to understand how porous is the membrane between what might have been and might yet be, between how things never go away but aren't coming back either, between life and that other thing we don't know the first thing about. As Jacques Austerlitz of *Austerlitz* says:

> I feel more and more as if time did not exist at all, only various spaces interlocking according to the rules of a higher form of stereometry, between which the living and the dead can move back and forth as they like, and the longer I think about it the more it seems to me that we who are still alive are unreal in the eyes of the dead, that only occasionally, in certain lights and atmospheric conditions, do we appear in their field of vision. As far back as I can remember ... I have always felt as if I had no place in reality, as if I were not there at all.

-+><+-

But it was not Max Ferber who ignited something in my mind. It was, instead, another character, Dr. Henry Selwyn, whose mesmerizing tale left a lasting impression on me. In Selwyn's story, the narrator remembers that years earlier, in 1970, he had befriended his English landlord, Dr. Henry Selwyn, and that, in the course of several conversations, the landlord had managed to reveal a number of facts about his earlier life: how, contrary to appearances, he was not really a Briton but a Lithuanian whose family had immigrated to England in 1899, when he was seven years old; how the ship on which the family sailed had ended up, not in America, where it was originally destined to sail, but, by accident, in England; how, growing up in England, young Selwyn had felt the need to conceal his Jewish identity from everyone, including, for a while, his wife, who is essentially estranged from him, though they continue to live under the same roof; and how, as a young man in 1913, he had met a sixty-five-year-old Swiss mountain guide named Johannes Naegeli. This mountain guide died soon after Selwyn returned to England at the start of World War I and "was assumed . . . [to have] fallen into a crevasse in the Aare glacier[s]." Young Selwyn, fighting on the British side, was devastated by the news of the missing Austrian guide, for he seemed to have been exceptionally fond of the older man. Fifty-seven years later, in 1970, Dr. Selwyn tells his tenant, "It was as if I was buried under snow and ice."

If the plot of this tale remains irreducibly simple, the situation grows increasingly complex when it becomes clear that the story is built on highly unstable temporal plates hurtling against one another like blocks of glacial debris. At one moment

a plate may be buried deep underneath the others; at another it bursts forth and buries everything else. Fifty-seven years later the subject of the mountain guide suddenly erupts in the course of a dinner conversation; the guide, it would seem, is far more alive to Dr. Selwyn now than is his wife, who shares his home.

Three aspects struck me in this story.

First, the Holocaust.

Dr. Selwyn's accidental migration to England took place long before the Holocaust, and therefore the Holocaust, as it affects Dr. Selwyn or his relatives in England, is irrelevant—except that the Holocaust, which hovers over the other three tales of *The Emigrants*, suddenly begins to cast a retrospective shadow over Selwyn's tale and, by implication, over his entire life, as if the Holocaust were not absent from his life but simply overlooked, as if it were inherent to it and had been hinted at all along but that we as readers had just failed to notice, because Selwyn as a character never quite saw things in light of the Holocaust either, because Sebald himself had never put the pieces together until he'd written the other three tales, as if, to echo Selwyn's own words, the Holocaust were buried under ice, and no one saw it. The Holocaust is never brought up once in this first tale.

If Jacques Austerlitz in *Austerlitz* eventually finds out that he is Jewish and, like Ferber, saved by *Kindertransport*, in *The Emigrants* there is no amnesia to delay the discovery of Selwyn's Jewish roots. Sebald simply does not mention his Jewishness except almost as an inadvertent aside. And yet the whole tale is written in the retrospective key of the Holocaust.

I look for hints of what happened in Selwyn's life during World War II, yet the subject has been perfectly elided and

screened off; I comb the text for what it does not say, will not say, refuses to say, is too timid or too repressed or scared to say, but I find nary a clue. Anyone seeing a film set in 1932 Berlin will automatically be filled with disquieting forebodings when watching two Jewish lovers in the film kissing debonairly in a secluded spot in the Tiergarten. Something is about to happen or may indeed not happen to them, but watching the lovers without intimations of what lies ahead makes no sense and is critically insufficient. The viewer nurses these disturbing feelings because he watches the goings-on of the lovers prospectively—and the film director, naturally, and without ever suggesting the Holocaust, exploits and stokes these misgivings. In a similar vein, it is impossible to read or say anything about the sharp-eyed, supremely Gallic Irène Némirovsky today without invoking retrospectively the Holocaust.

Dr. Selwyn may have escaped the Holocaust, but on closing all four tales of *The Emigrants*, we sense that he lives with the "memory" of this event that never happened to him but that would more than likely have happened to him had he not left Lithuania in 1899 as a child.

But far, far more uncannily yet, we also feel that the Holocaust, despite Selwyn's move to England, is not necessarily done with him yet. Retrospectively, the Shoah could come to exact its due in good time, for there is no statute of limitations for what hasn't happened—and the Shoah is in no hurry. This is not about past and present and future: this is irrealis time. It's not about what did not, will not occur, but about what could still but might never occur. If time exists at all, it operates on several planes simultaneously, where foresight and hindsight, prospection and retrospection, are continuously coincident.

Selwyn was spared by accident; history could easily decide to rectify the mistake. Something that never happened and couldn't have happened to him and had altogether stopped happening thirty years earlier continues to radiate, to pulsate, to reach into the 1970s like a totally defunct star millions of light-years away whose light is still traveling in outer space and hasn't even reached our beloved planet Earth yet.

This is not about the Holocaust happening all over again in the late twentieth century; it is not about facts, or even about speculative facts, but about counterfactual—i.e., irrealis—facts. It is about turning the clock back to 1899 while simultaneously living in the late twentieth century. How historians explain time is one thing; how we live time is quite another.

Freud, of course, understood this kind of counterfactual mechanism when he realized that with screen memories "there was no childhood memory, but only a phantasy put back into childhood." The later intrudes upon the earlier. The later alters the earlier. The later and the earlier trade places. There is no earlier or later. There is no then and now.

→>—<—

Second: the failed migration to America.

The promise of settling in New York was never realized for the Selwyns. Selwyn's parents settled in England, made the best of things, and indeed prospered, but their prospective life in New York was neither realized nor quite expunged from their minds. For them, even if they are dead now, things are still being worked out on some sort of parallel time warp, and the ship that made the mistaken stop in England may still eventually

decide to leave England and cross the Atlantic with young Selwyn and his family aboard, even if he's much older now than were his parents at the time, even if their ship ended up in a scrapyard before the Second World War. The voyage out feels like a promissory note that has yet to but may never come due, not unlike those bonds sold by the Trans-Siberian Railway at the turn of the nineteenth century that you can still buy for next to nothing at the stall of any *bouquiniste* along the Seine in Paris: these bonds are very real, but they cannot be realized. They have become irrealis bonds, the way their bearers are irrealis people, the way the voyage to America is irrealis, the way the Holocaust and its impact have no time markers and are therefore free-floating on the spectrum of time.

And herein lies the real tragedy. The dead don't just die; death may not be the ultimate undoing. There is an after-omega. And it may be worse. "It truly seemed to me, and still does," as Sebald writes in *The Emigrants*, "as if the dead were coming back, or as if we were on the point of joining them." Or in the heartbreaking words of the author's father in Göran Rosenberg's latest book, *A Brief Stop on the Road from Auschwitz*, "We have already died once," but the rebirth, as the rebirth of Paul Celan, Primo Levi, Bruno Bettelheim, Tadeusz Borowski, and Jean Améry, proved to be a rebirth into something else, not life. Survival is too costly. In their case, the implacable Shoah has a persistent, long reach, and there are things that are worse than death. For what the Shoah does if it doesn't kill you the first time around is utterly demolish, in the words of Jean Améry, your trust in the world. Without trust in the world, you are, like the dead, simply hovering in the twilight. There is no place to call home, and you will always keep getting off at the wrong sta-

tion on the long road from Auschwitz, from Lithuania, or from wherever you came.

Sebald's narrator is deliberately silent on the subject of the Holocaust, just as he is very opaque about the failed voyage to New York. I have no sense of why that is, nor am I convinced that I am not pushing my reading of this tale. What begins to grow clear, once you collapse Max Ferber's and Dr. Selwyn's accounts and have laid out the names of the temporal plates like suspects on a police station bulletin board, is that language lacks the correct verbal tense or the correct mood or the correct verbal aspect to convey the haunting and unwieldy counterfactual reality of a might-have-been that never really happened but isn't unreal for not happening and might still happen, though we feel it might still but cannot happen.

This is the very reflux of time, the cynosure of counterfactual thinking. Call it "retro-prospection" collapsed into a single and unthinkable gesture.

It is the script of roads not taken and of lives that have been cast adrift, unlived, or misspent and are now marooned in space and time. The life we're still owed or that fate dangles before us and that we project at every turn and feed upon and, like a virus or a suppressed gene, gets passed on from one day to the other, from person to person, from one generation to the next, from author to reader, from memory to fiction, from time to desire and back to memory, fiction, and desire, and never goes away because the life we're still owed and cannot live transcends and outlasts everything, because it is part yearned for, part remembered, and part imagined, and it cannot die and it cannot go away because it never, ever really was.

This script is ultimately what we leave behind, what still

remains and still pulsates after we stop breathing—our *Nach-lass* in time, our unfinished business, our ledgers left open, our accounts receivable, our unrealized fantasies and unlived minutes, the conversations still on hold, the unclaimed luggage in the cloakroom still waiting for us long after we're gone.

This is Sebald's universe. Supremely tactful, Sebald never brings up the Holocaust. The reader, meanwhile, can think of nothing else. Sebald barely mentions the accidental move to England, but I have no doubt that Selwyn has been living not just the unintended life, or the accidental life, but the wrong life. The life he lives contends with a counterfactual life occurring in some sort of nebular, spectral, irrealis zone. This sense of having mislaid one's true life, one's real self, is finally formulated in *Austerlitz*, when the eponymous character tells the narrator: "At some time in the past I must have made a mistake or something was done to me and now I am living the wrong life."

People may take their own lives when they realize they've been living the wrong life; or, as is sometimes the case with people whose lives have been devastated by loss and tragedy, they may outlive the course of their years precisely because they're clinging to the hope of encountering the life they're still owed. This was the tale of my colleague's father.

Hardly surprising then that, while vacationing in France, Selwyn's former tenant, the narrator, should hear that the good old doctor had finally closed the ledger and shot himself.

<center>→>-<←</center>

And here comes the third baffling aspect of Sebald's tale. Dr. Selwyn's business is by no means over even after he dies. In

1986, as the narrator is traveling by train through Switzerland, he begins to remember Dr. Selwyn. And as he thinks of Selwyn, he accidentally—actually, the adverb should be *coincidentally*—spots an article in that day's newspaper reporting that "the remains of the Bernese alpine guide Johannes Naegeli, missing since summer 1914, had been released by the Oberaar glacier seventy-two years later."

The body that was lost during the summer of 1914 moments before World War I has finally worked its way up to the surface, long after the war became a hazy memory, long after its dead have decomposed, long after the bodies of those who lived through that war only to perish in the Holocaust have completely disappeared. In fact, no one who was old enough to be a soldier in 1914 is alive today. Yet suddenly the frozen, undecomposed body of Johannes Naegeli is now younger than Henry Selwyn, himself dead for sixteen years. When Rip Van Winkle returns, he is not only an anachronism; he has every reason to believe, unless he looks in a mirror, that he is twenty years younger than those of his own generation. Meanwhile, Sebald's narrator would have loved nothing better than to show the newspaper article to Henry Selwyn, to allow the older doctor to come to a reckoning with his younger self. But therein lies the stunning cruelty of time. A reconciliation, which would in theory have straightened out so many things, cannot take place. Reconciliation, reckoning, reparation, restoration, redemption: these are, at best, paltry figures of speech—words—as are the concepts of "unfinished business" and "open ledgers" and being "indefinitely put on hold." Time has no use for such words. Because, no matter how crafty the ancient grammarians, we still don't know how to think of time.

Because time doesn't really understand time the way we do. Because time couldn't care less how we think of time. Because time is just a limp and rickety metaphor for how we think about life. Because ultimately it isn't time that is wrong for us, nor, for that matter, is it place that is ineradicably wrong. Life itself is wrong.

SLOAN'S GASLIGHT

The Sixth Avenue El train has just cleared the steep bend off Third Street. It is picking up speed and will, at any moment now, bolt uptown. Next stop, Eighth Street, then past Jefferson Market, Fourteenth Street, then all the way north till it reaches Fifty-Ninth Street. But perhaps it is not racing at all but grinding to a stop after that notoriously difficult curve just seconds before it reaches Bleecker Street. It's hard to tell. The blue lettering on the train's marker light must spell something, but it's hard to decipher. Under the El two vehicles seem to know where they're headed. To the left of the train, on the corner of Sixth and Cornelia, a scrawny, wedge-shaped, twelve-story high-rise strains to look taller than it is. Its numerous lit windows suggest that, despite darkness everywhere, this is by no means nighttime but evening, maybe early evening. The building's residents are probably preparing dinner, some just walking in after work, others listening to the radio, children doing homework.

This is 1922, and this is Sloan country. The Sixth Avenue El no longer exists as John Sloan painted it in *The City from*

Greenwich Village or in his views of Jefferson Market. Despite its deafening noise, Sloan must have loved the El, and his many portraits of it pulsate with the brassy, vigorous thrill of an over-confident, urban painter who never spurned the clunky, steely structures punctuating life in the city. Under his brushstrokes, though, the here-and-now Village suddenly acquires a lyrical, beguiling, almost dreamlike cast, and its crepuscular inflection suggests that Sloan might have been trying to capture the city as it looked on that day, in that year, from his window, sens-ing, as rumors must have already been flying by then, that the El didn't have long to live. "The picture," he wrote, "makes a re-cord of the beauty of the older city which is giving way to the chopped-out towers of the modern New York."

Did Sloan like the El—could anyone really have liked the ugly, thundering, mastodonic El? Or was he, like so many of us, struggling to preserve the old—ugly, junky, beaten-up old that it was—simply because it was old and familiar and had been there for so long that no one could even remember the city without it? The scrap metal of the El, they say, would eventually be sold and shipped to Japan; Japan would then bomb us with weapons built from it. Most likely an apocryphal tale but uncanny all the same, since, to alter Freud's words just a tad, the uncanny is the return of something that was once familiar and later forgotten.

I am standing before John Sloan's *The City from Greenwich Village* at the National Gallery of Art in Washington, D.C., and can't seem to get away from his portrait of the view from his window. Earlier in the day I sat in one of the Study Rooms at the National Gallery looking over Sloan's studies for his painting. I loved watching how each of his studies dovetails into the next, and how from mere sketches a work of art eventually blossoms.

But the studies reveal very little that is not already in the painting itself. I was hoping to unearth an "extra" of sorts, something telling that the painting covers up, but my untrained eye found nothing.

The city has changed a lot since. And yet, if you remove the El and add more traffic and lights and people, this corner of New York City is really not so different. Bleecker Street is still there, Cornelia still there, the Woolworth Building still looms fluorescent in the distance, and in the evening the store windows along the sidewalks still glisten and beckon to those who pass by and are sometimes reluctant to rush home and hope to wander about a bit or make up a sporadic errand if only to kill time. This is the gloaming, the twilit, two-faced hour between day and night when the city promises things that are at once troubling and enchanting, because our bearings are thrown off, and everything seems so timeless yet so thoroughly time-bound that we drift into phantom zones, urged on by lingering traces of dawn that are either this morning's or tomorrow's. Like Edgar Allan Poe, Charles Baudelaire, who was Poe's French translator, was always stirred by this gaslight hour of the day and, in his tepid love for Paris, must have longed for a long-lost older Paris or perhaps even for desultory vistas of Poe's New York, the way Poe himself nursed spectral notions of a Paris he never lived to see. Baudelaire was doing what his greatest critic, the German Walter Benjamin, found himself doing sixty years later when he ambled along the streets of a revamped, updated Paris, all the while seeking out haunting reminders of Baudelaire's vanished arcade passages. As with dowsers, Benjamin felt the magnetic induction of a Paris that had altogether vanished and left no trace of itself.

Benjamin had every reason to intuit Baudelaire's probable fascination with New York. His escaped German Jewish friends had taken refuge in the United States and kept clamoring for him to join them. Benjamin never made it across the Atlantic. When he finally realized that the Nazis were fast closing in on him and that there was no escape, he took his own life.

Sloan's painting is my imaginary version of a vanished New York. In the city, we always tread on others' footprints. We never walk alone. All of us have followed in the footsteps of an artist in the city. All of us have followed a stranger in the crowd at least once in our life. All of us have retraced our own footsteps many years later and been in the same place twice and, like Whitman, "[thought] of time—of all that retrospection."

Sloan may never have known what his painting would mean in the years to come, but it resonates with the fear that the city—as someone said of his pictures—changes even before the paint dries, that all things die, that the El itself would soon be taken down, and that this was a snapshot of a world already meant to be looked back on someday. He was painting for someone he might no longer be but hadn't quite become and to whom he was already slipping coded messages in the only notation system "fore-self" and "after-self" understood.

The vision of a city "now" or of a time "now" that will soon become a city "then" is, like twilight itself, a mirage caught between two illusory temporal zones: the not-yet and the no-more—or, more precisely, a no-more that looks back to a time when it was a not-yet but already knew it would soon be no more.

Art is how we quarrel with time. We burrow between two moments, neither of which stays long enough, and make room

for a third that overlooks, shakes off, transcends, and, if it must, distorts time. In his poem "The Swan," Baudelaire is crossing the Carrousel Bridge and, as he stares at his city, realizes to his great sorrow that Paris changes (*"Paris change!"*) and that old Paris is no more (*"Le vieux Paris n'est plus"*). With its scattered relics and shards and perennial dust, Paris reminds him of what the Hellenes left behind once they sacked Troy and burned it to the ground. Cast away in a city that is still his home and yet forever longing to go back to something he cannot name, the poet is now exiled in time.

The Carrousel Bridge had been newly built when Baudelaire walked across it. But because it was too narrow for twentieth-century traffic and not high enough to permit the passage of boats and large barges beneath it, it was eventually torn down and another bridge built a short distance downstream. The new had become old, and I am sure that Walter Benjamin in his perennial yearning to find and roam through Baudelaire's Paris might have lamented the disappearance of that old bridge. The Paris that all Parisians today would hate to see disappear is, in fact, the very Paris that once displaced Baudelaire's lamented old Paris.

Everyone has seen pictures of Penn Station rising from the ground of its razed neighborhood, and everyone has seen horrifying images of Penn Station being demolished. Parisians were no less horrified when Baron Haussmann had old Paris *pierced* to build the new Paris everyone loves today. They were already collecting sketches and photographs of the Paris that was disappearing before their very eyes, particularly in Marville's stunning photographs of an old and sometimes quite icky Paris whose glistening gutters perpetually run through grimy alleys

and side streets that exist only in Marville's photographs, be-cause those streets and those gutters no longer exist in Paris or in our collective memory of Paris. The destruction of large swaths of Paris and of the Butte des Moulins to house Charles Garnier's Avenue de l'Opéra in today's Paris is nowhere cap-tured as hauntingly as in Marville's photographs. Similarly, George Bellows's *Pennsylvania Station Excavation* captures the excavation before the building of Penn Station (1904)—not the demolition of Penn Station (1963).

I never see one thing only; I see double. Like the stereoscope, "an optical instrument used to impart a three-dimensional effect to two photographs of the same scene taken at slightly different angles and viewed through two eyepieces" (*The Ameri-can Heritage Dictionary of the English Language*), or like Charles Marville's desire to invent a stereochronic camera able to pre-serve a solid, three-dimensional image of the Paris that was fast disappearing under Haussmann's ambitious reconstruc-tion plan, Sloan's painting is lodged between then and now. I discovered almost by chance an online site that compares pic-tures of Marville's Paris as it was then and Paris as it is now. And then on another occasion I stumbled on the Thunder Bay Press books *Paris Then and Now, Rome Then and Now,* and *New York Then and Now.* Each of these volumes asks us to consider two images of the same spot taken a century apart. We stare at the similarities and the differences, unable to envision the two simultaneously—stereoscopically—and are forced to flip back and forth, and back and forth again, trying to capture the mean-ing of the transit of time.

And yet, much as the passage of time changes almost everything—the stores, the clothes people wear, the kind of

vehicles parked alongside the curb—some things remain constant. It is never clear whether it is permanence or change in these contrasting pairs of photographs that I long to grasp. If part of me longs to live at the beginning of the twentieth century, another is grateful I'm stuck in the twenty-first. If part of me loves the present, another yearns for the past. I am confused, but I can't let go of these double images. I am constantly looking for the right coordinates in time and place. The more I stare and flip back and forth between centuries, the more I realize that I don't really know where the real me lives, in 1921 or in 2021, or is there some ideal point forever hovering between the two that is my true spot, except that I never seem to find it. Nothing corresponds to what I think I want. I am a free-floating prisoner of endless double takes.

And perhaps it is not so much the old city that I am seeking in Sloan's city, or another time zone, or just some form of time tourism; what I may be seeking in these paintings and images of a bygone world is just me. Where am I? When am I? And, since we're asking, who am I?

When I step into the glass-domed arcade of the Galerie Vivienne in Paris or into the far more beautiful Passage in St. Petersburg, or the one in Sydney, what I see is not only a beautifully restored old passageway waving at me from the nineteenth century; what I see is a highly familiar construction almost pulling me into another time warp that suddenly feels like my real home.

If I keep staring at Sloan's century-old portrait of Sixth Avenue and Third Street in the evening, will I spot myself or, better yet, a far earlier version of myself ambling along the gaslit avenue? And—let's say—if this gentleman crossing the street

on his way home is my great-grandfather, can he see me staring at him? Does he know I am trying to connect? Is he even interested? Does he know me? Do I know him? Who of the two is more real? Who has his feet more firmly planted on the ground? Or, let's turn it around and give this thought a further torsion: when, one hundred years from now, my great-grandson looks at a picture of me as I'm sitting by the statue of Memory in Straus Park at 106th Street, will he even know that I existed once and that in that picture an infinitesimal part of me was already desperately trying to reach out to him?

Or let me twist this around a bit further yet: as I'm looking at John Sloan's painting of Greenwich Village, with the elevated train very much in evidence, and then examine his incipient studies of it, I notice that one of these sketches doesn't even show the El at all. Sloan is as though remembering Sixth Avenue before the El was ever built, with a prescient eye cast on its eventual demolition. In his studies, Sloan is rehearsing the El that both is about to be built and has already been taken down.

What we're looking for, what we're trying to grasp, is not there, will never be there; yet looking for just that thing is what makes us turn to art. As we attempt to understand our lives, ourselves, and the world around us, art is not about things but about the interrogation, the remembrance, the interpretation, perhaps even the distortion of things, just as it is not about time but about the inflection of time. Art sees footprints, not feet, luster, not light, hears resonance, not sound. Art is about our love of things when we know it's not the things themselves we love.

As I look at my volume of *New York Then and Now*, I am reminded of the ultimate paradox: that those who were alive in a photograph taken a century ago are all dead, but that if the city

lives on and scarcely changes, then perhaps those who walked the streets a century ago have just changed clothes, bought newer cars, and all come back to us, because if the city never really ages, we don't age, and we don't die.

I stare at John Sloan's picture and see the city in 1822, when there was no El, in 1922, when indeed there was one, and in 2022, when the memory of the El will long since have faded. And suddenly I am struck by one scary thought. That I'm absent from all three of them! But then I think of Bleecker Street with its gas jets and its shoppers and its stores that are just about to close for the evening, and I know that I've always been there and thus might never, ever leave.

EVENINGS WITH ROHMER

Maud; or, Philosophy in the Boudoir

April 1971. I am twenty years old. My life is about to change. I don't know it yet. But just a few more steps and something new, like a new wind, a new voice, a new way of thinking and seeing things will course through my life.

It's a Thursday evening. I have no papers due tomorrow, no reading, no homework. I still have my daily ration of Ancient Greek passages to translate, but I can always take care of these tonight or tomorrow morning on the long subway ride to school. This, I realize, is another one of those very rare, liberating moments when I've got nothing hanging over me. I was right to leave work before it got dark today: it's a perfect evening for a movie. Tonight, I want to see a French film. I want to hear French spoken. I miss French. I would have preferred going to the movies with a girl, but I don't have a girlfriend. There was someone, or the illusion of someone, a while back, but it never worked out, and then someone else came along, and that didn't work out either. Since then, I've grown to hate loneliness and, more than loneliness, the self-loathing it stirs up.

But tonight I am not unhappy. Nor am I in a rush to find a movie theater. After working all afternoon in that dingy machinery shop in Long Island City, where I was lucky to find a job, because my boss is a German Jewish refugee who likes to hire other displaced Jews, I want to hurry back to the city, get out of the subway, and take in the busy luster of lights of Midtown Manhattan's twilit avenues. They always remind me of J. Alden Weir's spellbinding *Nocturnes* of New York, or of Albert Marquet's nights in Paris—not the real New York or the real Paris, but the idea of New York and Paris, which is the film, the mirage, the irrealis figment each artist projects onto his city to make it his, to make it more habitable, to fall in love with it each time he paints it, and, by so doing, to let others find an imaginary dwelling in his unreal city. I've always liked this illusory Manhattan glazed over the real Manhattan, altering it just enough to make me want to love it. Being in Midtown now feels so much better than heading directly home to emerge from the drab subway station on Ninety-Sixth Street and Broadway and walking up a dark, sloping Ninety-Seventh Street, where the occasional roadkill reminds me that this modern megalopolis could just as easily be a gigantic culvert. Nothing could be further from either Pissarro's or Hopper's beloved cities. Scuzzy Ninety-Seventh Street is the last thing I want tonight.

I like this sudden break from reality, this mini spell of freedom and silence at dusk that lets me feel one with this bright-lit city. Its people going places after work lead exciting lives, and, because I've almost crossed paths with theirs by stepping on the same sidewalk, some of their vitality has rubbed off on me. There's something extremely grown-up about leaving work without needing to rush home. I like feeling grown-up. This, I suppose,

is what adults do when they stop at a bar or sit at a café after work. You find an uncharted moment in the day, and, because it's earmarked for nothing, rather than race through it, you allow it to linger and distend and slow things down, till this insignificant moment normally smuggled between sundown and nighttime and seldom lived through because it goes by so fast, from nothing becomes something, and from a vague hiatus in the evening finally unfolds into an instance of grace that could stay with you tonight, tomorrow, for the rest of your life—as this moment will, though I don't know it yet.

➤━◄

I enter the movie theater. I hear voices on-screen. I have no sense of how much of the film I've missed or if coming in late might ruin it. The sudden disappointment of missing the beginning distracts me and gives the entire viewing an unreal, provisional feel, as though seeing the film now doesn't really count, because it might need to be corrected by a second viewing. I like the option of a second viewing that is already implied in the first, the way I like to see places or hear tales told a second and a third time while I'm still experiencing them the first time—which is how I confront almost everything in life: as a dry run for the real thing to come. I'll return, but this time with someone I love, and only then will the film matter and be real. This, after all, is how I went out on dates, answered job ads, picked my courses, made travel plans, found friends, sought out the new: with enthusiasm, a touch of panic, reluctance, and sloth—the whole occasionally bottled up in a brine of incipient resentment, perhaps disdain. I am almost hoping to be disappointed

by the film. I am simply going through the motions of testing a film everyone has been raving about and which I've finally acquiesced to see, because this is its last run in New York.

I wasn't planning to see *My Night at Maud's* tonight. There had been such a to-do about it, especially after it was nominated a year earlier for best foreign film, that I wanted to let things die down a bit, put some distance between me and what others were all clamoring about. I liked what I'd read about the film and was intrigued by the story of the practicing Catholic played by Jean-Louis Trintignant who, owing to a snowstorm, finds himself forced to spend the night in Maud's home and, despite her beguiling looks and unequivocal advances, refuses to have sex with her but instead wraps himself tightly in a blanket as in a metaphorical chastity belt and sleeps right next to her on her bed until dawn when, in mid sleep, he almost relents. The next morning, after he leaves Maud's house, he runs into the woman he'll eventually marry. Maud was like the rough sketch of the final version. I liked this view of things. There was order in the universe, at least a desire to see order—something so totally unlike what we'd been seeing in print and on-screen in those years.

I didn't want to be yet another New Yorker eager to shower praise on the latest French film. I found myself resisting. Diffidence as an instance of desire. As a result, I was now perhaps the last New Yorker to see Éric Rohmer's film.

Which explains why the theater on West Fifty-Seventh Street was nearly empty. I didn't generally like going to the theater by myself. Always afraid people might see me, especially if I was alone and they weren't. But tonight I felt different. I wasn't even thinking of myself as a lonely, unwanted, ill-at-ease young man. Tonight I was another twenty-year-old with time on his

hands, who, on a whim, decides to go to the movies and, see-
ing as he has no one to go with, buys one ticket instead of two.
Nothing to it.

I lit a cigarette—in those days you could, and I always sat in
the smoking section. I'd sit through this film for fifteen, twenty
minutes. If it didn't do it for me, I'd pick up and leave. Nothing
to it either.

I put my raincoat on the seat next to mine and began to drift
into the movie, because something about the film had already
grabbed me. It must have started soon after I lit up and had as
much to do with the film itself as with my watching it alone.
The twining of the two—the film and I—was not incidental,
but in an uncanny, perhaps untenable, way, essential to the film
itself, as though who I was, alone at the age of twenty, craving
love, not knowing where to find it, willing to take it from al-
most anyone, mattered to the film, as if everything happening
in my private life mattered to the film. The ferment of lights in
Midtown Manhattan suddenly mattered, my longing to be in
Paris instead of New York mattered, the drab machinery shop
I'd left behind in Long Island City, the passages I still needed to
translate from the *Apology*, my misgivings each time I thought
of the girl I'd met at a party in Washington Heights more than
a year earlier, down to the brand of cigarettes I was smoking,
and—let's not forget—the prune Danish I had purchased on
the fly to snack on, because something about prunes brings
out a sheltered, old-world feel I continue to associate with my
grandmother who was living in Paris at the time and who kept
summoning me back there because life in France, she used to
say, gave every semblance of extending life as she'd known it in
Alexandria—all these had, like unpaid extras, chipped in and

played their small part in Éric Rohmer's film, as though Rohmer himself, like every great artist, had, without knowing exactly how, opened up a space in his film and asked me to furnish it with snippets from my life.

The personal lexicon we bring to a film or the way we misunderstand a novel because our mind drifted off a page and fantasized about something entirely superfluous to the novel is our surest and most trusted reason for claiming it a masterpiece. The spontaneous decision to head to the movies that night was now forever grafted to *My Night at Maud's*, the way the impulse to head to a party in Washington Heights after deciding not to go there was itself woven into my sudden infatuation with the girl I met that night. Even walking into the theater halfway into the film seemed to cast a strangely premonitory if inscrutable, retrospective meaning to this evening.

<p style="text-align:center">→><←</p>

Jean-Louis, the protagonist of *My Night at Maud's*, lives alone and likes living alone, though he'll tell Maud in the film that he wishes to be married. His life has been crowded with many people, many diversions, many women; he welcomes his recent, self-imposed reclusion, even if it comes off sounding a touch too urbane, too smug, to pass for an authentic retreat. This is a man who seems to have put his personal life on hold and taken time out in Ceyrat, near Clermont-Ferrand, where he works for Michelin. He is not sulking or brooding, just serenely withdrawn. No shame, no loneliness, no depression. This is not Dostoyevsky's underground man, or Joseph K., or, for that matter, yet another jittery, self-hating, existential Frenchman. There was something

so un-tormented, so cushy, so restorative in his desire to be left alone that I can't help but suspect that what makes my loneliness unbearable by contrast is not so much solitude itself as my personal failure to overcome it. This might ultimately be the most insidious fiction of the film: the airbrushing of loneliness till it seems entirely voluntary. There was a big difference between Jean-Louis and me. He was not being deprived of company; he could have it any time he wanted. I could not. He could be lying to himself, of course, and he could be wearing a mask and moving in a dollhouse world from which the director had managed to purge all vestige of anxiety and dejection, the way some eighteenth-century comedies routinely removed all references to almshouses, suicide, syphilis, and crime. He may be totally self-deluded. But the world he steps into—and this world is made clear enough from the very first shot—is not the stark universe of action-driven films in which people hurt, suffer, or die; instead, it is inhabited by highly rarefied, well-spoken friends trying to figure out the meaning of conventional love with an unconventional mix of profound self-awareness and boundless self-delusion. There is no violence here, no poverty, no drugs, no breakdowns, no safecracking thieves pursued by the police, no disease, no tragedy, seldom tears, no exchanges of fluids, not even abiding love or self-loathing. Everything is whitewashed with irony, tact, and that French perennial *gêne*, which is the chilling sense of awkwardness and unease we all feel when we're tempted to cross a line but are held back. Youth shakes off *gêne*, doesn't accept it; grown-ups savor it, like an impromptu blush, the undertow of desire, the conscience of sex, a concession to society.

Jean-Louis and Maud are adults. They are versed in affairs

of the heart and in the sinuous course desires can take. They do not shun others, but they're not compelled to seek them out either. Rohmer's men, as I was later to find out from his other Moral Tales, are all on a hiatus from what appear to be thoroughly fulfilling lives. Soon they'll return to the real world and to their one love awaiting them there. The mini vacation in a villa on the Mediterranean in *The Collector*, the return to a family villa in *Claire's Knee*, or the adulterous afternoon fantasy in *Chloe in the Afternoon*—all these are interludes punctuated by women whom the male protagonist already knows he won't really fall for.

Rohmer's Six Moral Tales comprise nothing less than a series of what may be called unruffled psychological still lifes. The world may be at war—and the war in Vietnam was still raging when *Maud* was filmed (in fact, the night at Maud's was originally conceived two decades earlier and was set to take place not during a snowstorm in the late 1960s but during World War II). Still, the characters in Rohmer's world—like those seeking to escape the plague in Boccaccio's *Decameron*, or like so many disenchanted courtiers in seventeenth-century France—have ways of fending off the uglier side of things for a while by talking of love. They speak not of their love for each other, but about the nature of love in general, which, in polite conversation, is perhaps a way of making love while claiming—or trying to claim—not to, of seducing by exposing all the wiles of seduction, of reaching out to someone with the option of not going all the way and of backing out at the last minute. Among the disabused seventeenth-century courtiers who lived in Paris, it was customary to sit around the bed of a hostess, who would entertain her friends from there. Under those circumstances, the conversation

had to be intimate and candid—how could it not?—but always tempered by mirth, good judgment, and civility. Blaise Pascal, who wrote the *Pensées*, arguably the most spiritual and unsparingly incisive work in French literature, may also have been the apocryphal author of the no less probing but unflinchingly urbane *Discours sur les passions de l'amour.*

<p style="text-align:center">→>◄←</p>

To a twenty-year-old, the thirty-four-year-old Jean-Louis of *My Night at Maud's* seemed old, wise, and thoroughly experienced. Life was behind him; he had traveled to several continents, loved and been loved, didn't mind loneliness, indeed, thrived on it. At twenty, I had loved one woman only. And I was just that spring beginning to recover from it all. The longing for her, the phone messages she never returned, the missed dates, her snubbing *I've been busy*, coupled with her evasive and dissembling *I promise I won't forget*, and always my self-reproaches for not daring to tell her everything on the night I stood outside her building staring at her windows, wondering whether I should ring her buzzer downstairs, or the night I walked in the rain, because I needed an excuse to be out when she called—if she called, when she called, which she never did; our perfunctory kissing as we waited for the Broadway local one evening; the afternoon I spent at her place when I watched her change clothes in front of me but couldn't bring myself to hold her because suddenly everything seemed unclear between us; and the afternoon many months later when I went to see her again and we sat on her rug and spoke of that time when I'd failed to read her meaning when she'd taken off her clothes, and, even after

hearing her confide all this, I was still unable to bring myself to move but fribbled our time together with oblique double-talk about an us we both knew was never going to be an us—all of these, like untold arrows driven into Saint Sebastian, reminded me that if I'd never be able to forget loving the wrong girl, I should at least learn not to hate myself for it, because I also knew that it was far easier to blame myself for not seizing the moment that one afternoon than to question desire and not know what had held me back.

Jean-Louis, like almost all of Rohmer's men, had already been there and come out on the other side seemingly unscathed. This was the first time that I got a hint there might even be another side. As bashful and tentative as I was, I saw that there was still hope for me. But watching Jean-Louis evade Maud's advances, all the while leading her on, reminded me that what comes spontaneously to some is not necessarily impulse but deliberation, and that every spark of desire has a hiccup, a moment of deflection, a reflux of *gêne*, which cannot be dismissed, not just because some people are thinking in the heat of passion but because passion is itself a way of thinking. It is never blind. Watching the two think aloud about themselves and speak ever so eloquently about love on their one snowbound night together, I was reminded that thinking is at its very core erotic, almost prurient, because thinking is always thinking about Eros, because thinking is libidinous.

<div align="center">✦</div>

We first meet Jean-Louis in church. He is a devout Catholic. He is eyeing an attractive blonde. He has clearly never spoken to

her before, but by the end of the sermon he decides that one day this very woman, whom he has probably not seen other than in church, will be his wife.

Nothing could sound more prescient or more deluded. But, once again, the braiding of the two is typical of Rohmer. Foresight and delusion are inseparable bedfellows. One feeds the other. Their collusion is not insignificant. The stars are aligned to our wishes or to what is best for us—but never as we think.

Outside the church one day, Jean-Louis tries to follow her but eventually loses track of her. A few days later, on the evening of December twenty-first, he suddenly spots her on her motorbike but once again loses sight of her in the narrow, busy, Christmas-decorated streets of Clermont-Ferrand. On the evening of December twenty-third, he is strolling about town in the hope of running into her.

And of course he will run into her. But not just yet.

He will, however, bump into someone else: his friend Vidal, whom he hasn't seen since their student days. The men are so thrilled by their accidental encounter that, after spending time in the café, Jean-Louis suggests they have dinner together. Vidal cannot dine with his old friend that night, but he has an extra ticket for a concert. Jean-Louis accepts the invitation to join him—maybe another opportunity to run into his blonde, he thinks. But she is not at the concert. The men would like to do something the next night, but this time it's Jean-Louis who cannot go: he'd like to attend the Midnight Mass on Christmas Eve. Vidal joins him in church. The blonde is nowhere in sight there either. So Vidal invites Jean-Louis to dinner on the morrow, Christmas Day, at Maud's house. Vidal is probably in

love with Maud but, after what must have been a casual night together a while back, is resigned to a platonic friendship.

In the café on the night they first bumped into each other, the men had begun talking about, of all things, chance encounters and about, of all authors, Pascal, the writer most associated with chance, *hasard*, and, as chance would still have it, the very author Jean-Louis has been reading. Coincidence thrice removed.

These multitiered coincidences beguiled me and wouldn't let go of me and kept insisting there was a greater design at work here, as though the convergence of so many coincidences, however far-fetched, underwrote the whole film, and that this conversation between the two men about coincidence was merely a prelude, a tuning of the instruments, for things to come. The confluence of three *hasards* in the film, added to my own *hasard* in happening to be seeing this and not any other film that night, plus the creeping realization that there was something uncannily personal each time I apprehended anything occurring at multiple removes, all these didn't just stir me intellectually but in some inexplicable manner ignited an aesthetic, near-erotic charge, as if everything in Rohmer had to come back to sex, but only obliquely and ethereally, the way everything about Rohmer had to come back to me as well, but in an oblique and ethereal manner, because multiple removes kept reminding me that I too liked lifting the veil and looking under things, denuding one alleged truth after the other, layer after layer, deceit after deceit, because unless something wears a veil, I will not see it, because what I loved above everything else was not necessarily the truth but its surrogate, insight—insight into people, into

things, into the machinations of life itself—because insight goes after the deeper truth, because insight is insidious and steals into the soul of things, because I myself was made of multiple removes and had more slippages than a mere, straightforward presence, because I also liked to see that the world was made up like me, in shifty layers and tiers that flirt and then give you the slip, that ask to be excavated but never hold still, because I and Rohmer and his characters were like drifters with many forwarding addresses but never a home, many selves folded together—selves we'd sloughed off, some we couldn't outgrow, others we still longed to be—but never one, firm, identifiable self. I liked watching Rohmer uncoil his characters' secrets; I was all whorled up myself and kept assuming that, contrary to what everyone claimed, others were as well. It was good to watch someone practice what I'd been tinkering with, sneaking into people's private thoughts and intuiting their shameful little motives. People were two-faced, triple-faced. Nothing was as it seemed. I was not as I seemed. That evening I was confronted by the possibility that perhaps the truest thing about me was a coiled identity, my irrealis self, a might-have-been self that never really was but wasn't unreal for not being and might still be real, though I feared it never would.

But perhaps what stirred me in the scene of the two men speaking about luck was something far simpler than their discussion about luck: the intensity of their conversation reminded me that there were still places on this planet where similar conversations in the most polished French are not unusual and that people still spoke this way in the cafés of France. I was suddenly homesick for a place that wasn't even my home but that could

have been, longing to hear French spoken on the streets of Manhattan, all the while sensing that, given the choice, I'd never want to leave Manhattan to move to France.

<div align="center">→>–<←</div>

So here are the two men: I am here, says one, and you are there, says the other, and between us there's time, space, and a strange design, which, to some, is no design at all but, to us, is proof we're on to something whose meaning nevertheless eludes us.

It was the search for and the possible discovery of an undisclosed design in their lives that suddenly enchanted me, because everything in Rohmer is about design, which is another way of saying that everything is ultimately about form. Form is the imposition of design. In the absence of God, in the absence of identity, in the absence of love, even, is design—perhaps even the illusion of design.

The world teems with coincidences. Chance meetings, chance sightings, chance insights—these occur all the time. In fact, this is all there is: chance. In Rohmer, however, there is an algorithm to chance—or at least the search for such an algorithm—just as there might be a logic to happenstance. And this logic is not to be found outside the film, nor even in the film. It is the film itself. Form is the algorithm. Form, like art, is seldom about life, or not quite about life. Form is both the search for and the discovery of design.

Accidents happen in the lives of Rohmer's characters; they do so with a frequency that is nothing short of uncanny, and no less so than, say, in a paltry, nineteenth-century Realist

novel whose author has run out of tricks and relies on deus-ex-machina encounters to help move the plot along. But in Rohmer's world chance events are not without meaning; they are the external manifestation of an inner logic, which sometimes—sometimes—tips its cards. Form is how we investigate, discover, and, however briefly, firm up this logic before it turns into a mirage and gives us the slip again. Chance events may seem totally capricious, but this is only because we judge life according to a logic that is sequential. There is, however, another logic, though it is not logical. The workings of what we call chance events, exactly like the thought processes of Rohmer's highly insightful yet frequently deluded characters, are counterintuitive and willfully paradoxical. The world is paradoxically constructed; the psyche is governed by desires that couldn't be more paradoxical. To "read" life, one stands a better chance of understanding the world—and the seventeenth-century French moralists had figured this out—by reading it counterintuitively; i.e., antithetically. Pascal called this *renversement perpétuel*, perpetual reversal. But Pascal was a logician. And what he meant most likely was *symmetrical reversal*. A coincidence, after all, is nothing more than the suggestion of symmetry, of design, an elusive apprehension of meaning. The love of design is the love of God transposed to aesthetics. Symmetry is how we manufacture the illusion, the impression, the glint of meaning in our otherwise meaningless and chaotic lives. Irony itself is nothing more than the design our perceptions impose on things that our intellect already knows have no design whatsoever. This is the essence of all art. Chaos stylized.

The plot of *My Night at Maud's* screams symmetrical reversal.

Jean-Louis has his eyes on the blond Françoise, a seemingly virtuous churchgoer he's already decided he'll marry without ever having spoken to her once. Meanwhile, he meets Maud, the brunette, a typical temptress who wishes to sleep with him but whom he manages to resist. However, the morning after leaving Maud's apartment, Jean-Louis spots Françoise, walks up to her as she is parking her bike, and, mustering his courage, does something he claims he's never done before with a stranger on the street: he speaks to her. As with Maud, he will end up sleeping under Françoise's roof, but not with her. He does indeed marry Françoise, only to discover, completely by chance, when he and Françoise run into Maud at a beach five years later, that his wife had been the mistress of none other than Maud's husband. In fact, Françoise may be the reason behind Maud's divorce.

At the beach, Jean-Louis was about to confide to his wife that on the morning he first spoke to her, he had just left Maud's apartment. But before attempting to tell her this, he realizes in a flash of insight that what seemed to disturb Françoise at that very moment on the beach was not what she might finally discover about her husband and Maud. It was something else—and the symmetrical reversal and double remove here couldn't be more stylized. He looks at his wife and realizes that she was at this very instant inferring what he himself was just inferring about her. Nothing is ever stated in the film, but the inferences are clear enough. Françoise and Maud had slept with the same man, and that man was Maud's husband. In life, their pairing was simply reversed; in art, it was corrected.

The totally adventitious nature of this traffic of insights in multiple removes between husband and wife at the beach says

that truth is never arrived at methodically; it is only inter-
cepted, stolen, and therefore always unstable and subject to er-
ror or revision. An insight into something could always be right
or wrong—we know this. But an insight into an insight is al-
ways crafted and thus bears the imprint of form. In Rohmer we
are in a world where consciousness, like desire, like chance, like
thinking, like conversation, is always conscious of itself, and
therefore always stylized.

→>-<-

Sitting in the café at the beginning of the film, these two friends,
like almost all characters in Rohmer's films, derive a peculiar,
self-conscious thrill in finding themselves eagerly discussing
the very thing that is right that minute happening to them. Is
there a meaning to our meeting, or is it just luck? Since there
is no way to answer such a question, one has to wager—Pascal
again—that there must be a meaning behind coincidence, if
not in conventional, ordinary life, then at least in the conven-
tions of art—in film, for example. How dear are those moments
when we suddenly perceive in a series of accidents something
like an omniscient intelligence deploying—or, as Proust likes
to say, *organizing*—one by one, the events of our lives, so that it
is not just their alignment that strikes us but their resonance,
which is the specter of meaning. What can be better than to
espy in real, day-to-day, humdrum, desultory existence the
light touch of the great artificer himself framing our lives
according to the covenants of art? Happens once or twice in a
lifetime; these occasions are called miracles.

But the discovery that form is a way of attributing meaning

to coincidence is sidelined by another discovery: namely, that this ability to move in multiple removes—to discuss the act of discussing—is itself meaningful and becomes explosive when transposed to the boudoir, because it is already obliquely erotic. And this is exactly what happens about twenty minutes later between Jean-Louis and Maud. This kind of candor and this kind of self-conscious thinking and lifting of layers could only end up in a bedroom. It isn't even candor, though it bears all the inflections of candor: at once very frank and intimate, spoken with the confiding grace with which lovers open up to each other in bed, all the while maintaining a guarded distance. For all we know, they might as well be flirting. In every truth lies the inscription of whimsy and artifice, the intrusions of craft in our most spontaneous, halting avowals. "Tell all the Truth but tell it slant— / Success in Circuit lies . . .": Emily Dickinson. I had never seen things this way. Nor had I ever spoken about desire while I was prey to it.

I missed talking the way Maud and Jean-Louis spoke, though I'd never spoken to anyone in that manner. I envied Jean-Louis and Maud's insights, their wisdom, their misled smugness, their fearless impulse to analyze and overanalyze each nuance of desire and discomfort, then turn around and confide it right away to the very person who was stirring that vague sense of desire and discomfort. It would never have occurred to them that their well-wrought avowals, rather than clear the path for passion, might in the end choke its fire and stand in its way. Perhaps their words had come too soon and gone too far, while the body, like a cramped, self-conscious straggler, was a cheated extra who'd forgotten his lines.

And yet, all that they were doing was making conversation

during embarrassing spells of silence. Speech itself had given birth to surrogate pleasures. It did not dispel passion or put it on hold; it simply allowed it to talk, to think. In this instance, and perhaps only in this instance, can it be said that desire is a civilizing agent.

But as if to undo all these layers of conversation and subterfuge, at some point Maud will look at Jean-Louis and sum up his entire behavior that night with one word: "Idiot."

<div align="center">→>◄-</div>

On Christmas night, Vidal brings along Jean-Louis to Maud's apartment for dinner. The two meet for the first time. They discuss Pascal. The conversation is at once light and serious, and both Maud and Vidal rib Jean-Louis about his self-righteous adherence to Catholicism. Then Maud puts on a T-shirt and gets under the covers of her bed in the living room, fully enjoying the presence of both men in her salon, aware that she is replicating the ritual practiced among the seventeenth-century *précieuses*. Meanwhile, the evening is drawing to a close, and Vidal has to leave. Jean-Louis also says it is time for him to leave, but because of the snow he is encouraged to spend the night at Maud's. The pious Catholic in him is genuinely ill at ease, as he suspects that Maud may have designs on him, which is when Maud tells him he should rest easy and sleep in the other room if he wishes. Soon after Vidal leaves, Jean-Louis does say he'd like to retire and asks where that other room is, and he is summarily informed that there is no "other room." In fact, Maud adds in her typically taunting, lambent, mischievous manner, Vidal knew very well there was no "other room" in her home

when he'd heard her offer it to Jean-Louis—which explains Vidal's grumpy and hasty exit. The woman who will, in fact, offer him another room in her empty dormitory will be not Maud but his wife-to-be, Françoise.

Stuck together and yet clearly ill at ease, Maud and Jean-Louis continue to talk. While she is under the covers, he leans over and sits on her bed, fully clothed in his double-breasted gray flannel suit and, in a moment of silence that is as uncomfortable to Maud as it is to the spectator, stares intensely at her, while she returns his gaze, the two of them at a loss for words and yet already unburdening themselves to each other. She tells him of her life; of her ex-husband, who had been unfaithful; of her lover who died in a car crash; of her terrible luck with men. He paints a broad picture of love affairs in the past, but far more cagily. They discuss his conversion to Catholicism, his avoidance of light sexual affairs, his desire, as she sees it, to marry a blond woman, since, in her prescient view, all pious Catholic women are necessarily blondes. Then, as they stare at each other, Maud, in an unguarded moment, says, "It's been ages since I've spoken like this to anyone. I like it."

Their conversation skims "philosophy in the boudoir," but it is neither armchair psychology nor even seduction. It is, however, supremely analytical and almost uncomfortably intimate and penetrating. Analysis and seduction, like insight and chance, or chaos and design, are braided together and can no longer be told apart. What Pascal called *ésprit de finesse* and La Rochefoucauld *pénétration* lies at the heart of Rohmer's insights into that skittish and capricious ganglion called the human psyche.

If Rohmer has frequently been "accused" of being literary, it

is not just because his screenplays are extraordinarily well written; it is because he always wagers that the key to the psyche, like the key to every accident in our lives, can be found only in fiction, and this because fiction and, more broadly, art are the only mechanisms available with which to capture, however tentatively, the demon of design. There was always going to be a design, and if there wasn't a design, then the very act of searching for a design in that highly crafted, paradoxical way was already a way of wagering that life itself is a highly crafted and stylized affair. The thought that there may be nothing instead of something is aesthetically unacceptable.

→>≺‹-

In the makeshift "boudoir" of Maud's bedroom, Jean-Louis and Maud are analytical in a situation that is unbearably intimate and in which most people would much rather wish their senses might take over. But analysis is not allowed to slip into hasty sensuality. Here the mild *gêne* and the occasional lapses into total silence between the two are so intense and so disarming— one is tempted to say denuding—that they, more, even, than the bed itself, keep prodding at the hovering sensuality of the moment.

The senses cannot deflect analysis; they become analytical. Passion in this instance, as is more often the case than people admit, is not really the end, but the cover, the way out, the pretext; physical contact often buries the tension between two individuals who cannot stand either tacit ambiguity or the rising awkwardness between them. In some cases, it is speech that is spontaneous, not passion; speech undresses us; passion can be

a cloaking device. This reversal, which would become the hall-mark of so many of Rohmer's films, is not just using talk to de-flect or defer sex. It is, rather, a desire to find the sort of intimacy that sex, allegedly the most intimate act between two individu-als, hastily cheats us of by sidestepping intimacy altogether. In Rohmer's world, passion is nothing more than a desired blind-fold that allows us to work around the unbearable moment when we are forced to disclose who and what we really are.

<p align="center">→>—<←</p>

While watching the film and feeling the growing discomfort of the two would-be lovers stuck in the same bedroom, I began to think of the girl I'd taken to Central Park a year earlier one night and made out with, right by Bethesda Fountain. How suddenly it had all happened: her call, going to the Paris Cinema on Fifty-Eighth Street, getting a bite to eat in some unnamed place, then heading through the park until we'd reached Seventy-Second Street. All of it so unplanned, as if life itself had taken things into its own hands and told me not to intrude, don't even think of meddling, everything was taken care of. Two policemen walked up to us and told us that the park was closed to lovers. There was a snigger in their voices, while I thought to myself, *So we're lovers now—fancy that!* We joked with the officers until we'd walked out of the Women's Gate on West Seventy-Second and then headed uptown on what was once known as the CC train to Washington Heights. When we reached her home, she asked me to come up-stairs. So I hadn't misread the signals at all that evening. She put some water to boil to make instant coffee, and we began to kiss on the sofa, then on the rug, where months earlier we'd had our

long conversation about the cue I'd missed the year before. We kept speaking about that until, during a pause in our conversation, she told me that her mother might wake up in the room right next to the living room. Not to worry, I said, we weren't making noise. Well, perhaps you should start heading home, she said, it was getting late. So she'd changed her mind, I thought on my way to the subway station that night. Only then did it hit me: I had hesitated. I had wanted to resolve the mystery of the afternoon when she'd taken off her clothes in front of me, I had wanted to talk about that and square it away, to speak not just freely but intelligently about that day or about the night when we'd first met at a party I had already decided not to attend; I had wanted so many things that were obviously not scripted for that night. Without knowing it yet, what I'd wanted was a Rohmerian moment—that magical span when a man and a woman, unwilling to rush to where both know they are unavoidably headed, heed another impulse, which is to dissect their chance encounter, to examine how they got to where they are, and to unlock the logic of how desire and fate are indissolubly fused, and, having thought about these things, to turn around and confide them right away to each other, which is when they'll also disclose their hopes and their oblique maneuvers, only to be told that these hardly went unnoticed by the other. I wanted that span of time, that *durée*. It wasn't courage I wanted; what I wanted was courtship. I wanted more.

It took no time while I was still viewing the film to realize that I was borrowing Rohmer's fictions on-screen and projecting them retroactively onto my own failed love affair with the girl from Washington Heights. I was replaying my life in the key of Rohmer—misreading my life, and certainly misreading

Rohmer, but in both cases finding something eloquent and arresting in the transposition. Our conversation on her mother's sofa, my hand under her clothes, her story about an ex who wasn't doing it for her but wasn't disappearing fast enough, and suddenly the kettle whistling just when I was about to tell her that I'd always hoped she'd call me someday—we might as well have been speaking French and living in the black-and-white world of the New Wave years.

But perhaps what was also happening to me in the theater could as easily be reversed: it was not I who was casting a retrospective glance on that night in Washington Heights; it was Rohmer. He had borrowed my night for an hour or so, pared down its roughness, and trimmed it of all psychobabble, given our scene a rhythm, an intelligence, a design, and then projected it onto the screen while promising to return it to me after the show, though slightly altered, so that I'd have my life back but seen from the other side—not as it was, nor as it wasn't, but as I'd always imagined it should be, the idea of my life. The idea of my life in France. My life as a French movie. My life symmetrically reversed. My life scaled down and cleansed of all chaff and all interference till all that was left was its irrealis watermark on a blank sheet of paper on which was written a might-have-been life that hadn't really happened but wasn't unreal for not happening and might still happen, though I feared it never would. I couldn't have felt more rudderless—or more liberated.

→>-<←

I walked out of the film that night knowing that even if I was destined to remain totally feckless when it came to courtship

and romance and was too timid a lover to speak as boldly or as intelligently as men and women did in Rohmer, something about the film had enlightened and allowed me to see that in Rohmer everything bearing on love, on luck, on others, on our ability to see through the mirages life throws our way was reducible to one thing: the love of form. His film was classical. It didn't care about the way things are, about reality, about the here and now, about urban blight, the war in Vietnam, World War II, or about what everyone else was busy filming in the late sixties; it was beholden to and chastened by a higher principle: classicism. A short film where nothing happens and where mind is the plot. This was totally new. I was enchanted. It had never occurred to me until that moment that classicism had never died and that art itself, which is the highest mankind can aspire to, might indeed be just a bubble, but that what's inside this bubble and what we learn from walking through it is better than life.

Outside I looked around me. The city looked nothing like Weir's or Hopper's that night, or like that of any other painters who had touched up Manhattan to make it their own. I could see it clearly now. Without patina, without art coating its buildings, without layers, the city had no beauty, no kindness, no love or friendship to give; it radiated nothing, meant nothing, to me. This was not my city, was never going to be. Its people were not my people, were never going to be. Nor was theirs my tongue— would never be.

Watching Manhattan grow lusterless at this hour of the night, I also realized something more disheartening yet: that I was losing France, had lost France, that Paris too was not my city, had never been, would never be. I wasn't here, but I certainly wasn't

anywhere else either. Nothing seemed to work. The woman I wanted I couldn't have. The street I lived on wasn't my street, and the job I had would never last. Nothing, nowhere, nobody. Some words of Dos Passos, whom I'd never even liked, coursed through my mind. "At night, head swimming with wants, [the young man] walks by himself alone. No job, no woman, no house, no city."

What I took with me on my subway ride home that night was an imaginary Paris and an imaginary New York, places that weren't real, where people spoke a medley of bookish French and bookish English and watched unreal things happen to them, almost as though they knew they were being filmed and belonged in a beautifully composed screenplay and had grown to like their lives done up that way, because they too distrusted this thing everyone called brute reality, because brute reality did not exist, wasn't even real, had no place in the world, because the things that mattered were not real, could not be real. I was not interested in the real world but had never had the courage to say it. I wanted something else. I wanted more.

I took the subway, not to 96th Street but all the way north to 168th, then crossed over to the other side and took the downtown train home. She and I had done this once, riding the subway north, rushing over the footbridge to take the downtown, and getting on just as the doors had closed the first time and then suddenly reopened barely to let us in. Before she got off at her stop on 157th Street, she kissed me on the mouth. The kiss stayed with me all the way to my stop at 96th Street, then on my walk up 97th, then to bed, and when I awoke the next morning, I could tell it had spent the night with me and hadn't gone away. It never did. On my way uptown, I knew that

after 116th Street the train would bolt out from underground as it comes up for air and races to the 125th Street El. I liked that brief intermezzo on the El before the train chugged its way back underground. I even like watching the train today, when I walk on Broadway past 122nd Street and glimpse the Broadway local suddenly gun its way out of the tunnel like a giant armored vehicle bearing down on the tracks with lockstep speed and purpose, its red light in the front like a watchman's lantern telling the world that its course and its passengers are once again safe for the night. On the night I discovered Rohmer, I had headed uptown hoping to run into the girl from Washington Heights. I knew that such encounters seldom happened in life. But I liked the thought of it, and I liked the things we would tell each other, and I loved her sprightly repartees each time she'd take my insights about why things hadn't worked between us and turn them around to show me that, however clever I thought my insights were, there was always going to be another way of seeing things, and that if she had to speak her mind, she'd tell me in four plain words that I was an idiot, a real idiot, because on the night she said her mother might wake up in the adjacent room, all she might have meant was *Let's go to my bedroom instead.*

EVENINGS WITH ROHMER

Claire; or, A Minor Disturbance on Lake Annecy

was thirteen years old when I first glimpsed Claude Monet's *Les Coquelicots*, known in English as *Poppy Field*. It was the first painting I'd ever seen by Monet, and it immediately spoke to me and continues to do so, half a century later. I know the painting is beautiful, but I wouldn't begin to know why it is beautiful, why it simply transcends almost everything I can say about it, or what precisely stirs the sense of profound harmony that rushes through me each time I look at it. I know it's the colors, and I know it's the subject, the disposition, the sense of total tranquility that mornings or afternoons in a country home in Vétheuil are supposed to suggest. All these and more. But I continue to react to it today as I did back then, because, even when I was thirteen, the painting instantly took me back to far earlier years of my childhood. Which leads me to suspect that the painting means a lot to me not just for aesthetic reasons but for reasons that are entirely subjective, personal, biographical—unless, of course, a subjective or personal response, especially among Impressionist painters, is exactly what an aesthetic stimulus is meant to stir.

The painting reminds me of our summer house not far from the beach. A lot of wild growth, lots of bushes, and a few slopes took you from that house to a road that led to a tiny pathway filled with poppies and jasmine that eventually led to the beach. In the painting there are two characters in the foreground: one is a child, the other a grown woman. The boy is me, of course, and the woman, my grandmother. I think of the woman in the painting as my grandmother and not my mother because my grandmother was an even-tempered and very composed woman, whereas my mother was loud, tempestuous, and passionate. As in Monet's painting, we walked beneath trees and a clear, luminous sky dotted with bright white clouds, and at the very top of a rise, possibly a hillock, sat a house. I am unable to remember whether the house on the hill was owned by a Russian lady—most likely aristocratic, since I was always told to behave in her presence—or whether it was ours.

The painting evokes a sense of plenitude, of leisure, comfort, even happiness and serene idleness unknown to post-world-war Europe. I don't think I ever revisited that house past the age of five. Yet suddenly, at the age of thirteen, I was yanked back to that summer house as though reminded that, in those years, my life too had been serene, safe, and harmonious. In that house in those years my grandmother would prepare pastries and cakes, and we would sit downstairs in the garden at a round table with an open umbrella standing in its center. In the morning we sat there and had a little snack, and in the afternoon it was tea, while my grandmother would talk about the past as she kept to her needlepoint, always her needlepoint. Not a ruffle in our lives then. If I am giving a prelapsarian vision of those years, it's because the painting by Monet suggests nothing less. The

real world is so thoroughly shut out that it is difficult to imagine that *Poppy Field* was painted two years after France's most humiliating military defeat of 1871 against Prussia, immediately followed by occupation, the collapse of the Second Empire, the Paris Commune, the capture of Napoleon III, and the payment of exorbitant war reparations. None of this is in Monet's painting, just as none of the calamities my family was to face by the time I was thirteen are lodged in my memory of the house on the hill.

Like all great art, what Monet's *Poppy Field* does is not so much allow me to project, to graft my own life, onto Monet's painting, but to borrow from his painting hints and aspects of my own life, to discover and see better and more clearly the arrangement, the logic, the highlights of my life, to read my life in the key of Monet's painting. The process here is less one of projection than of retrieval, not of discovery but of remembrance. I could go a step further and say that Monet has taken scattered moments of my early childhood and redesigned them for me to see in his painting something like a distant echo of my own life. Monet has simply taken memories of that house on the hill and given me a better version of life in a house that is no longer really in either Vétheuil or in that place where I spent my boyhood summers. It is no longer even on his canvas. It is and will always be elsewhere.

->-<-

When I saw *Claire's Knee* in May of 1971, I immediately recognized the film's summer setting as Lake Annecy, although I'd never been to Annecy before. I couldn't even tell whether what

I was sensing from the film was an echo of Monet or of our old summer house. Maybe it was the lakefront, or the table in the garden around which people could sit and talk, or maybe the birds chirping in the first few shots of the film, or just the ambient silence hovering near a large body of water. But for some totally intractable reason, my childhood and Monet's painting or something neighboring the two had come alive. I might not have made the connection at the time or didn't quite know what to do with it even if I suspected a connection; perhaps I felt it was extraneous to the film and therefore irrelevant. Not incidental, however, but just as inexplicably braided into the film was my plan to fly to Paris later that summer to spend a few weeks with my grandmother. With Monet's painting in the back of my mind, I watched the semi-familiar setting of this film cast both a shade of remembrance on the scene as well as an undefined presage of my forthcoming trip to Europe. For a moment I was holding three tenses in my hand: Monet's Vétheuil coupled to our summer house in the past, the present moment inside the 68th Street Playhouse on Third Avenue, and the immediate future awaiting me in France.

None of it was real, of course. The Monet painting was just an illusion, the 68th Street Playhouse was crowded with people eating popcorn, and my grandmother's studio on rue Greuze was slightly bigger than a maid's room. But the movie seemed to deflect reality and provide instead, without my knowing exactly how, a far, far better world.

Claire's Knee was my second Éric Rohmer film, and I'd gone to see it a few weeks after seeing My Night at Maud's. I had loved the scene and the conversation in Maud's bedroom and asked my cousin, who had seen both films, whether a similar

scene occurred in *Claire's Knee*. Her answer couldn't have made things more irresistible: not only was there a similar scene in *Claire's Knee*, but all of *Claire's Knee* was like that one bedroom scene in *Maud*.

As had happened on the evening I went to see *Maud*, I was alone that Friday night. And perhaps seeing the film by myself, undistracted, was exactly what I needed in order to let Rohmer speak to me.

The film was set in Talloires, which should not have surprised me, since Rohmer's films after *The Sign of Leo* and his first few shorts seldom take place in Paris. People may travel to and from Paris, yet Paris seems strangely peripheral. Paris, which sits at the heart of almost every French film and novel, is suddenly displaced, marginalized, almost questioned, as though another reality with totally different orientations were about to be proposed. And this, as I was to see, is true of *Claire's Knee* as well. Something is very tacitly examined; it deflects or at least defers but certainly challenges conventional French perspectives.

Seduction and desire, which have been the bread and butter of all French narratives, are also displaced. In *My Night at Maud's* and *Claire's Knee*, as I would soon find in *The Collector* and *Chloe in the Afternoon*, the leading men are either about to get married or are already married and have at best either the most reluctant interest in the women they are drawn to or find themselves being pursued by women whose tentative, indirect advances they already mean to turn down. At most, they might go through some of the familiar motions of courtship, because the situation makes them unavoidable or because they have no sense of how else to behave in the presence of an attractive woman.

These urbane, worldly, hard-bitten former Lotharios have mended their ways and are trying to hold back. I, on the other hand, at just barely twenty, was desperately trying to practice what these men were seeking to unlearn. They were embracing chastity; I couldn't wait to cast mine off. Like Adrien in *The Collector*, they were reclaiming their "calm, their solitude"; nothing could have stifled me more than my calm and solitude. They welcomed their monk's bedroom; I hated my monkish existence in my parents' home.

I did not have enough experience with women in those days and was forever fascinated by, not to say envious of, Rohmer's accomplished men who had known, loved, and been loved by women and are finally eager to embrace wedlock and marital fidelity. As Jérôme, played by Jean-Claude Brialy, tells Aurora in the film, "I have become indifferent to all other women."

And yet, despite all of these men's pious claims of wanting to stave off sex, their old, philandering ways are so ingrained that nothing could feel more natural to them than to reach out and hold a woman in the most ambiguous embrace. I envied them their unhindered friendships with women. Time after time in *Claire's Knee* we witness Jérôme, a French cultural attaché stationed in Sweden, holding his friend Aurora when he explains to her why he is marrying Lucinde. Jean-Louis, in *My Night at Maud's*, comes uncomfortably close to Maud and then stares into her eyes ever so intensely in what everyone is asked to believe is a sexless moment between a woman who is lying half naked in bed and an ex-womanizer who is now determined to remain chaste. Similarly, Frédéric in *Chloe in the Afternoon* caresses and kisses Chloé in what we are meant to assume is no

more than the physical contact between two Parisian friends who are pleased to speak intimately about their lives.

I missed French intimacy and was suddenly realizing while watching the film how distant was that world from Third Avenue New York, where people always needed "space" and refrained from touching unless they were already lovers. Part of me wanted to think that perhaps this was why I was alone on a Friday night at the movies.

⇥⇤

Rohmer's men inhabit two worlds: the more or less philandering world of their younger days, which they're leaving behind, and the exclusively monogamist life they are hastening to enter. This is what made his films so unusual and what drew me to him at so young an age. His men and I shared more than I suspected, but only if you reversed the equation. They were inhibited because they knew where things went if you didn't stop them; I was inhibited because I hadn't found the courage to let them take me there. They thought as much as I did about the opposite sex, and they, as I, were totally familiar with the paradoxes and ironies punctuating every human impulse. "The heart has its reasons that reason knows nothing of" (Pascal). I liked their disabused, almost blasé, frank, and frequently self-indulgent yet unsparingly shrewd and canny insights into desire and human nature; they spoke my language if only because they resisted the commonplace and, instead, provided a skeptical view of conventional notions prevalent during the late 1960s and early '70s. I also liked that they, as I, balked before temptation. But they balked because they chose to fight it; I

balked because I didn't know how to yield to it. They were try-
ing to evade a woman's advances; I was trying to spur them on.

But there was one unassailable difference between us. Their
knowledge came from experience, mine from books. They were
tired of the same landscape; I had scarcely traveled in it. What
bound us—superficially, perhaps—was our bookish love of the
French *moralistes* of the seventeenth century who read human
nature in the key of paradox. Everything Rohmer's characters
say goes against the grain. They may be tirelessly unscrambling
the makeup of the psyche and are constantly out to steal elu-
sive insights into themselves and others, but their rarefied and
polished probes are frequently the product of a form of self-
deception that is not easy to pinpoint because it is couched in so
much eloquence. I knew enough about contradiction to see that
what I envied in these adults was more than simply their knowl-
edge of the world or their profound distrust of appearances; it
was the ease with which they assumed that identity was a tangle
of contradictions that are held together by cadenced phrases.
Rohmer is a contrarian. I was a contrarian. I loved seeing it in
someone else. I wasn't sure what the connection was between
us, but I knew there had to be one.

Rohmer's men lived in Western Europe in a style I longed to
copy and that took me back to Monet's house on the hill, to my
grandmother, to me and the walks through tall grass, to those
endless afternoons of leisure, comfort, and ease—it was all
there. Jérôme himself owns an old house surrounded by trees
and wild growth; this, as he tells Aurora, is where he used to
spend his summers as a boy. I, on the other hand, lived with my
parents and held a part-time job in a machinery shop in Long

Island City. Jérôme was a touch foppish and smug, but he was perfectly accomplished, held the perfect job, was perfectly well traveled, looked perfect, and had perfect friendships and a perfect girlfriend who was soon to become his wife; in short, he led the perfect life. He even wore perfect clothes. What he wore had so impressed me that, after seeing *Claire's Knee*, I desperately tried to find a shirt like his. When I did find it, it cost me a fortune. Wearing it, of course, made me feel that I already belonged in Rohmer's world.

But there was one thing I envied even more. It was the ability of Rohmer's men to speak to women about things most men are reluctant to disclose to themselves or to other men, much less to a woman. I loved the idea that one could speak so openly and so freely to women about the things that mattered most to me. To feel totally exposed with a woman is like having one's clothes removed but without passion veiling our avowals. Our candor must be a touch difficult, awkward, embarrassing. Which is why romance in Rohmer is always passion served chilled.

There is a moment when Jérôme takes the novelist Aurora on his motorboat and lets her visit his family's property, which he intends to sell. There he explains that, except for Lucinde, he has become indifferent to all other women; in fact, the physical aspect of love no longer moves him. One is tempted not to take him too seriously, but then he goes on to tell the sixteen-year-old Laura, who is Claire's stepsister, that if he is now resolved to live with Lucinde, it's because he still hasn't gotten tired of her. His reason for marrying Lucinde, as he tells Aurora, is quite simple: despite all their efforts to break up, he and Lucinde keep getting back together, and therefore—as though logic governs

these matters—they have no choice but to stay together and comply to fate.

Jérôme's thinking may itself strike one as a piece of casuistry; it alerts the viewer that, for all his cunning observations into what moves people to seek others, this man who is so good at catching self-deception in others, and who discusses with Aurora how all protagonists in novels wear blindfolds, is himself supremely self-deceived. Aurora greets his argument with forbearance and skepticism, but she doesn't refute his claims. Part of leading a perfect life, it seems, is to have found all manner of shields to ward off the suspicion that things may not be as perfect as one might wish them to seem.

Aurora, the novelist who is still struggling to come up with a plotline for her latest novel, encourages Jérôme to flirt with Laura to help her see her way through the novel she is writing. He'll be her guinea pig. Together, secure in their little world, Jérôme and Aurora begin to concoct a devious plan to test whether Jérôme can indeed seduce the sixteen-year-old Laura or, more accurately, where such a seduction might lead. Their complicity and heartfelt intimacy are just a touch less mischievous than the letters of the Marquise de Merteuil and the Vicomte de Valmont.

Still, the project is a trifle too raw. And this exposes a dark fault line in Jérôme, which suggests that, despite his elitism, his good standing, his patina and status as a career diplomat, his pithy, wise observations, his privileges, his women, his house on the lake, his boat on the lake, his childhood on the lake—despite all of these here is a man who might be undergoing an acute midlife crisis, the visible signs of which elude him completely.

And yet on the surface, all is safe and all is well in Jérôme's lakeshore world.

Until Claire enters the scene.

→>←<

There will always come a Claire in Rohmer's universe. Unlike Laura—Claire's stepsister, who, for all her discerning observations about her emotions, is still awkward at sixteen—the slightly older Claire is perfect. She is beautiful, poised, blond, smart, graceful, patrician, and ultimately forbidding and unattainable. The Claires of this world always have a boyfriend who is himself so handsome, athletic, and self-possessed that no one can challenge his hold on her. Claire's attitude toward Jérôme, when she meets him, is neither discourteous nor hostile; her greeting is civil, but only civil, and therefore nonchalant, indifferent, and ultimately a touch dismissive.

Jérôme is not smitten, but he is, as he says, definitely intrigued. His attempts at the most trivial conversation with her fall flat, and during a Bastille Day dance, when he tries to ask her to dance with him just after she's finished dancing with Gilles, her beau, she turns him down. He is, perhaps for the first time in a long while, reduced to the role of a middle-aged wallflower.

But he is experienced enough not to take this amiss. He is, as he'd told Aurora much earlier, "through running after girls." Still, when he and Aurora speak again, he admits he is *troublé* by Claire.

"I think I might have some problem talking to her."

"She intimidates you," says Aurora.

"She intrigues me," he replies. "With girls like her I feel completely powerless."

"I'm amused that you admit being shy."

"But I am very shy," he repeats emphatically. "I've never run after a girl when I didn't feel she was already favorably disposed."

"How about with Claire?" asks the intrigued Aurora.

"Well, it's very strange. There's no doubt she does arouse a very strong desire, one that's all the stronger in that it has no purpose, no goal. Pure desire, a desire for nothing. I don't want to do anything about it, but the mere fact of feeling this desire bothers me. I thought I was past feeling desire for any woman except Lucinde. And to make matters more complicated, I don't want her. If she threw herself at me, I'd turn her down."

One can once again hear the wheels of sophistry churning. He is clearly attracted to Claire but is unwilling either to own this or to do anything about it. He would probably not get anywhere with her if he tried and may be scrambling to find a way out with his dignity intact. Still, his ability to parse his perplexities with this strange mix of probing candor and shameless self-delusion puts him on the same level as the other characters in the film, with the exception of Claire herself and her boyfriend. The young Vincent, who clearly has a crush on Laura, alleges she is not his type; Laura herself frequently makes totally high-minded pronouncements about her own feelings; and then there is Aurora, who justifies being single because she finds all men attractive, so why settle on one. ("Fate insists on putting nothing in my path, so I take nothing. Why struggle against fate?")

But to call this self-deception or sophistry may be inaccurate. These characters are at once quite guileless yet so unsparingly insightful that they teeter on self-deception without necessarily falling into it. There is a corrective at the end of every

Rohmer film, a moment when one character or all of them are summarily disabused of their illusions. Rohmer's characters are intellectually slippery; one can't quite tell whether they're covering up their insecurities or have perfected the art of spying into themselves and have intercepted and then snuffed out every nuance of raw desire. When Jérôme asks Aurora if she has someone, her answer is neither ambiguous nor necessarily self-deceived: "I have no one," she says, "but I am not in a rush. I prefer to wait. I know how to wait. I like waiting." Jérôme's hasty reckoning of his conquests seems similarly straightforward: "Whenever I've desired a woman, I've never gotten her. All my conquests have come as a surprise. Desire followed possession." Rohmer is a contrarian. Everyone in his films thinks counterintuitively, perhaps because there is more truth found in the counterfactual vision of things than in the rational understanding of them. Desire is supposed to come before possession, not after. And as for waiting, no one likes to wait. And yet this is how Rohmer's characters read life: in the key of paradox, which is another way of saying by unsaddling, or at best by questioning, what we think we know. Rohmer's vision operates by inversion. Apparently nothing is of interest to Rohmer unless seeded in Pascal's perpetual reversal of the pro and the con (*renversement perpétuel du pour au contre*).

And this is precisely what made me love Rohmer. He is constantly deflecting, displacing, and deferring the unavoidably obvious, because at the heart of his aesthetic is an almost perverse resistance—call it a recoil vis-à-vis the alleged hard-and-fast realities of life. Indeed there was something reassuring and comforting in Rohmer's counterintuitive pronouncements that seemed to go against the idea, so prevalent during my younger

years, that only willing an outcome could make things happen, that willing was everything. Rohmer's characters, on the other hand, put their trust in fate, in the adventitious, the accidental— *hasard*. If our internal makeup is guided by things that do not make sense—paradox, contradiction, whimsy, impulse—the external events of life are equally guided by what makes no sense: hap, serendipity, coincidence. But there is an uncanny logic and meaning to the vagaries of emotions, as there is to seemingly nonsensical hap. The serendipitous is never without purpose and, like the subconscious, is a marker of an intention somewhere that knows what we really want from life. To parody Pascal, hap has a logic that the will knows nothing of. Rohmer's belief in reason is sophisticated enough to distrust reason.

<p style="text-align:center">→►◄←</p>

And this is where the knee comes in. Jérôme had watched Claire's boyfriend place his hand on her knee. It was a lame, mindless, stupid gesture, he thought. He himself had almost grazed his face against her knees when she was standing on a ladder picking cherries from a tree. But from these two observations springs the sudden realization that what he wants from Claire is not her body, not her heart, not her love; what he wants is her knee, nothing else. Call it curbed desire. Jérôme now could tell himself that he would not have given Claire another thought were he not spurred on by Aurora, whose novelistic intrigues urge him to explore the situation first with Laura and then with Claire. If he feels emboldened enough to proceed, the idea that he is playing

a game under Aurora's sponsorship provides the perfect ex-
cuse to continue to let himself think of Claire without sus-
pecting he is pining for her.

In fact, by accepting his role as a guinea pig in Aurora's
experiment, he has banished all his doubts about his own cour-
age and overridden his inhibitions and self-proclaimed shyness.
Jérôme is now free to pursue Claire without feeling he is in any
way implicating himself. To his mind, he is (a) operating under
Aurora's guidance and (b) asking absolutely nothing of Claire.
He just wants her knee. This should exorcize his desire for her
altogether.

By allowing Jérôme to approach seduction as an experiment,
what Rohmer has done is remove the sting of insecurity and
splenetic self-blame that every man feels each time he goes after
someone and fears he'll fail. Self-hatred was something Rohmer
had explored in a much earlier film, *The Sign of Leo*. Now he's
replaced it with guile, mirth, and mischief. I too was eager to
dispel any form of self-blame from my life. If Jérôme fails in his
stratagems, he has one last card to play: namely, his repeated
admission to Aurora that each time he desired a woman, he
never obtained her. All his successes came to him by surprise.
Casanova he never claimed to be.

All he wants is Claire's knee. The question is not why her
knee, but why only her knee?

The allegation—and that's all it is, an allegation—is that ev-
ery woman has a vulnerable spot. It could be her neck, her hand,
her waistline, or, in this case, her knee. The idea that the body
of a woman can be reduced to a particular "vulnerable" spot or
magnetic pole of desire, as Jérôme calls it, is, of course, absurd.

No such spot exists. Or maybe it's just that Claire's knee caught his attention more than anything else. But the theory of its significance allows him to pinpoint the exact coordinates of the siege he plans on Claire's body. It also allows him to limit his hopes, since he already knows, given the age disparity between them and her own clear indifference to him as a man, that she will continue to remain off-limits and impregnable.

What he's done is to displace the woman and substitute her knee for her body, the part for the whole—pure synecdoche. He has sublimated all desire by singling out the knee and ignoring everything else, thus essentially fetishizing the knee.

The opportunity to gratify his wish comes in the form of the most contrived, flat-footed gimmick: rain. This is typically Rohmerian. It was snow in *My Night at Maud's* that kept Maud and Jean-Louis in the same room; here, rain comes to the rescue. As Jérôme and Claire are traveling in his motorboat on an errand, the fear of a sudden downpour forces them to land and take shelter in a boat hangar. There, as it's raining, he tells her that he's just seen her boyfriend with another girl. This makes her cry. He attempts to comfort her as she is weeping, and, finally, having mustered all the will and courage needed, places his palm around her knee and caresses it, again and again. She must have taken it as a gesture of consolation; for him it was nothing but a gesture meant both to satisfy Aurora's prodding and to quell what could have been a furtive whim passing for desire.

The explanation and the description of how he placed his hand on her knee and her passive reaction to his touch followed by his own reading of her non-response is filled with subtle turns and counterturns and remains a classic of a genre

of French fiction called the *roman d'analyse*. It could have been written by Madame de La Fayette, Fromentin, Constant, or Proust.

> Anyway, there she was, seated across from me, and there, too, at arm's length, was her knee, that smooth and shining, delicate, fragile knee. So near and yet so far. So near I could have reached out and touched it; so far because it was so unattainable. So easy, yet so impossible. It's as though you're on the edge of a cliff, and you know all it takes is one step and down you go, and even if you want to, you can't. So I put my hand on her knee; it was a rapid, assertive gesture that gave her no time to react. All she did was look at me—indifferently, I think; in any case, with hardly any hostility. But she said nothing. She didn't remove my hand; nor did she move her leg. Why, I couldn't say. I don't understand. Or maybe I do. You see, if I had tried to caress her hair or forehead, she would certainly have reacted with some classic, instinctive gesture of self-defense. But what I did took her by surprise. She probably assumed it was the initial tactic of an assault that was to follow. And when it didn't, she was reassured. What do you think of that explanation?

Although Jérôme's narrative bears all the marks of a predatory mind-set, he is so blinded by his own intentions that he even manages to justify his behavior to Aurora by congratulating himself for rescuing Claire from a boyfriend he considers unworthy of her. The irony is that he performed no good deed at all. Gilles turns out to be a good boy who was most likely not

doing anything unsavory when Jérôme thought he'd caught him betraying Claire. In typical Rohmerian fashion, every sure resolution is right away undercut by the appearance of a new fact that forces new interpretations, which may be subjected to subsequent revisions themselves.

And so the film ends with Jérôme leaving to marry Lucinde, totally persuaded that he's done Claire a good turn.

→>—<←

I wrote all this while at Yaddo, in Saratoga Springs. Yaddo is a writers' retreat, and as I sat meditating about all this and looking out at the dazzling greenery all around me, my thoughts went back to Aurora, who is herself spending time in Madame Walter's house on Lake Annecy to write a novel. Her desk sits on a balcony overlooking the magnificent scenery, and if you look closely enough, you can spot pages and sheets neatly stacked on her table. On looking at her desk and at mine, I was reminded of my days at our old house when the sea was too rough and my mother would decide not to take us to the beach. These for me were heavenly mornings, for all I wanted to do then was sit on our balcony at a tiny square table my mother had placed there just for me and either paint or write. My mother would sometimes drop by to remind me that the weather hadn't turned out as badly as she feared, so why not think of heading to the beach. But being reclusive by nature, I preferred to stay home. The boys and the girls my age at the beach left me feeling very anxious; I liked home better. *Hiding*—that's what it's called, my father said. Perhaps he was right. I was always slipping away, always belonging elsewhere. The real world with its real people who lived

here-and-now lives weren't really for me. I was like the moody, solitary Laura in *Claire's Knee*. I wanted to be like Claire— everyone else was like Claire—just as I know that every man wants a Claire in his life, or, better yet, everyone wants to be like Claire, but no one is, not even Claire. Everyone wants to be Jérôme, and no one is either.

We knew at the time I painted or wrote on my tiny balcony abutting our dining room that we were never going to summer in that house again. So at school the following autumn, when I spotted the picture by Monet, I was right away taken back to a house I already felt was as good as lost. Our summer house was not two miles away from where we lived in the city, but I never returned to it. Even back then, it bore the stamp of something lodged forever in the past. Today, I have no picture of the house. Only Monet's rendition.

But I returned to it in 1971 while seeing *Claire's Knee*. Jérôme, after all, is himself returning to the house where he spent all his summers as a boy, and he too is abandoning it before moving to a better life in Sweden. He feels no nostalgia; he's simply moving on. So confident, so well spoken, so clever, even when he's completely wrong, not only about Claire but ultimately about his alleged love for the woman he is to marry.

Two years after seeing *Claire's Knee* I went to see it again when I was in graduate school. It was during the spring, and I was writing a paper on Proust, but I was really drawing on Éric Rohmer to speak about Proust. Each time I lifted my eyes and looked out the bay windows in my dorm's living room, I was trying to see not the moonlit trees of Oxford Street but the mirage of a nightscape on Lake Annecy. I had a girlfriend at the time, and she would drop in, brew tea in my living room, and, wearing

a light blue bathrobe, sit in an old armchair and read the latest draft of my paper. Later, when my roommate at the time would leave to spend the night working in his studio, we would make love. I'd been to see *Claire's Knee* with her once. She'd uttered a laconic statement about it but added nothing more.

Four years later *Claire's Knee* was playing somewhere at the university that spring. So a group of us went together. Then we had drinks in a bar and spoke about the film. One of my friends claimed he had just had a Rohmerian encounter. "What's that?" I asked. Man meets woman on a train. They chat. They're enjoying the chat. No need to rush things, each thinks. Then they chat about meeting on a train and chatting about not needing to rush things. Are we flirting, one of the two finally asks. I'm not sure, but we might be. Perhaps we really are, says one. Then probably we are indeed, adds the other. That night they don't sleep together. But he calls her in the middle of the night and says I can't sleep. I can't sleep either, she says. Is it because of me? Maybe. Is this really happening? I think so. I think so too.

"That's just meta-dating," I said.

"But that's what Rohmer is, don't you think?"

He was right, though not quite.

But as I was nursing my drink among such good friends, I tried to put together the history of the film in my mind: how it took me back to my first sighting of Monet, which was now permanently laced into the memory of our home by the beach, and how this too was tied to my seeing the film in 1971, which took me to my college days, and to my grandmother whom I'd gone to visit in France that summer and who had since then died, and I thought of all the times I'd seen Rohmer's films again

and again since 1971, especially on Sunday evenings with other friends in a small church that charged a dollar a ticket—all of it is so braided that I could no longer and still cannot sort apart the strands of time. Then suddenly at the bar I remembered my girlfriend in her bathrobe. She too belonged to a strand of time. "The film is so simple," she'd once said. "It's about a man who wants a woman but is happy to have just a part of her because he knows he can't or shouldn't even presume to have her. It's like wanting a whole suit and settling for a swatch of cloth."

But then it occurred to me that the film is also about something else: it's about the friendship of Aurora and Jérôme, who are frequently sending each other vague allusions about their friendship that could so easily morph into something else but that won't because neither probably wants it to or dares to think it might.

The whole film was never about Claire's knee. What a red herring this was. The film is about the ever-intimate conversations between Jérôme and Aurora, which are entirely reminiscent of that one-night extended dialogue between Maud and Jean-Louis. The Rhomerian encounter was between Jérôme and Aurora, and no one noticed, not even the two of them, that theirs was no platonic love at all.

But the film was also about me, except that I couldn't tell this to my friends, because I wasn't sure it was or that I was entirely grasping this myself. It was about the me I might have become had I continued to live in that house on a hill a few steps from the beach. I was seeing who I'd have been in the person of the actor Jean-Claude Brialy, and the best way for me to understand what was happening between him and me was to see myself as versions of him, the me I might have been but hadn't become

and wasn't going to become but wasn't unreal for not being and still hoped to be, though I feared I never would. The irrealis me. I'd been groping around this for years.

If I liked Rohmer's contrarian insights and counterfactual view of the world, it's because neither he nor I was ever quite at home in what everyone else called the real, factual world. We were making up another world with what was good about the world we knew. I was making mine up with driftwood from his.

EVENINGS WITH ROHMER

Chloé; or, Afternoon Anxiety

The last time I saw *Chloe in the Afternoon* in a movie theater was in February 1982. After that I watched it countless times on TV or on a computer monitor. Over the years, however, those small-screen viewings left no impression on me and melded into a sort of disembodied mush. Perhaps I'd seen the movie too many times; I can't remember anything about even a single home-screen viewing. There might be a reason for this. We can study a film more closely on a computer, but we can't let the film take over our lives or our imagination. One has to be overpowered and kept in complete thrall in a large, dark hall to let a movie do what it is supposed to do: take us out of ourselves and borrow our lives.

I remember this last screening perfectly, because it occurred on the very day that I'd lost my job, which was why I was free to see a film that weekday afternoon. I called a woman with whom I'd been desperately in love for four years, and together we went to New York's Alliance Française. She wore boots, she wore a shawl, she wore Opium. In the movie theater we ran into my

father and his friends; they had just seen the same film earlier that afternoon. I was happy finally to have the opportunity to introduce her to him; I introduced her as my friend—because this was what she was, a friend. She knew I was still in love with her, my father knew, even the man who was also fired that same morning and who was my best friend and remained so even after marrying her—he knew it too.

Four years earlier I had made a pass at her, but she had turned me down—brusquely. Two years later, it was her turn to make a pass; to my shame I didn't realize it was a pass until she told me so, three days later. By then it was too late, she said. I never recovered from this. Perhaps neither of us did. So there we were, two ex-lovers who'd never been lovers, forced to be friends without really caring to be, yet neither daring—while possibly wishing—to be other than just that. Perhaps friendship was all we had to give. Perhaps ours was an unhappy medium lodged between a might-have-been that never was and a could-still-be that didn't stand a chance.

I was uneasy watching the film with her. A film about afternoons seen in the afternoon. This was about us, I thought she thought. The plot couldn't be simpler. A woman, Chloé, turns up in Frédéric's office one day completely unannounced. They had a friend in common years before and knew each other very slightly. He isn't too pleased by her visit but remains distantly cordial. A few days later, she reappears, almost as though she'd been encouraged to do so. With the passing of weeks and her frequent reappearance, Frédéric, who is happily married, will eventually want more than friendship with Chloé but has no clue how to ask for it without compromising himself, nor is he

so sure that he even wants the friendship, much less the no-strings-attached sex that she is so clearly offering him. He may, in fact, want nothing at all from her. But he finds himself cast in the awkward position of someone who should want something but really doesn't, and he can't bring himself to tell her so, especially when he sometimes catches himself wanting it.

Besides, the film, as all Rohmer films were to me then, was not about friends who could become lovers or lovers who prefer to stay friends, but seemed to probe some amorphous condition that I was plenty familiar with: namely, that strained, frequently uncomfortable middle mist that hovered between friendship and sex where one is too reluctant to move things one way but not particularly eager, or encouraged, to move them in the other. There might be a third choice, but it has no name, and no one knows where or how to look for it.

It would have been too Rohmerian for us to even broach the subject of our hazy friendship and air out its history, its uneasy turns, maybe even its bruises. Without quite knowing it, perhaps, I had taken her to see this film in the unavowed hope that the movie might do the talking for me, push things along, force us to open up what we'd been so silent about, maybe even bring things to a crisis. It did not. Nor did we let it.

In the end, it was safer and more accommodating to ignore the theater armrest where both our elbows touched in the dark. One look and we both knew why we were so quiet.

It was nighttime when we walked out of the theater. There was nothing we wished to add or say about the film. We walked up Third Avenue to a small Chinese restaurant in the low eighties, where we had dinner. Then I put her in a cab, and she went

back to her place. Later that same week I called to ask if she wanted to go to the movies again. She said she was going away that weekend. We did not speak again for a whole year.

It took me a week or so to realize why what we had was not and could never be Rohmerian. To be Rohmerian, a situation has to occur between a man and a woman who are essentially strangers; they may have met a couple of times before or had a few friends in common, but they were never close and had no interest in being close. As always in Rohmer, what brings them together now is nothing short of serendipity. Someone may have introduced them over dinner. Or both happened to be accidental summer guests in the same villa by the beach. Or, as in *Chloe in the Afternoon,* one decides to look the other up for no real reason, perhaps out of sheer ennui and whimsy. But the ice breaks, and suddenly they find themselves enjoying each other's company, even if reluctantly and without the remotest expectation that their friendship is headed anywhere. They both know that whatever light was kindled between them has a very short life span and that the two will more than likely soon become complete strangers. They are like two passengers who happen to sit next to each other on a train and who find themselves almost playing at flirtation simply because the situation seems to call for it, or because, despite having no ulterior motives, they don't know how else to behave. Something could come of this, but chances are that nothing will. Frédéric is very happily married and very much in love with his wife, Hélène, and Chloé is far too erratic and freewheeling to want to settle down in a long-term relationship with a married man. But the game is tempting, and they find themselves confiding truths about themselves that they'd never have the courage to confide to those they claim to

have no secrets from. Candor and boldness exist not necessarily between people who are intimate, but between two individuals who scarcely know each other and find it easier to confide intensely private details precisely because they might easily never meet again.

My friend and I were not strangers. But we were not intimate either. Watching Frédéric shuttle between his wife and his would-be mistress reminded me that we too were caught in an emotional no-man's-land, except that ours thrived on silence and oblique hints, while theirs floated between amicable candor and a disabused sense of where things were unavoidably headed. They speak without blushing, without faltering, without ever feeling awkward or uneasy. When they're drawn to kissing, he tells her about the wife he loves. She scorns his pieties and reluctant caresses and reminds him that, contrary to what he fears, his wife doesn't have to know.

The two like putting their cards on the table and telling each other that, though they may not be particularly interested in each other, they are by no means indifferent. She'll eventually tell him she is in love with him but that all she wants is a child from him. He finds her very attractive but on more than one occasion can't help bringing up his wife. What makes their situation so unmistakably Rohmerian and so totally unlike mine is that they are completely dispassionate about each other. I wasn't dispassionate but wished to think I was. One day, I kept hoping, I would be able to sit over lunch with her in a French café in Manhattan—it would have to be French—and go over the story of our lapsed faux-something-or-other love-friendship as blithely as the two would-be lovers do in Rohmer's film.

As with *My Night at Maud's* and *Claire's Knee*, what I contin-

ued to admire in Rohmer's men was that speaking about what they want or do not want comes not, as many think, *after* intimacy, when one tends to open up more freely, but *before* physical contact is even a possibility. Verbal intimacy trumps physical intimacy each time—which might explain—just *might*—why consummation does not occur or isn't even sought. Rohmer's characters may have no problem with desire—they always have a desired someone else (Françoise instead of Maud, Lucinde instead of Claire, Hélène instead of Chloé, Jenny instead of Haydée in *The Collector*)—but emotional clarity and, better yet, verbal clarity always take precedence. There is something almost unbearably bold in how Rohmer's characters not only refuse to veil their feelings and intentions but rather go a step further and clearly enjoy the deliberate and near-libidinal manner with which they expose their desires, their doubts, their ploys, down to their shameful subterfuges, to the very persons who stir their desires and subterfuges.

I had often been in the habit of using friendship to draw closer to women. When contact was not easy, I found myself concealing my desire or couching it in ambiguous terms or silencing it altogether. Rohmer's characters trust language, partly because they do not like to let passion cloud their judgment or their ability to speak it, but also—conversely—because language almost always helps them conceal their true motives, mostly from themselves. In *My Night at Maud's* Jean-Louis may deliver a very persuasive speech about his newly embraced Catholic faith, but in the morning, still fully dressed and in bed with Maud, his body flouts all his moral protestations of the night before.

Still, even when they are totally deluded, the ability of

men and women to speak the most elusive, awkward, bare truths to each other is never an act of confrontation, which is antisocial—and Rohmer's universe is far too placid and tactful to be anything remotely antisocial. Instead, it is an act of penetration. *Pénétration*, which is the French word for insight, not only flatters everyone's intelligence but frequently sees things through a prism that is slightly paradoxical or anti-doxological and is best suited to explain our behavior and our desires to ourselves and others. It is a medium not of seduction but of exposure. If the word *pénétration* harbors another meaning, perhaps this is not entirely coincidental: it suggests that the pleasure of reading or intercepting or spying into one's own or someone else's psyche is itself irreducibly erotic and libidinal. It may explain why the pleasures of insight and exposure in Rohmer almost always deflect those of the flesh. It also explains why candor can be so clever and so sexy.

Here is Frédéric's internal monologue about his feelings for Chloé. It is drawn from the book version of *Chloe in the Afternoon*.

With Chloé I feel oddly at ease. I confide in her as I have never confided in anyone, even my most secret thoughts. Thus, instead of repressing my fantasies, as I used to do, I have learned to bring them out into the light of day and to free myself from them . . . I have never before been as open with anyone, least of all with the women in my life, with whom I always thought I had to put up a good front, to wear the mask I thought they wanted to see. Hélène's seriousness and intellectual prowess have led me gradually to keep our conversations on a superficial level. She likes my wit, and a kind of mutual modesty has grown

between us, a tacit understanding to refrain from discussing anything we feel really deeply about. Probably it's better that way. This role I play, if indeed it is a role, is in any case more pleasant and less stiff than the one I played when I was going with Miléna.

About his wife: "I don't love my wife because she's my wife," says Frédéric, thinking he has finally grasped the essence of his relationship with his wife, Hélène, "[I love her] because she's the way she is. I'd love her even if we weren't married." To which comes Chloé's totally chiding retort: "No, you love her—if you love her—because you think you have to."

There is nothing as disarming and as enchanting as this back-and-forth between Rohmer's characters. They are intelligent, and even when they are smug and speak their delusions, there is always a touch of brio and brilliance in these exchanges.

The love of insight may, in the end, be more compelling, more libidinal, than love itself.

If Freud was fierce when stripping the human psyche of its myths and illusions, Rohmer's gesture is tamer and perhaps more forgiving; it not only turns divestment of illusions into an art form, it simultaneously rehabilitates our illusions by giving them a new face, a better mask. Yet no one is fooled.

>-><-<

The last time I'd seen *Chloe in the Afternoon* before this was a few months earlier. I was alone late on a weekday afternoon in early fall of 1981 at the Olympia Theater on 107th Street and Broadway. The Olympia does not exist any longer, and

neither does the 68th Street Playhouse, where I'd originally seen *Claire's Knee* and *Chloe in the Afternoon* in the very early 1970s. Autumn 1981 was an exceptionally lonely period for me. I had just moved back to New York after eight years in graduate school and felt totally rudderless, with no degree, no career plans, no money, and not a single friend in the city.

I had gone to see the film because I had absolutely nothing else to do that day, but also because I wanted to nurse the illusion that I lived in Europe, preferably Paris, and that I had a successful career, maybe even a wife and a family. Nine years earlier, the film had given me the image of life in France. Now I was as old as Frédéric. My life had no script; everything had stalled to a halt. And I didn't want to be on the Upper West Side. I had promised my mother I'd attend her Rosh Hashanah dinner that evening, but I was in no mood to celebrate anything. So I sat and watched the romance of a man who is so thoroughly pleased with himself, his life, and his prospects that he ends up turning down a woman who is basically offering herself to him with a lot of affection, if not even love.

When I left the movie theater I felt more solitary than ever, and the dream bubble that envelops us as we walk out of a film theater burst the moment I spotted tiny, desiccated Straus Park across the street. Broadway at that time of the evening, and in those years, was dirty, with homeless people sleeping in makeshift corrugated cots just about everywhere along the sidewalks. Not a sight to compare with my imagined Paris.

I had walked out hoping to be enveloped by something I'd taken away from the film, a sort of residual incandescence that might add cinematic luster to my drab autumnal evening. I wanted a state of reverie to blossom between the film and me.

But nothing like this happened. All I could do as I walked home was to measure how distant too was the first time I'd seen *Chloe in the Afternoon* in the fall of 1972. By then I had met a few women, loved and been loved by some, and even lived with one for a while. But when she settled in Germany during her junior semester abroad, we broke up. Faculty and friends at my school knew we'd been living together and kept asking about her. She's spending the semester in Germany, I said. Then they stopped asking, and I couldn't understand why.

During that fall semester, my last in college, I had arranged to have my Tuesday afternoons free from work. One Tuesday, I walked up Third Avenue and headed to the 68th Street Playhouse. I would see the film by myself. As usual, back row, cigarettes at the ready, and a small notepad in case ideas sprang to mind. I'd just bought a new sweater that afternoon and was pleased with the flirtatious banter that had blossomed between me and the French salesgirl in a boutique on Sixtieth Street between Second and Third Avenues. I knew I'd paid a lot for the sweater, but I liked the sweater, liked the scent of wool, and I liked the girl. Even if I knew that nothing would come of our short badinage, still, the possibility of talking with so beautiful a woman in French had pleased me. I even liked the residual scent of the store on the sweater.

It was November 1972, and I felt good about myself. A dark cloud would race over me each time I'd think of my ex traveling in Munich and Frankfurt or wherever her jaunt through Germany took her every weekend. But I knew I had to be good to myself, so I bought myself a few things that I didn't really need, took time off from various obligations, made new friends, spent a bit, and learned to be alone again. Good things awaited me

that year. I knew I was going to start graduate school, though I hadn't yet decided where. I was long past the insecurities of 1971. I'd also met a slightly older woman with whom I could have a Rohmerian conversation and uncover the intricate folds and mainsprings of the human psyche, particularly in matters of love. Never again the tiresome psychobabble I was so frequently subjected to in the school cafeteria when one girl or another would use me as her confidant and lament the state of her relationship with her boyfriend, when all I wanted was something else.

I came out of the movie theater that first time in 1972 feeling at once chastened and awed. Once again, here was a man who had said no to a woman because he was honest enough to know that no man needs to say yes simply because a woman's taken off her clothes. His masculinity was never threatened, never questioned. He could speak frankly, because nothing he said might diminish or hurt him.

That he chickens out and slinks away without explaining himself to Chloé or saying goodbye—well, that's another side that doesn't quite jibe with the candor I so admired and envied in Rohmer's men. It might turn out that the famed Rohmerian encounter is itself a delusion, a mask, a fiction that ends no less accidentally than it started. Frédéric slips away down Chloé's stairway while she's waiting for him naked in bed; Jean-Louis leaves Maud's apartment very early in the morning after she snubs his indecision, Adrien drives away when it seems that Haydée is almost ready to be his lover, and Jérôme, having found the ultimate substitution in *Claire's Knee*, drives off in his motorboat after getting what he wanted. It is not only that their sexuality is dispassionate; it is almost entirely incorporeal.

Behind the ease with which people touch and make themselves available for sex, what struck me was the implicit difficulty behind sex. There was a sort of reluctance on the part of each film to let sex happen as easily as the story clearly seemed to promise.

Which raises the issue of what these men are truly like behind their perfectly fulfilling personal and professional lives. Are they asexual? Is sexuality being put indefinitely on hold? Are human relationships simple formalities? In their relationships, theirs is a world where nothing is really staked—not the heart, not the psyche, not the ego, and certainly not the body, which is another reason why they talk so freely, and why rejection is neither anticipated nor feared. If it happens, it rolls off their shoulders, because in the eighth arrondissement, or in Annecy, or in Clermont-Ferrand, passions are so rarefied and etherealized that there is not even room for ego or pride or what the French call *amour-propre*. *Amour-propre*, that bête noire of La Rochefoucauldian psychology, which loves nothing more than to hide its wiles, the better to keep us under its thrall, is still very much there, just hidden. As La Rochefoucauld knew so well, sometimes our ego lets us catch a glimpse of its own machinations simply to flatter what we mistake to be our ability to penetrate its guile. Thus, Rohmer's men do not know insecurity and self-doubt; they have no amorous or material worries, and everything comes easily to them. And though Frédéric's former classmate whom he runs into one day blithely admits to suffering from a form of afternoon anxiety syndrome

(*angoisse de l'après-midi*), most likely, as he claims, caused by luncheons, Frédéric counters by saying that he keeps his "anxiety in check—if anxiety it is—by running errands." Both men, it turns out, have managed to keep their masculine poise and egos intact.

→>⋅<⋅

Twenty years after my last viewing of this film, on my computer screen at home, the girl I'd once dated during my senior year in college dropped by my office. "I knew you'd put me off if I simply called and said I wanted to see you again," she said, "so I decided to drop by during your office hours. These are your office hours, aren't they?" I could tell she had already called and asked my secretary. "May I sit down?" She sat down. "And by the way, just to ease your mind, I want nothing."

"Did I say you wanted something?"

"No, but I know how your mind works. So, no surprises, no thirty-year-old bugaboo waiting to make its grand entrance to call you da-da. I simply wanted to see you."

I took this in. "To see me." I repeated her words, with a touch of intentional incredulity, if only to give myself time to come up with what sort of attitude to strike.

"Nice to see you too."

"I've thought about you," she said.

"I have too. On and off."

"More off than on, right?"

I smiled, guiltily.

There was, it occurred to me, nothing to say. I'd have to make conversation. She told me what she'd done over the years.

I told her about my life. It seemed to me that all she'd done was bum around Europe, while I ended up giving her the impression that my life had been an unerring, straight path. I decided to take her out to lunch somewhere near my office.

And then in the elevator it occurred to me that I was living the film I'd gone to see for the first time just after she'd broken up with me in 1972. I told her about *Chloe in the Afternoon*. She thought she remembered the film, but vaguely. So I did not push the point. I had wanted to tell her that the similarity between Chloé's visit and her own unannounced visit to my office seemed to suggest something beyond synchronicity, and that seeing the film in 1972 less than a month after she had gone to Germany underscored the echoing effect, as if the meaning I had intuited in the film at the time but hadn't quite put into words was less about men and women, less about desire itself, than an announcement of a repetition to come in years to follow. I held her hand and told her how happy I was that she had shown up. We had coffee in a small coffee shop that was half empty at the time, which made me think of France, and I told her so, and it made us happy, and then it suddenly hit me.

Years ago I used to think it might be wrong to think that Rohmer's films were about my life. I was never sure that it was right to read them in light of what I'd lived. Now I realized that these films were indeed about my life, but were more like a template for my life, and that this template would be filled in due time with moments that might once have seemed scattered but were not in the slightest scattered the moment I applied Rohmer's vision to them. I wanted to go back to the young self I was then and tell him that I'd always known the day would come when she'd return, and on that day I'd tell her everything, where I'd

been all these years, what I'd seen, done, loved, and suffered—because of her and others—and that whatever course my life took had in good part started when she fled to Germany. Better yet, I wanted my younger self to be present at this reunion and, having sat him down with us in the small café, to tell him that this moment here, between two ex-lovers who were happy to be together for a few hours and didn't quite know if this was really now or then, was possibly the very best that life had to offer.

ADRIFT IN SUNLIT NIGHT

On an intensely bright morning in late June, I find myself roaming the streets of St. Petersburg, looking for the nineteenth century. I have always meant to roam the city. That's what I thought you did in St. Petersburg. You shut your door, head downstairs, and before you know it, you're wandering to places and squares you never thought you'd be passing through. A guidebook won't help, and neither will a map, for what you want is not just the thrill of getting lost when you stray off the chart and discover corners you hardly expected to find and might actually grow to love; what you want is to drift along the streets in as flushed and jittery a state of mind as everyone does in Russian novels, hoping that some internal compass helps you find your way about a city you've been imagining since your bookish young teens. Stop thinking, shut down everything, and for once go with your feet. This is supposed to be déjà vu, not tourism.

Part of me wants to visit Dostoyevsky's city as it once was. The heat, the crowds, the dust. I want to see, smell, and touch

the buildings on Stoliarny Place and hear the bustle of Sennaya Ploshchad, where hawkers, drunks, and all manner of slovenly people still come close enough to jostle you, as they did 150 years ago. I want to walk along Nevsky Prospect, St. Petersburg's major artery, because it appears in almost every Russian novel. I want to get a firsthand feel for this boulevard that was once peopled by wretched waifs on one end, affluent fops on the other, and in between by a flotsam of petty, hapless, embittered, backbiting civil servants whose only task, when they weren't drafting mindless reports or copying them forever again, was to spend their hours groveling and gossiping and feeding off one another's blighted lives. Call this paleo-travel: searching for what's underneath, or for what's no longer quite there.

I want to see the building where Raskolnikov lived (5 Stoliarny Place), scarcely a block across from where Dostoyevsky himself had lived and written *Crime and Punishment*; the bridge Raskolnikov crossed on his way to the murder on 104 Ekaterininsky (now renamed the Griboyedova) embankment; and, a few steps away, at number 73 on the same street, the place where meek and sweet Sonia, the prostitute, lived. All these places have hardly changed since Dostoyevsky's time, though Raskolnikov's five-story building has four floors now. The house on Stoliarny where Gogol himself lived no longer stands, and the old wooden Kokushkin Bridge, which Gogol's Poprishchin crosses in "Diary of a Madman," is now made of steel.

But it is the crowd and the stultifying bleakness of Sennaya Ploshchad and the unremitting thirst that I seek. These, I realize, would matter less in the end if they weren't inevitably

linked to the angst that comes of solitude and destitution and of wearing such utterly drab clothes—a young man's nightmare, as Dostoyevsky describes it in Constance Garnett's translation of *Crime and Punishment*:

> The heat in the street was terrible: and the airlessness, the bustle and the plaster, scaffolding, bricks, and dust all about him, and that special Petersburg stench, so familiar to all who are unable to get out of town in summer—all worked painfully upon the young man's already over-wrought nerves. The insufferable stench from the pot-houses, which are particularly numerous in that part of the town, and the drunken men whom he met continu-ally, although it was a working day, completed the revolt-ing misery of the picture . . .
>
> Rag pickers and costermongers of all kinds were crowding round the taverns in the dirty and stinking courtyards of the Hay Market.

Everyone has an imagined St. Petersburg. Everyone's life took a sudden turn because of books set in St. Petersburg. Everyone wishes to go back to that disturbing first page when a writer called Dostoyevsky prodded demons we never knew we had and, because of these demons, put loutish noises in our heads and, in the process, gave us the most twisted romance we've ever nursed for a city.

We *come back* to St. Petersburg to recover the forgotten first spark of that unsettling romance—who were we when it took hold of us, and what were we thinking when we allowed it to happen, knowing what it was already doing to us? What we want

is not St. Petersburg as it looks now—though parts have hardly changed. Neither do we want to be dazzled by its avenues and palatial buildings—though you need to have seen these enough times to stop focusing on them. Our inner St. Petersburg will come from the sheer exhaustion of our aimless trundling up and down its streets and embankments, over and across this or that bridge, this park or that island, "without noticing his way" until the oppressive heat and the suffocating loneliness of it all take hold of us and we begin to recall how for a few days we too belonged in *Crime and Punishment*:

> On an exceptionally hot evening early in July a young man came out of the garret in which he lodged in Stoliarny Place and walked slowly, as though in hesitation, towards Kokushkin Bridge.

For a few days or weeks every reader has lived on Stoliarny Place.

→>⋘-

Dostoyevsky's was certainly not the city that Peter the Great envisioned when he wrenched it out of the mud off the Neva River in 1703. From literally nothing he created one of Europe's most stunning cities and made it the capital of Russia, which it remained until the fall of the Romanovs two centuries later in 1917. Peter appointed Alexandre Jean-Baptiste Le Blond to design his new city after seeing some of the architect's magnificent creations in France and conferred upon him the title

Architect-General of St. Petersburg. Simultaneously, he appointed several Italian architects to design palatial buildings like those he had seen on his travels through Europe. Petersburg was going to be Peter's window to the West, but it was also going to rival in grandeur any city in the world.

To build this new port city on the Gulf of Finland, Peter forcibly put Swedish prisoners of war and Russian serfs to work day and night. More than one hundred thousand of them paid with their lives as they pounded piles into the slosh and drained the bogs and carried stones with their bare hands, leaving nothing but their bones underfoot. Peter couldn't be bothered with their deaths. He had big plans. Inspired by Amsterdam and Venice, his city was going to be crisscrossed by canals, but it was also going to outdo Paris and London in splendor and magnificence. To this end, Peter forced all Russian aristocrats to build homes in St. Petersburg—and if they demurred, he'd haul them there by force. The streets were going to be wider and longer and far better planned than any in Paris, with one stately home after the other lining the lavish avenues and canal embankments, each building rising to the same height as its neighbors. Since St. Petersburg did not grow out of a previously existing town, Peter's planners did not have to contend with narrow medieval lanes winding in absurdly circuitous paths. They were able to design a grid layout for the city, with streets and avenues intersecting at right angles, and a central plaza where the spire of the Admiralty Building—St. Petersburg's focal point—would surge and be seen from everywhere.

From that spire, three interminable boulevards would radiate: Nevsky Prospect, Gorokhovaya Street, and Voznesensky

Avenue. All three lead to train stations today, and all three are intersected by canals and three large avenues. The only other city I know that was as symmetrically and as rationally planned is Washington, D.C.—but Washington doesn't come close.

From sketches and cityscapes drawn in the very early 1700s, St. Petersburg was already turning into a sumptuous metropolis. By the end of Peter's reign in 1725, it could boast 40,000 inhabitants and 35,000 buildings, and by 1800 its population had swollen upward of 300,000.

Still, Peter was so barbaric in his mission to civilize Russians that he also managed to create an entire naval fleet the way he'd created the city: from nothing. In the end, and by dint of ruthless, despotic will, Russia was dragged by the scruff of its neck into the modern world, after which there was no turning back.

Instead, many turned inward. Neither the mud nor the buried bones nor Peter's monomaniacal reign ever went away. They are seared into the city, for St. Petersburg internalized both the frightful tyranny of the tsars and the smoldering dissent it stoked. In literature, wraiths and nightmares and distorted, demonic thoughts seep into a landscape where repression and flight are forever wrangling at cross purposes. Nevsky Prospect may be one of the longest and most polished boulevards in Europe, but as so many characters in Gogol and Dostoyevsky discover, it just as easily chokes every human impulse that it stirs. Love, envy, shame, hope, and, above all, self-loathing scavenge the sidewalks. Shoo one, and it plays tricks on you; try to seize the other, and it shoves its ghost at you. Here, as everywhere in St. Petersburg, you can make out the grieving resentment that finally gives birth to either madness or revolution or both. "I am a sick man," says Dostoyevsky's underground man.

"I am a spiteful man. I am an unattractive man. I believe my liver is diseased." No one is the same after reading this. No city can be whole after this. We take sneaking peeks at its subconscious, the aching, bruised, damaged, self-hating, tormented subconscious that it lays bare before us like those defunctive tramway tracks that continue to furrow so many streets and avenues that no longer have any use for streetcars. The rails still stare at you, refusing to sink underground, the way so many things continue to show up even after they've been covered up here. Nothing goes away.

Take the weather, for example. On winter days, darkness descends much too soon on Nevsky Prospect, and the freezing wind sweeps in from all sides and then gathers up hellish speed down the avenues, because the brilliant city planners of St. Petersburg failed to remember that a chill wind loves nothing more than long urban canyons and thoroughfares.

Or take the river Neva itself. It floods the city and has done so three hundred times since the city was founded. In 1824, it rose thirteen and a half feet, and in 1924, twelve feet. Here is Oliver Elton's translation of the overflowing Neva in Pushkin's narrative poem "The Bronze Horseman":

But the wind driving from the bay
Dammed Neva back, and she receding
Came up, in wrath and riot speeding;
And soon the islands flooded lay.
Madder the weather grew, and ever
Higher upswelled the roaring river
And bubbled like a kettle, and whirled
And like a maddened beast was hurled

Swift on the city. And things routed
Fled from its path, and all about it
A sudden space was cleared; the flow
Dashed in the cellars down below;
Canals above their borders spouted.
Behold Petropol floating lie
Like Triton in the deep, waist-high!

A marble plaque marking the level of the flood of 1824 is flush with the wall of the building where Dostoyevsky's young criminal lived. The Neva, like the weather, and like Petersburg's two most notorious butchers—Peter the Great and Raskolnikov—will always haunt the city, wrangling to expiate their crimes. Even Stalin's determined reconstruction of the city after it withstood Hitler's brutal nine-hundred-day siege is still trying to cover up what the city can't forget.

→>·<←

I came to St. Petersburg to stroll on Nevsky Prospect. Then as now, one strolls or one drifts along; one shops or stops for a meal or to drink coffee somewhere. The avenue is named after Prince Alexander, who was given the name Nevsky after defeating the Swedes at the Battle of the Neva in 1240. Here the rich and the wannabes ambled up and down, to see and be seen, in all seasons and all garbs. Here, also, people always heard French and English spoken and came to purchase the most luxurious wares from all parts of Europe. In Garnett's prose, Gogol's uncanny and biting descriptions are inimitable:

There is nothing finer than Nevsky Prospect, not in Petersburg anyway. It is the making of the city. What splendor does it lack, that fairest of our city thoroughfares? I know that not one of the poor clerks that live there would trade Nevsky Prospect for all the blessings of the world. Not only the young man of twenty-five summers with a fine mustache and a splendidly cut coat, but even the veteran with white hairs sprouting on his chin and head as smooth as a silver dish is enthusiastic over Nevsky Prospect. And the ladies! Nevsky Prospect is even more attractive to the ladies. And indeed, to whom is it not attractive? As soon as you step into Nevsky Prospect you are in an atmosphere of gaiety... This is the only place where people put in an appearance without being forced to, without being driven there by the needs and commercial interests that swallow up all Petersburg... All-powerful Nevsky Prospect.

Gogol lists how Nevsky Prospect changes aspect by the hour. Nevsky Prospect in the morning, at noon, at two in the afternoon, at three, at four:

Let us begin with earliest morning, when all Petersburg smells of hot, freshly baked bread and is filled with old women in ragged clothes, who are making their raids on the churches and on compassionate passers-by.

Gogol's most lyrical and Baudelairian brushstroke comes in his final description of Nevsky by twilight:

But as soon as dusk descends upon the houses and streets and the policeman covered with a piece of coarse material climbs up his ladder to light the lamp, and engravings which do not venture to show themselves by day peep out of the lower windows of the shops, Nevsky Prospekt revives again and begins to stir. Then comes the mysterious time when the streetlamps throw a marvelous alluring light upon everything.

For about two hours during my five nights in late June—called "white nights," because the sun never sets during that time of the year—Gogol's evening lights on Nevsky were the view from my window. The lights are totally unnecessary during high summer, but they still cast a beguiling incandescence on the emptied avenue. Today, although the gas jets studding the sidewalks have long since been replaced by electric streetlights, the imaginary trace of glowing old lanterns on Nevsky Prospect all the way to the Admiralty hasn't disappeared.

Nevsky Prospect, which has four lanes leading to the Admiralty and four heading in the opposite direction, is no different from any other major city's shopping strip: high-end boutiques, fancy restaurants and cafés, department stores, Pizza Huts, KFCs, McDonald'ses, buses, trolley buses, and tramways; and, wedged in between larger stores and abutting porticos to courtyards that have seen better days, are the usual assortment of rinky-dink cellular telephone stores and currency exchange windows. The buildings along the avenue are extravagant—some indeed majestic—built in the floral, Italianate style favored by the Romanovs. Most have been restored (at least externally), though some garrets on the top floors, which can't

be seen from street level, remain in deplorable condition. Restoration has always been the byword in St. Petersburg. After the floods, after the German siege, after near-intentional neglect by the Soviets, at twilight, as if to echo Gogol's gaslit world, many of the buildings and hotels along Nevsky, with their façades illuminated, sneak back into the past.

When I walk during the day, I want happenstance. So it is by happenstance—and therefore miraculously—that, while strolling, I discovered a glass-vaulted arcade at 48 Nevsky Prospect and, almost on a fluke, decided to step into its two-tiered gallery. It rivaled the tinier remaining galleries in Paris, London, and Turin, though it was not as large or as open as the Galleria in Milan or the GUM gallery facing Red Square in Moscow. Still, as I stepped into this nineteenth-century shopping mall, which Dostoyevsky described in *The Double* and "The Crocodile" and which had been entirely restored to suit twenty-first-century tastes, I spotted one store that sold a product you find in every gift shop in St. Petersburg: colorful, high-end matryoshka dolls. The painted wooden dolls of increasing size nested one inside the other provide a metaphor for everything here: one regime, one leader, one period nested in the other, or, as Dostoyevsky is rumored to have said, one writer coming out of another's overcoat pocket.

Just across the arcade, between 25 and 27 Nevsky Prospect, stands the Cathedral of Our Lady of Kazan. The external colonnade is clearly modeled after that of Saint Peter's Basilica in Rome, but inside, to my complete amazement, it is not exactly a tourist attraction, though tourists do throng around the nave and the transept. It is a place of worship, the way Saint Peter's is not.

Outside the cathedral stands the statue of Nikolai Gogol, erected in 1997. His presence there is not exactly an accident, since Gogol was a pious man. But it should be noted that this is also the church outside of which the nose from Gogol's eponymous tale, after escaping from Kovalyov's face, is seen riding in a carriage on Nevsky Prospect, wearing, of all things, the gold-braided uniform of a state councilor. Kovalyov, of course, is eager to get ahold of his nose and put it back where it belongs, on his face. It has long been a subject of ribald speculation among Gogol's fans whether the body part in question here was something other than a man's nose.

The cathedral was closed after the Communist revolution and was turned into the Museum of the History of Religion and Atheism. Soviet propaganda notwithstanding, religious fervor went underground—the way so much has always gone underground here. Faith would soon return, however, even in a country that had appropriated one of its most imposing religious edifices to house the history of atheism. This, after all, is the capital of things that never go away: they just go underground for a while.

Nowadays, there is such scant evidence of the seventy years of Soviet life in St. Petersburg that one must suspect that the population had either never taken to Marxism or that Marxism itself has gone underground. One of the telltale signs of the return to pre-Soviet times is that the tsarist names of many of the streets and avenues have returned, not least of which is the name of the city itself, which reverted to St. Petersburg in 1991 after being named Leningrad shortly after Lenin's death in 1924. One is always free to speculate in what buried chamber

old Soviet street signs are being stored. Seeing the power of the current Putin regime, one has to ask what, precisely, about the Soviet regime actually did go underground.

Not too far to the west of the cathedral, at 35 Nevsky Prospect, is the Gostiny Dvor, built in 1757, the oldest and largest shopping center in St. Petersburg, its infinitely long arcade circling the huge block and echoing similar arcades on rue de Rivoli in Paris.

At number 21 is an art nouveau wonder, a structure built by Mertens Furriers in 1910 and now a Zara clothing store. Across from it, at number 28, is the art nouveau domed turret of the Singer sewing machine company's building, now a large bookstore with a café overlooking Nevsky Prospect. Much farther to the west, at 56 Nevsky Prospect, is another glorious art nouveau building, which at one time housed the Eliseyev (or Elisseeff) Emporium and still bespeaks the luxury that must once have existed on this thoroughfare. After many permutations, the emporium has now been turned into a gourmet food shop.

The wealthy Eliseyevs lived in the Chicherin House at 15 Nevsky Prospect, a building that went through several hands before they acquired it in 1858. Here, Dostoyevsky, Turgenev, Nikolay Chernyshevsky, and the inventor of the periodic table, Dmitry Mendeleyev, were guests. Later, after the Eliseyevs fled the revolution, the writers Blok, Gorky, Mayakovsky, and Akhmatova would gather here until part of the building was converted into the Barrikada cinema—where a young Shostakovich played the piano for silent films.

But the Eliseyevs are also famous for once owning a large collection of Rodin statues in Russia. This collection was

nationalized after the revolution and is now housed in the Hermitage. The Soviets were notorious for "requisitioning" and "expropriating" or—to use a more appropriate term—looting private art collections. The wealthy cloth merchant Sergei Shchukin had developed a strong relationship with Matisse, which explains why the Hermitage holds a large collection of Matisses and Picassos as well as many works by Cézanne, Derain, Marquet, Gauguin, Monet, Renoir, Rousseau, and van Gogh. Like Shchukin, Ivan Abramovich Morozov also fled the revolution, thus allowing his collection of works by Bonnard, Monet, Pissarro, Renoir, and Sisley to end up in the hands of the Bolsheviks. Both Shchukin and Morozov eventually managed to leave Russia, although not without first undergoing deplorable *Doctor Zhivago*–esque conditions in their own homes. Needless to say, and for all of Russia's proclaimed de-Sovietization, these priceless art collections are seldom allowed to travel outside Russia, because the inheritors of the Shchukin and Morozov estates, living abroad, always threaten to sue in local courts to repossess what is rightfully theirs. The same is also true of Otto Krebs's art collection at the Hermitage: works by Cézanne, Degas, Picasso, Toulouse-Lautrec, and van Gogh.

Unless the paintings were purchased by the state commission of experts or given as gifts—and these represent a minuscule fraction of impressionist, post-impressionist, fauvist, and modern French paintings at the Hermitage—with very minor exceptions, the Hermitage does not possess French work painted after 1913. This is when time stopped. Coincidentally enough, 1913 was the very year when the United States first opened its doors to modern European art at the famous New York Armory Show.

Come to Nevsky Prospect today and you cannot help but feel the three hundred years of Russian history and culture crammed into this one street. Pushkin, Gogol, Dostoyevsky, Goncharov, Bely, Nabokov—these figures never leave. We come to Nevsky Prospect hoping to run into them, or to catch a glimpse of their shadows, or to happen upon some private space that is our projection of who we think they are, which may in the end say more about us than about them, though we need their ghosts to feel the pulse of that unfathomable organ we still like to call the Russian soul.

→>-<◄

I've been walking up and down Nevsky Prospect the whole day. On this night, I decide to take a bus up Nevsky and head to the Admiralty, facing the river, to see the Dvortsovaya palace bridge open at 1:00 a.m. Very, very few people can give you directions in English. When you ask whether someone does speak English, everyone in St. Petersburg answers with the same two words: "a leettl"—which is really less than a little. But Russians are magnificent and munificent, especially when three or four individuals on the bus have watched you struggling to get directions and become determined to take charge of you and make certain not to let you step off at the wrong stop. Suddenly I realize that I should have mastered at least a phrase-book knowledge of Russian, if only to say *pozhaluysta*, for please, *skol'ko* for how much, and *spasibo* for thank you. Such beautiful words and such frank, unguarded glances from strangers.

By then it's already nearing one in the morning, and I am

probably on the last bus. I get off at the Hermitage. Like so many buildings here, the Hermitage is illuminated. I walk to the riverbank, where a large crowd has already gathered to watch the opening of the bridge, which is supposed to be raised for three hours, until 4:00 a.m., to allow the larger boats through on the Neva.

The crowd at the head of the bridge keeps swelling, and people with all manner of sophisticated cameras and video equipment are getting prepared. Individual flares, launched ever so softly from the left and right of the bridge, begin wafting in the air, hovering way above the ground like distant kites, eventually dropping into the water as gingerly as they'd been released, one down, two up, three up, one down. The crowd cheers.

Across the river, another crowd has also gathered on the artificially created sand beach by the Peter and Paul Fortress. There is still a lot of traffic crossing the bridge. Groups of younger pedestrians are running back and forth, almost taunting the security personnel on the bridge. There is laughter in the huge crowd, and there's music, and a festive atmosphere prevails as people bide their time, everyone already sharing in the good cheer. People love to party in June.

By 1:20 a.m. a clamor ripples through the crowd, and traffic authorities begin attempting to stop cars, but no one seems to pay much heed, and the cars keep racing across the bridge. Minutes later, bridge workers begin to order everyone off. Some yell, and people applaud. Meanwhile, a flotilla of small and midsize boats has gathered in the middle of the Neva, sitting still in the water, waiting for the chance to pass.

Then it happens. Cell phones light up everywhere, mottling the twilight from both sides of the bridge, while cameras click

and flash frantically, as if members of a famous rock band have just arrived and are about to step out of their limousine. There are astounded gasps and cries, as a loud hoorah races through the crowd, down to the park area by the Admiralty, where yet more people, I only now realize, are gathered. Finally the bridge starts to open.

This is the moment everyone has been waiting for. The crowd applauds yet again. Then all manner of tourist boats begin to pass under the opened bridge, cars honk, a police-boat siren wails half in greeting and half as a warning, and the Hermitage still glows in the backdrop, its floodlit front reflected on the Neva. And it suddenly occurs to me that I need to come back here to watch the exact same thing tomorrow night. Who wouldn't come back for this? So many people, so much joy, not even the shadow of a policeman on the ground, not one person becoming a public nuisance or going rogue, nothing loutish anywhere, and so much mirth everywhere.

This was my very first white night. I've been waiting to see this ever since reading Dostoyevsky's story "White Nights" as a very young man.

<p style="text-align:center">+>-<+-</p>

And it is precisely because I've begun thinking of "White Nights" again that I do not wish to head back to my hotel. Instead, I want to put off going to sleep, knowing I'll be up in a few hours because of jet lag. So I keep walking to experience St. Petersburg during one of those sunlit day-nights that occur for such a brief spell every year. But I have another agenda. I want to visit the very spot where the Kryukov Canal meets the Griboyedov

Canal. I want to go back to the place where the unnamed narrator of "White Nights"—the solitary, bookish dreamer—sees Nastenka along one of the deserted embankments, "leaning on the canal railing . . . with her elbows on the rail." She is crying. The two talk. Eventually they must part. But they meet on the same embankment the following night, and the night after that, and one more night after that as well, which is when she finally decides to accept the narrator's love. Yet no sooner is she about to pledge herself than someone suddenly brushes by the pair. It's her old flame, who has come back as promised. The old lovers are reunited and leave together, while our anonymous narrator is left alone, startled and forlorn.

The tale is sentimental to the core, but on nights such as this, especially when, in Gogol's words, "the streetlamps throw a marvelous alluring light upon everything," nothing could be more real than the tremulous colloquy of two strangers on a bridge.

When I get back to the hotel, I do not wish to lie down and end up sleeping through the whole day. So I sit around, turn on the TV for a while, and, rather than wait for breakfast in the hotel, decide to step out and walk. I don't get lost, though I don't know where I'm going. I think of having breakfast in the bookstore café located right under the dome of the Singer House, but I've had coffee already once there and wasn't impressed. Instead I find a side street off Nevsky Prospect and, thinking it's a shortcut to a place I've passed by earlier on Gorokhovaya Street, find myself walking on Rubinstein Street.

And there it is.

The sidewalk café is bathed in sunlight, its white chairs and tables gleaming. A couple is sitting in one corner; another

is chatting with the waiter. A third table is occupied by someone who seems a regular, dressed in swanky clothes, obviously coming back from a party and having breakfast before heading home. This, it occurs to me, is a neighborhood restaurant-café. In another corner, three women and a man rocking a baby stroller with his foot are laughing and talking. Because the air can be cool sometimes, especially in the evening or early morning, restaurants regularly provide shawls for their customers; these are folded on every chair. Two of the women in the group of four near me are wrapped in pure white blankets that bear the emblem and name of the café in golden filigree: *Schastye*.

When I ask one of the four, in English, if I might bum a cigarette, two readily produce their packs. I apologize, saying I had long ago stopped smoking but that watching them all smoking and enjoying it makes it difficult to resist. One thing leads to another. Where do I live? New York. Where do they live? Upstairs. I laugh. They laugh. Perfect camaraderie. I was going to leaf through the day's English-language paper but decide otherwise. Everyone is happy on this quiet Sunday morning. I order coffee and soft-boiled eggs, and, because the waiter speaks perfect English, I ask if I can have my Americano before the eggs. Of course. Three-minute eggs? I ask, making sure they aren't going to be hard. Of course. There is something wonderfully snug with a touch of understated chic about both the café and its clientele, the whole thing without pretense and perfectly *décontracté*. I begin to wonder whether their lives upstairs correspond with what I am seeing here or whether they still live in cramped, Soviet-style homes. But I put the thought away. This, I realize, is the new St. Petersburg. Happy to be what it is and

totally un-Dostoyevskian. Not a trace of heat, no crowds, no dust, no drunks or hawkers jostling their way about. I am seeing something altogether unexpected. This is a lovely place, the weather is perfect, and I want to enjoy every moment of it before heading out that morning to discover my new St. Petersburg. I just want to get as far away from myself as I possibly can—forget what I know, drown out the noise in my head, stop being such a bookish tourist for once, and finally see what's right before me.

I promise myself to come back exactly a year from now and spend a few months here, venture a new life, because here lies a new, unborn me waiting to come alive. I stare at the building above the café, only to be told by the waiter that the large archway of the building next door belonged to the Tolstoy House. No, not Leo Tolstoy, but still, a member of the same family. The building has a large courtyard that I should definitely visit later—if I head straight through its courtyard, I'll come out the other end at number 54 on the Fontanka embankment. I want to look at the windows of every apartment in this large complex and spy into all those lives and wonder which might possibly be mine someday should I be lucky enough to come back and live here for a while.

I want to learn Russian and say *pozhaluysta* when asking for a cigarette and *spasibo* when offered one, and I want to say *prekrasnyi den'*, because it is indeed a beautiful day, and *poka* for bye, and so many other things. And I want to come back here every morning of my stay in St. Petersburg, because I'll find something that I know might still take days to pinpoint and understand, something in me or outside me—I'm not sure which—but in the meantime the one thing I know for certain, as I sit back in my chair, wrapping myself in a white shawl the

way all Russians do when the weather isn't warm enough, is that "I am not a sick man . . . not a spiteful man . . . not an unattractive man . . . and that nothing is wrong with my liver."

What does *schastye* mean? I finally ask our young waiter. He looks at me and, placing my Americano on the table, says, "Happiness."

ELSEWHERE ON-SCREEN

In 1960 *The Apartment* was playing at the Rialto Theater and was advertised with a loud red poster. I was too young to see it at the time, but I do recall overhearing my parents describing it to their friends as an unusually bold film. What was shocking about the film was its subject. A young, rather hapless, timid junior executive named C. C. Baxter (played by Jack Lemmon) has been lending the key to his apartment to a number of married senior executives who need a place to spend a few leisurely evening hours with their mistresses. The key does the rounds of the office building, earns the young executive the goodwill of the company bosses, and eventually gets him promoted. In 1960 the subject was decidedly risqué. But something about the reaction of my parents intrigued me. They enjoyed talking about the film with their friends—about the acting, about the story itself, about this place called New York City, which neither they nor their friends had ever seen before and which hovered in the distance like one of those places none of them was ever likely to set foot in. I never forgot my parents' fascination with

the kind of New York City the film evoked, but since the film was not available on video or on late-night TV until the mid- to late 1970s, I seldom gave it another thought. Yet when I finally did see it, where I saw it and who I myself was that evening left an indelible mark.

The year was 1984—late fall of 1984. I was single at the time, living on Manhattan's Upper West Side, and had been dropped by my girlfriend a couple of months earlier. I had no money, not much of a job, and my career prospects were decidedly grim. So one Saturday, with nothing to do, no friends, nothing planned, and no desire to stay home, I went out for a walk down Broadway just to experience a Saturday evening lost in the crowd.

At Eighty-First street, I stepped into what was then the only Shakespeare & Co. bookstore in Manhattan and was idly leafing through various books, envying couples who, like me, had wandered into the store. Then I saw Maggie. I knew Maggie from a café where the two of us used to hang out almost every evening; neither of us was attached, and neither liked being homebound on a weekend by ourselves. She was single and, like me, held a job that hardly paid anything. We were not attracted to each other, though something like a muted friendship had blossomed between us in our lonely-hearts café. That evening we couldn't have been more pleased to run into someone we knew. We spoke, as usual made fun of our lives, and, because we were both smokers, couldn't wait to leave the bookstore to light up. We walked down Broadway on the Upper West Side with lit cigarettes, not knowing what to do, neither of us eager to spend money at a bar.

When we reached the Regency Theatre on Broadway and Sixty-Eighth Street, I saw that *The Apartment* was playing. My

decision was instantaneous. As for her, who knows why she consented—because I coaxed her into joining me or because she had nothing better to do that night. I'll never know, nor did I ask. I loved the Regency, where old double-feature films were still being played, frequently to a full house, and I loved the shape of the theater itself, which wasn't rectangular but circular. There was a sense of intimate coziness inside, in good part because one felt in the company of people who shared a love for vintage films, which is perhaps nothing more than a love for things that endure despite their age. Later that night, I walked Maggie home, and we said goodbye in her lobby.

But what has stayed with me ever since that evening is the echo, the reflux, the hazy afterimpression of the film. It lingered all night and into the following week.

After leaving Maggie, I did not want to go back home and, even past midnight, continued to wander around the Upper West Side in the mid-seventies and high sixties, perhaps looking for *the* apartment and trying to see if the world inhabited by its characters continued to exist more than two and a half decades later. Without knowing it, I was on an improvised pilgrimage, the sort that many people take when they travel to the site of a film or novel they've loved and whose resonance continues to hover over their lives, almost beckoning them to slip into a world that suddenly feels more real and far more compelling than their own. It's not just that they want the movie to stay with them indefinitely. They also want to borrow the lives of its characters, because they want the story to happen to them. Or, better yet, the film feels as though it has already happened to them, and what they're asking the site to do for them is to help them relive what they lived through on-screen.

So here I was, walking on the Upper West Side at night, feeling not too different from C. C. Baxter on the evenings when someone was using his apartment and he was forced to linger out in the cold. All I could find, though, was not the old Upper West Side of 1960, which I was hoping to drift into somehow, but one that was systematically being revamped and modernized. So many small, insignificant landmarks had already vanished or had their impending disappearance written all over their storefronts: groceries, bakeries, butchers, cobblers, fruit and vegetable vendors, drugstores large and small, delicatessens, and hole-in-the-wall mom-and-pop stores, to say nothing of the many neighborhood movie theaters. Now, more than thirty years after I took that walk past midnight, I want to list all these vanished theaters, because I don't want them forgotten: the Paramount, Cinema Studio, the Embassy, the Beacon, the New Yorker, the Riviera and the Riverside, the Midtown, the Edison, the Olympia, and, of course, the Regency. The Thalia and the Symphony, now renamed Symphony Space, still exist today, but gone are the days of continuous film runs. And as for the Midtown, renamed the Metro, it was gutted a number of years ago and remains an empty shell.

That night, as I walked on Columbus Avenue, which was being heavily gentrified but had once been quite a dicey area, I kept passing boutiques that hadn't been there a few weeks before but whose earlier incarnation I no longer could even recall, and I felt guilty for not remembering. Maybe I'd been noticing changes in the neighborhood for longer than I knew, but only after seeing the film and the way it seemed to coddle its own tranquil, mildly shabby image of an Upper West Side that no

longer existed was I made aware of how pervasive and irreversible these changes were.

A new Manhattan was creeping into existence. The very store where I'd bought my first pair of American sneakers had disappeared, gone as well the Syrian bodega where cigarettes were cheaper than anywhere else in the city, and the numberless Botanica incense stores on Amsterdam Avenue—vanished, each one.

At the start of the film, Jack Lemmon's voice said that he lived at 51 West Sixty-Seventh Street, and as I was approaching that location, I felt that I was actually about to enter a spellbound portal through time, until I saw something I'd never considered before: many of the brownstones between Columbus Avenue and Central Park West had had their stoops removed to allow for more renters. Worse yet, the brownstone on Sixty-Seventh Street was no longer even there. As I later found out online, it had been demolished in 1983 to allow a large apartment complex to be built on its site. I had missed the building where *The Apartment* had been filmed by one year. It was just like me to come looking for a building that didn't exist any longer. Worse, as I would also discover online, I was in search of a brownstone that wasn't even real. The brownstone that had inspired the producers to build a look-alike in Hollywood was not even on Sixty-Seventh Street but at 55 West Sixty-Ninth Street. And the Hollywood replica, as happens so often in art, was ultimately more persuasive than the brownstone allegedly located on Sixty-Seventh Street.

I was living in a city that held no loyalty to its past and was so hastily slipping into the future that it made me feel behind the times, and, like a debtor who can't manage his loan payments, I

was perpetually in arrears. New York was disappearing before my eyes: Mrs. Lieberman, C. C. Baxter's landlady, who spoke with a thick Brooklyn accent; Dr. Dreyfuss, who lived next door and spoke English with an audible Yiddish inflection; while Karl Matuschka, the cabbie and Fran Kubelik's outraged brother-in-law, who punches C. C. Baxter in the jaw, thinking that Baxter had taken advantage of her, spoke with a typical outer-borough accent—all these ways of speaking already sounded dated in 1984 and have almost disappeared today. *The Apartment* was offering a rearview-mirror portrait of a lost New York and allowing us to think that a part of us, however small, still belonged, still missed living there.

Once I reached Central Park West, I entered the park and there discovered the long row of benches, exactly as it was captured in the film, where a fluish and irritated C. C. Baxter sat tugging his raincoat while one of his company's senior execs was entertaining a mistress in his apartment. Here he sat, shivering, feeling lost, unloved, and ever so solitary. I too decided to sit on one of those benches in that deserted spot in the park, trying to take stock of my life, which wasn't going well, for I too felt abandoned, alone, and unmoored in a world where neither the present nor the future held any promise for me. There was only the past, and now that I think of the night when I scoured the streets looking for an Upper West Side that might have felt more congenial, I realize that, like the Regency itself, like the Rialto of my childhood, that welcoming area of the city, with its strange accents, old shops, and dingy bars, has been completely expunged. The Regency was gone in 1987, and the Rialto was brutally demolished in 2013. How could I belong there when I couldn't find a personal landmark anywhere except on the silver

screen of a theater that itself would never even achieve land-mark status? Sometimes even the past, real or imagined, can be taken from us, and all we're left holding on a cold night in late fall is our raincoat.

And it hit me then that one of the reasons why some people cling to what has vintage status is not because they like things old or marginally dated, which allows them to feel that their personal time and vintage time are magically in sync; rather, it's because the word *vintage* is just a figure of speech, a metaphor for saying that so many of us don't really belong here—not in the present, or the past, or the future—but that all of us seek a life that exists elsewhere in time, or elsewhere on-screen, and that, not being able to find it, we have all learned to make do with what life throws our way. In C. C. Baxter's case, this happened on New Year's Eve, when Fran Kubelik—his love interest, played by Shirley MacLaine—knocks at his door, sits on his sofa, and, watching him shuffle playing cards, says, "Shut up and deal." In my case, what life had to offer was far simpler: late that Sunday evening I went to see *The Apartment* again. The film was about me. All great art invariably lets us say the same thing: *This was really about me.* And this, in most cases, is not only a consolation, it's an uplifting revelation that reminds us that we are not alone, that others are like us too. I couldn't have asked for more. Then I went on the same pilgrimage as the night before.

SWANN'S KISS

used to think that if the dominant principle in Machiavelli's work was acquisition—how to acquire power, land, loyalty and, once acquired, how to keep them—for Proust it was possession—the desire, the compulsion to possess, to retain, to hoard, to hold, to have. I am not so sure now. Today I feel it is wanting that is so central to Proust—or, more precisely, yearning and longing. Yearning, as *The American Heritage Dictionary of the English Language* defines it, is "a persistent, often wistful or melancholy desire." Longing, on the other hand, is "an earnest, heartfelt desire, especially for something beyond reach." But someone once suggested a far more subtle difference between the two: one longs for something in the future; one yearns for something in the past.

Proust's entire epic begins with a boy's obsessive craving for his mother's good-night kiss. She is downstairs entertaining guests over dinner, but the boy, who is sent to bed after leaving the table, wants his good-night kiss. And he wants a real good-night kiss, not a perfunctory peck on the cheek, which is what

he gets in front of the guests. Still, on his way upstairs to his bedroom he tries his very best to keep alive the memory of his mother's hasty kiss, to savor it, and then he plies all sorts of maneuvers to obtain the kiss he feels is still owed him. He'll end up asking the maid Françoise to bring down a scribbled message to his mother, and when this fails to summon her upstairs, young Marcel waits until all the guests have left and intercepts his mother when she is on her way to her bedroom. She is not pleased to see that he's disobeyed her instructions to go to bed, but the father, who also happens on the scene and who is usually less indulgent with his son, sees that Marcel is so agitated that he suggests the mother spend the night with him. Marcel finally got not just the kiss he desperately wanted all evening long but a whole night with his mother. In C. K. Scott Moncrieff's translation:

> I ought then to have been happy; I was not. It struck me that my mother had just made a first concession which must have been painful to her, that it was a first step down from the ideal she had formed for me, and that for the first time she, with all her courage, had to confess herself beaten . . . Her anger would have been less difficult to endure than this new kindness which my childhood had not known; I felt that I had with an impious and secret finger traced a first wrinkle upon her soul and made the first white hair show upon her head.

Marcel begins to weep, while his mother is herself on the verge of tears. The frantic desire to have, to hold, to take, and ultimately to keep may have prevented the young Marcel from

going to bed after his mother had consented to her first kiss at the dinner table, but getting what he wants produces no pleasure either; instead, it yields a form of pleasure so unfamiliar as to be confused with displeasure and sorrow, neither of which can be assuaged or, for that matter, dispelled. If the kiss was a tangible sign of concord, intimacy, and love between the two, the kiss now signals distance, disenchantment, dispossession. Getting what one wants takes it away.

With the exception of the love shared between mother and son (and grandmother), the form of love most commonly encountered in Proust has nothing to do with love. Instead, its form is the obsessive, self-tormented pursuit of the beloved to the point that she will have to be imprisoned in her lover's home. You may not really love her, you may not want her love, even, or know what to do with that love, much less what that love is, but you cannot stop thinking and ruminating about how she might be double-crossing you. In fact, without totally knowing it—and here it is again: the specter of Proustian dispossession—even as your prisoner, your beloved will always find ways to give you the slip and cheat on you. Worse yet, you'll even make it possible for her to double-cross you, either by turning a blind eye to those you've allowed her to befriend or by overlooking, if not unintentionally colluding with, her treachery. Odette may cause Swann a great deal of sorrow, but he has no respect for her, nor is he truly taken in by her lies. When the two break up, he utters to himself one of the most famous closing sentences in world literature: "To think that I've wasted years of my life, that I wanted to die for a woman who did not appeal to me, who was not my type."

Pages later, however, we discover that Swann has married

the very woman he never loved and who, on their first meeting, had stirred in him "a sort of physical repulsion" (*une sorte de répulsion physique*). When we meet Swann again in *Within a Budding Grove*, he has long since stopped loving his wife, Odette, and indeed is now jealous over another woman. "And yet," Proust writes,

> he had continued for some years to seek out old servants of Odette, so strongly in him persisted the painful curiosity to know whether on that day, so long ago, at six o'clock, Odette had been in bed with Forcheville. Then that curiosity itself had disappeared, without, however, his abandoning his investigations. He continued the attempt to discover what no longer interested him, because his old ego [*son moi ancien*] though it had shrivelled to the extreme of decrepitude still acted mechanically, following the course of preoccupations so utterly abandoned that Swann could not now succeed even in forming an idea of that anguish.

We continue to want something from those we have long since ceased to want anything from. We could be driven by "the simple love of truth" (*par simple amour de la vérité*) to wish to resolve old doubts, but love of truth, in such instances, is nothing more than the mask worn by the green-eyed monster himself. As Madame de La Fayette showed, jealousy does not necessarily die when the cause of jealousy is removed. The truth is that we continue to want without knowing what we want; the wanting has simply latched on to someone, and that someone, we are convinced, needs to be possessed. On the night when

Swann finally sleeps with Odette, the narrator very cautiously writes that Swann moves from "the insensate, agonizing desire to possess her" (*le besoin insensé et douloureux de le posséder*) to "the act of physical possession (in which, paradoxically, the possessor possesses nothing)" (*l'acte de la possession physique—où d'ailleurs l'on ne possède rien*). What he may want is intimacy, but not necessarily with Odette or, for that matter, with anyone.

Total intimacy, if it exists at all in Proust, is perhaps the true manifestation of love or of something bordering on love. The ability to read people's minds, to see through them, to palpate their pulse and know their heart, their undisclosed frailties and vulnerabilities, may be the most telling sign of love—but it is also the source of that indomitable lust for spying, for intercepting signs of real or imagined treachery, for possessing the key to who others are. It is love and it is trust, but it is also the ultimate in distrust and hostility. The transactions may be different, but the currency is the same. And yet perhaps one of the most moving scenes in the entire *À la recherche* is about total transparency. I am thinking of the scene in the hotel at the beach where Marcel's bedroom is adjacent to his grandmother's. She asks him to tap three times on the thin wall between their rooms when he wakes up in the morning so that she can order his warm milk. When Marcel wakes up, however, he doesn't know whether she is already up that morning and doesn't want to wake her with his three knocks, so he hesitates. She, on the other hand, has intuited his qualms and knows exactly why he held off knocking:

> Do you suppose there's anyone else in the world who's such a silly-billy, with such feverish little knuckles, so

afraid of waking me up and of not making me understand? Even if he just gave the least scratch, Granny could tell her mouse's sound at once, especially such a poor miserable little mouse as mine is. I could hear it just now, trying to make up its mind, and rustling the bedclothes, and going through all its little tricks.

Intimacy this is, but who can forget that in this highly stirring moment there is still a wall standing between grandmother and grandson? As with the scene of the kiss with the mother, something always stands in the way of allowing you to be one with someone else. This fusion of identities, which is perhaps the definition of possession, is never comprehensive enough. You either get glimpses of it in the jittery expectation of pleasure, or you have reminders of its transience. You possess nothing. You rehearse possession to come, or you ritualize the memory of a possession that never lasted long enough for you to know if indeed it was possession. Neither form takes place in the present tense.

The other moment that no reader of Proust can forget—because it occurs in so many versions, including in his correspondence—is the long-distance telephone conversation with his grandmother. Because of the difficulty of establishing a connection via telephone, Marcel cannot always hear her voice, nor can he make out that it is really his grandmother who is speaking to him, so that each time her disembodied voice breaks up and seems to float in and out of the ether, it gives every intimation of straining to reach him, like a voice from the underworld. He is already apprehending her imminent death. He is, in fact, rehearsing her loss.

Death is the final and everlasting separation and, hence, is terrifying. You may have disquieting premonitions of it; however, in Marcel's case, this means that he'll practice separation and loss, he'll rehearse it, he'll rehearse dispossession, so that when the separation finally comes about, it won't be as devastating as he fears. He slips into an imagined future the better to stem what lies in store for him, but to do this he needs to cheat himself of the present and consider his grandmother not as a living presence but as one who is fast slipping into the past. When his beloved grandmother does indeed die, Marcel feels nothing. To his own surprise, he is relieved and almost ready to admit that he's been let off easily. It is only later, when he is attempting to tie his shoelaces in the same hotel bedroom where he used to knock three times on the thin wall between him and his grandmother, that he has a sudden, violent realization of the extent of the loss. Death means never, ever seeing someone again.

In confronting his grandmother's death, Marcel is caught between two passive moves: rehearsal and ritual. Rehearsal is the act of repeating what has yet to happen; ritual, repeating what has already happened. Between the two something is clearly missing: call it the present, or call it experience. What do you do when you are not inhabiting the present? You temporize, you defer, you anticipate, you remember. There is a telling scene where Marcel and Albertine are finally not *in* bed together but *on* the bed. Because Marcel feels that what may soon happen between them is a sure thing, he decides that he might as well defer it for a short while and asks Albertine for a rain check. But the most significant instance of this same situation is when Swann is finally about to kiss Odette for the first time. At that moment, he not only wants to bring to bear all the hopes and

fantasies he cradled about an Odette still untouched by him but is equally bidding farewell to the Odette who was, until that very moment, not yet possessed.

And Swann it was who, before she allowed her face, as though despite her efforts, to fall upon his lips, held it back for a moment longer, at a little distance between his hands. He had intended to leave time for his mind to overtake her body's movements, to recognize the dream which he had so long cherished and to assist at its realization, like a mother invited as a spectator when a prize is given to the child whom she has reared and loves. Perhaps, moreover, Swann himself was fixing upon these features of an Odette not yet possessed, not even kissed by him, on whom he was looking now for the last time, that comprehensive gaze with which, on the day of his departure, a traveler strives to bear away with him in memory the view of a country to which he may never return.

Swann wishes to overtake the present—to acknowledge moments in the past during which he had long anticipated the kiss that is about to happen and, thus, bring the past to bear upon the present—all the while wishing to defer this present by seeing it as a moment that will all too soon vanish into a remembered past. That Swann ends up sleeping with Odette on that same night seems so incidental and so foregone an outcome that Proust, ever fussy with minute details elsewhere, overlooks it altogether and then pays it lip service by calling it simply: "the act of physical possession (in which, paradoxically,

the possessor possesses nothing)." Experience and fulfillment in the present tense are either ungraspable or of no interest to the narrator, who is more focused on both the might-soon-be, which could so easily slip from our grasp, and the long-awaited might-occur that happens before we're entirely aware of it.

This is the signature Proustian time zone.

Wordsworth, whose sensibility is not dissimilar to Proust's, had long awaited the subliminal moment when, crossing the Simplon Pass in the Alps, he would finally find himself with one foot in France and the other in Italy. When he asked a local peasant when that desired moment would occur, the man simply told him that he had already crossed the Alps. The anticipated moment had occurred without his seizing it. This failure to experience whatever he had expected to feel when crossing the pass into Italy comes almost like an oversight. There was a future, then that future became a past, but there was no present. And yet, given that very failure to feel a spiritual revelation, Wordsworth pens one of the most eloquent hymns to the imagination, flashes of which "have shown to us / The invisible world." Error, loss, oversight, and failure to grasp experience in the present may be deemed a minus to armchair Freudians, but to Proust, writing about this minus becomes a plus.

Similarly, the reluctance, the difficulty to consummate experience and, instead, to rehearse, to defer, to ritualize, and ultimately to "unrealize" experience, lies at the very source of Proust's aesthetics. There is, on one hand, a desperate longing to grasp, to hold (the verb *tenir* is key in Proust), to possess, and yet on the other, a distrust of or insufficiency vis-à-vis experience that compels Marcel to play all manner of mental stratagems to defer if not obviate either the inevitable disappointment

that comes from experience or to force him to relinquish what he fears he wants too ardently and may either never get or be indifferent to by the time he gets it. After yearning so long for something, he may even be resigned to believe he never really wanted it.

From the street, Marcel looks up at the window of the Swann household and wishes to be invited inside and become a member of Gilberte's and her parents' inner circle. One day he is finally admitted into their fold and finds himself so confirmed a habitué among them that, on looking out from that same window, which seemed to promise who knows what wonders once, he sees people who are as eager and as intimidated as he once was before being admitted in.

> Those windows which, seen from outside, used to interpose between me and the treasures within, which were not intended for me, a polished, distant and superficial stare, which seemed to me the very stare of the Swanns themselves, it fell to my lot, when in the warm weather I had spent a whole afternoon with Gilberte in her room, to open them myself, so as to let in a little air, and even to lean over the sill of one of them by her side, if it was her mother's "at home" day, to watch the visitors arrive who would often, raising their heads as they stepped out of their carriages, greet me with a wave of the hand, taking me for some nephew of their hostess.

I don't remember whether the third move is ever narrated in Proust, but it is always present in my mind: I am sure that, on feeling so welcome among the Swanns, Marcel is already

looking out the window and seeing himself one day as an outsider on the sidewalk looking up at a window to rooms he knew so well but in which he no longer feels welcome.

Between the memory of having longed for admission into the Swann household and the final admission itself there hovers an inability—maybe an unwillingness—both to savor the present, so as not to lose sight of its anticipation, and to unrealize it, the better to shield himself from pain or disappointment. In the end one can no longer "succeed in knowing [one's] own happiness."

When reality is folded over to cover the ideal of which we have so long been dreaming, it completely hides that ideal, absorbing it in itself . . . whereas we would rather, so as to give its full significance to our enjoyment, preserve for all those separate points of our desire, at the very moment in which we succeed in touching them, and so as to be quite certain that they are indeed themselves, the distinction of being intangible . . .

After I had spent a quarter of an hour in her drawing-room, it was the period in which I did not yet know her that was become fantastic and vague like a possibility which the realization of an alternative possibility has made impossible. How was I ever to dream again of her dining-room as of an inconceivable place, when I could not make the least movement in my mind without crossing the path of that inextinguishable ray cast backwards to infinity, even into my own most distant past, by the lobster *à l'Américaine* which I had just been eating?

Marcel even finds himself yearning for the memory of long-ing for the Swann home. What, it seems, stands in the way of retrieving the memory of what he'd once desired is his actual presence in their home:

> Our thought cannot even reconstruct the old state so as to confront the new with it, for it has no longer a clear field: the acquaintance that we have made, the memory of those first, unhoped-for moments, the talk to which we have listened are there now to block the passage of our consciousness, and as they control the outlets of our memory far more than those of our imagination . . .

This perpetual figure-eight movement is what, for want of a better verb, grounds Proust's universe in something like reality—transient, shifty, impalpable reality that it is. Marcel's most trenchant insights, his naïve misreadings and niggling paradoxes, all are governed by his reluctance—or inability—to absorb and consummate ordinary experience or, for that mat-ter, to adhere to ordinary, linear, monochronistic time. He is forever holding out for and anticipating something more, some-thing that needs to be coaxed, that doesn't even exist in normal time and that immediately skitters away no sooner than it is about to be seized. Everything from his narrative to his style is about abeyance, retrospection, and, of course, anticipated retrospection.

When things eventually sour between Marcel and Gilberte and he notices that she is clearly drawing away from him, he makes a point of being absent from her parents' home and finds all manner of ways to avoid running into her when he does visit

them. He feigns indifference. But as it is with Swann's kiss, so it
is with Marcel's love.

I knew not only that after a certain time I should cease
to love Gilberte, but also that she herself would regret it
and that the attempts which she would then make to see
me would be as vain as those that she was making now, no
longer because I loved her too well but because I should
certainly be in love with some other woman whom I
should continue to desire, to wait for, through hours of
which I should not dare to divert any particle of a second
to Gilberte who would be nothing to me then . . . that fu-
ture in which I should not love Gilberte, which my suf-
ferings helped me to divine although my imagination
was not yet able to form a clear picture of it, certainly
there would still have been time to warn Gilberte that
it was gradually taking shape, that its coming was, if not
imminent, at least inevitable, if she herself, Gilberte, did
not come to my rescue and destroy in the germ my na-
scent indifference. How often was I not on the point of
writing, or of going to Gilberte to tell her: "Take care.
My mind is made up. What I am doing now is my su-
preme effort. I am seeing you now for the last time. Very
soon I shall have ceased to love you."

In the end everything is unrealized. If Swann wished to
recall his desire for Odette all the while bidding farewell to an
"Odette not yet possessed," with Marcel the situation is hardly
different. He may wish to recall his imagined picture of a Swann
household not yet visited, but what he is simultaneously doing

is anticipating that moment when he might no longer care for that home or for a Gilberte never even possessed.

→>≺+

Is there a present tense in Proust?

Is there experience in Proust?

Is there love in Proust?

The fundamental register of Proust's narrative is *comprehensive*—meaning *prehensile*. Proust's grasp is universal; he wishes to let go of nothing. Aside from the fact that Proust's style is allegedly complicated, it is perhaps the most perfect machine ever invented in language to examine, to absorb, and appropriate all experience. But it does so on condition that it bear in mind that it will not keep whatever it seizes. Like a lover who is totally smitten, it seeks to capture every aspect, every fugitive impression, every instantaneous emotion, every memory, every skittish glance that tells one whether others should be trusted or not. It wants to secure the past, capture the present, and, to the best of its ability, foretell or be forewarned of a future that is already an anticipated past. In this sense jealousy is not only the ultimate figure underlying Proust's comprehensive project, it also signals the failure of every man's desire to possess or to trust anyone or anything. Jealousy, as the history of world literature teaches, is fundamentally *impertinent*—it cannot hold, cannot seize, is irrelevant. It anticipates treachery or, worse yet, brings it about. The desire to possess always implies the failure to possess.

But Proust not only treats the world as though it were an elusive and disingenuous partner whose lies may represent a self-

perpetuating tissue of deceit; as we know from the galley proofs themselves, he does to the text itself what the text already does to the world. Every investigatory sentence opens up further space for further investigation and intercalation. The very pages that scrutinize the deceits of Odette, Morel, and Albertine are themselves subject to subsequent scrutiny and emendation. Writing as investigation is regressive, digressive, dilatory. Everything on every page generates its own effluents and mini effluents. A simple image of the typesetter's galleys after Proust's edits proves my point.

The sinuous and insidiously long Proustian sentence, which cautiously lays siege to reality, ultimately participates, not necessarily in the emergence of truth, but in its deferral, sometimes in its obstruction, and ultimately in its unrealizing. Either an incidental, though not irrelevant, fact is overlooked, or irony always unsaddles the earnestness with which every sentence begins its journey.

Even the rewards and diversions that the process of writing itself confers on the narrator detract from its purpose. For the Proustian sentence, so knowing and so astutely beautiful, may ultimately enjoy one thing more than unraveling or even postponing truths: with an unrivaled appetite, it delights in showing that it is unworthy and unable to terminate any investigation whatsoever. It thrives on its own errors and oversights, in rejecting the very devices it has so shrewdly crafted, in its own ability to doubt what it has seemingly made clear. It doubts everything, including itself. It enjoys showing that the highest knowledge of which it is capable is the knowledge, the certainty, that it does not know, that it does not know how to know. Every attempt to disprove this privative piece of information is subsequently

repudiated as a more insidious form of ignorance. The desire to resolve mysteries about the world becomes Proust's characteristic way of narrating the world and Marcel's characteristic way of being in the world. Marcel does not act; nor does the Proustian text narrate acts. They reflect, interpret, remember, and speculate. Irony, which is the shadow partner of why-didn't-I-know-at-the-time-that-so-and-so-was-such-and-such, always takes away what might have been straightforward, good-enough truths. Consummation is always stymied.

The Proustian lover, like the Proustian narrator, has come to define his being-in-the-world as a series of acts of insight and compulsive speculation. His way of being, of acting, is to speculate—to write—to write speculatively. As a jealous narrator, he is proscribed from the world of action, of plot, of trust, of love and derogated to the role of observer and interpreter. In writing the way he does, he has already established his demotion from the role of active participant to passive observer, from beloved to jealous lover, from zealous lover to indifferent lover. Writing itself now is embroiled in the intricacies of jealousy.

Proustian writing reflects a sensibility that is thwarted in both the world and the present. It says, *Any tense but the present!* The Proustian narrator, like the Proustian lover, avoids truth and resolution for the very reason that resolution invites deeds, actions, certainty, and decisions and might, therefore, wrench him out of his safe and private epistemophilic cocoon where writing and speculating have acquired the status of life and promise and may indeed confer rewards and satisfactions that rival those of life. This is exactly how the Proustian search manages to perpetuate itself: by giving to written life the status of life, to literary time the status of real time.

But because a consciousness capable of such an intellectual ploy must be conscious of this fundamental inauthenticity vis-à-vis life and time, it must constantly show that it is unsatisfied with the answers that writing provides: this not only allows it to keep searching, to keep writing, but also prevents it from losing sight of the fact that it should never presume to displace the primacy of lived life.

Thus Proustian writing perpetuates its search not only because it finds its raison d'être in writing, but, paradoxically, because it knows that it should not find its raison d'être in writing and wants to show that it knows this. Error—say, the knocking at the wrong window in an access of jealousy—not only reflects the demotion the jealous narrator feels he deserves in his role as a bungling speculator lost in a world where men act and cheat on other men, where men of insight are always resourceless, where writing turns against men of writing and makes fun of their attempts to substitute literature for life, but also serves as a reminder that the world of writing, of fiction, in which the jealous narrator sought refuge, is, paradoxically again, no fictitious realm at all: it is so real that it can be as merciless and cruel with the jealous lover as is the very world he flees.

BEETHOVEN'S SOUFFLÉ
IN A MINOR

I n her classic *Mastering the Art of French Cooking*, Julia Child explains how to prepare a soufflé. The trick is to mix in beaten egg whites without deflating it, and she is very specific: first you must lay the billowy mounds on top of the milky yolk mixture. Then, "using your rubber scraper, cut down from the top center of the mixture to the bottom of the saucepan, draw the scraper quickly toward you against the edge of the pan, and up to the left and out. You are thus bringing a bit of the mixture at the bottom of the pan up over the egg whites. Continue the movement while slowly rotating the saucepan, and cutting down, toward you, and out to the left, until the egg whites have been folded into the body of the soufflé."

The whipped egg whites, in case the chef was not clear, are nothing more than trapped air. What Julia Child has in mind is a sort of oscillating, figure-eight movement of the rubber scraper, which takes the mixture to the top, folds it back toward the bottom, then takes what was just folded to the top again. Call this layering—not moving forward or backward, just stationary

wrist motions—the equivalent, say, of treading water without budging in a swimming pool. What was at the top is folded to the bottom, then folded sideways and back up again. Think of a sentence with zigzagging parallel clauses, each feeding off the former.

And this, to stretch a point, is pure Beethoven. Toward the end of a quartet, a sonata, a symphony, Beethoven takes a string of notes, whatever string it is, repeats it, folds it in, again and again, not going anywhere with it, yet always careful never to deflate it, and, summoning up all his creative genius, plays for time until the end—except that when he reaches the end, he will find some way to uncover newer musical opportunities, if only to keep on folding and refolding again. *You thought I was done and expected a resounding, clamorous close,* he says, *but I halted the process, kept you suspended for a very short while, and then came back with more, sometimes much more, and made you wish I'd never stop.* The endings of many pieces have these moments of mounting repetition, a sudden arrest that feels like the announcement of a closing cadence, only for Beethoven to utter a new promise, folding again and again, until the listener longs for perpetuity—as though the purpose of all music is not to seek closure but to come up with new ways to put it off.

At the level of plot, literature tries to do this all the time. A detective novel or a serialized novel is dilatory at its very core. It creates opportunities for hasty resolutions, only to surprise the reader with deceptive clues, mistaken assumptions, unexpected deferrals, and cliff-hangers. Suspense and surprise are as essential to both prose and music as are revelation and resolution. Bram Stoker's *Dracula* is punctuated by endless setbacks and unforeseen delays. Jane Austen's *Emma*, on the other hand,

could so easily have ended midway, when it became clear to the reader that Emma Woodhouse had a crush on Frank Churchill and that he too was seemingly stricken. This would have been an acceptable ending, and the first time I remember reading the novel, I was entirely persuaded that this is where the novel was indeed headed. I was wrong, and Austen, rather than finish with the marriage of these two would-be lovers, decided to reject this plausible ending and instead went in search of another and, having proposed this other ending, discarded it for yet another.

Music is far more adept at this, because it can fold and refold numberless times. Literature cannot. Barring plot, however, there are similar stylistic instances in literature, and I would like to mention two: Joyce and Proust.

Among the most beautiful and most musical passages in the English language are the closing pages of James Joyce's "The Dead." They are the most musical, not only because of their cadence—when read aloud, they'll persuade anyone of the stunningly lyrical, anaphoric beauty of Joyce's prose—but because the story itself does not end when it should. The story, in fact, has already ended before it ends, except that Joyce wasn't quite done yet and, like Beethoven, simply kept going, withholding the full stop, folding one clause into the next, again and again, as if in search of a closure he wasn't finding but wasn't going to give up on, because the search for closure and cadence was not incidental to what he was writing but had always been its true drama, its true plot. Rhythm, in this instance, is not subsidiary to the story of Gretta and Gabriel or to the portrait of the elderly aunts on the Feast of the Epiphany; it becomes the story. If every reader recalls "The Dead," it is precisely because the rhythm of its closing pages totally transcends what

would have simply been the longest and chattiest tale of *Dubliners*. I've always suspected that Joyce had no idea how to close "The Dead"—a seemingly rudderless tale—and stumbled on its final segment simply because he had waited for something to happen and had the genius to make room for it, to leave open spaces for it, even when he didn't know what might come to fill those spaces or where the story might take him once he had indeed filled them. All he knew perhaps was that closure would most likely have something to do with snow. He had the audacity not to give up waiting. Waiting for something to happen, avoiding hasty completion, deferring the period, opening up space for the unknown visitor, trying out seemingly pointless clauses provided they adhered to a particular rhythm—this was genius. Call it, if not folding, then padding, or to use Walter Pater's word for it, surplusage, or, in keeping the soufflé analogy, trapping air. Real meaning, real art, does not necessarily reside in the nitty-gritty, bare rag-and-bone shop of the heart; it resides just as easily in the seemingly superfluous, in the extra, in the joy of folding and refolding air, in creating space for the unexpected visitor, the extra who, in this case, happened to be a young man called Michael Furey, who shows up almost adventitiously at the tail end of the story.

Taking one's time, folding and refolding with no clear sense of where, exactly, one might be headed, trapping air bubbles, making extra room for things that have yet to come brings up another metaphor: the nineteenth-century Russian chemist Dmitri Mendeleyev, who invented the periodic table of elements and was able to arrange the elements of our planet by their weight, valence, and behavior. Mendeleyev created several columns in his table and proved that elements layered under the same column

might have different atomic weights but would still share the same valence and hence react to other elements in similar ways. Thus lithium, sodium, and potassium, with atomic numbers 3, 11, and 19, might have different atomic weights but all share a valence of +1, while oxygen, sulfur, and selenium, with atomic numbers 8, 16, and 34, have a valence of −2. Mendeleyev was so sure of his discovery—and this is the purpose of the analogy here—that he left empty "boxes" in his table for those elements that had yet to be discovered.

Mendeleyev's table not only attributes an unavoidable, rational sequence to what might otherwise have seemed a random arrangement of elements on planet Earth, it also offers something more than an unavoidable, rational sequence: it offers an aesthetic design. Design itself transcends the sequence, transcends the elements of chemistry, transcends melody and counterpoint, transcends the story of Joyce's dinner on the Feast of the Epiphany. Design and rhythm themselves become the subject of the sequence. In the creation of empty, tentative boxes in the periodic table, or in the endless, exploratory folding and unfolding of musical phrases or verbal clauses, the chemist-composer-writer is, in fact, operating under the spell of three things: design, discovery, and deferral.

By folding and refolding, layer after layer, art hopes to restore order on the fringes of chaos. And if *restore* is the wrong verb, then let's say that by folding and refolding, art tries to *impose* or, at best, to *invent* order. Art is a confrontation with chaos—the revelation and construction of meaning through form. By folding and refolding, artists create the opportunity for invoking a deeper layer of harmony, one that goes further yet than the original design artists were so pleased to have created.

The joy of discovering design by dint of waiting for it, not just at the level of plot but at the level of style, is perhaps the pinnacle of artistic achievement. Art, as said earlier, is always about discovery and design and a reasoning with chaos.

And here, perhaps, we should turn to Marcel Proust, who, exactly like Joyce, was not only devoted to music but was a master stylist himself. Proust's sentence is recognizable because it operates on three levels: the start is frequently a muted afflatus, a moment of inspiration or uplift, an insight or idea that needs to be elaborated upon and examined and that sets the course of the sentence. The end of the sentence, however, is entirely different. A Proustian sentence normally closes with a fillip, what in French is called a *pointe*, or, in Latin, a *clausula*, to use the critic Jean Mouton's word: a burst of revelation, a short, almost lapidary dart that uncovers something altogether surprising and unforeseen and unsaddles every expectation the reader might have had. The middle of the sentence is where folding occurs. Here Proust allows the sentence to tarry and swell with intercalated material that proceeds ever so cautiously, sometimes forced to fork and to fork again while opening up subsidiary parenthetical clauses along the way, until, after much deliberation, unannounced, having acquired enough air and ballast along the way, the sentence suddenly unleashes the closing fillip. Proust's sentence needs this middle zone. Like a huge wave, it needs to swell and build momentum—sometimes with totally negligible material—before finally crashing against the shoreline. Proust's *clausula* reverses and capsizes all that preceded it. It is the ultimate product of continued folding and refolding, of the persistent trapping of air. It is how Proust seeks out the possibility of a miracle. It's also how he holds out for what he does

not yet know, cannot yet see, and has no sense he'll even end up writing.

All artists labor to see other than what's given to be seen; they want to see more, to let form summon up things that were hitherto invisible and that only form, not knowledge or experience, could have discovered. Art is not just the product of labor; it is the love of laboring with unknown possibilities. Art is not our attempt to capture experience and give it a form but to let form itself discover experience, to let form become experience.

And in this I am reminded of what is probably Beethoven's most beautiful piece of music: the "Heiliger Dankgesang eines Genesenen an die Gottheit, in der lydischen Tonart," composed after a close bout with sickness and death. The "Song of Thanksgiving" is a handful of notes, plus a sustained, overextended hymn in the Lydian mode, which the composer loves and doesn't wish to see end, because he likes repeating questions and deferring answers, because all answers are easy, because it's not answers or clarity, or even ambiguity, that Beethoven wants. What he's after is deferral and distended time, a grace period that never expires and that is all cadence that staves off the scariest chaos awaiting next door, called death. Beethoven will keep repeating and extending the process until it is reduced to its barest elements and he's left with five notes, three notes, one note, no note, no breath. The fullness of the absence after the final note is the whole point, and he's fearless in making us hear it. And maybe all art strives for just that, life without death. The greatest art—Beethoven's soundless last note, Joyce's snow, the Proustian sentence that enacts the paradox of time—peers squarely into the unfathomable: the mystery of not being there to know we're already absent.

ALMOST THERE

am an *almost* writer.

Almost is almost a useless word. Sometimes it serves no purpose but to add rhythm, cadence, and two extra syllables to a sentence, like that guest we invite at the last minute to fill an empty seat at a dinner table. He doesn't talk too much, won't annoy anyone, and he disappears as quietly as he's arrived, usually with an older person he's kind enough to escort to the first taxi he is able to hail. And yet no word is useless or should be allowed to die simply because it casts a long shadow and perhaps is just that: all shadow. *Almost* is a shadow word.

A quick and random sweep through a few of my manuscripts reveals the following uses of *almost*: *almost* never, *almost* always, *almost* certainly, *almost* ready, *almost* willing, *almost* impulsively, *almost* as though, *almost* immediately, *almost* everywhere, *almost* kind, *almost* cruel, *almost* exciting, *almost* home, *almost* asleep, *almost* dead. She said to him: "Don't even try" *almost* before his lips touched hers.

Did they kiss?

We don't know.

Indeed, in Goethe's *Elective Affinities* we have this: "The kiss her friend had given her and which she had almost returned brought Charlotte to herself." (Translation: R. J. Hollingdale.)

We know what *almost* means. Dictionaries, however vaguely they define the word, agree on this: that *almost* means something between "short of" and "sort of." *Almost* is an adverb, but it is also a stringer, a filler. Two extra syllables, like blush after makeup, just that requisite fuzziness, like ambiguity in an instance of candor. A halt in mid-speech, an extra tap on the piano's pedal, a suggestion of doubt and degree, of resonance and approximation, where straight, flat surfaces are the norm. "By using *almost*," says the writer, "I'm saying there is 'less than'; but what I mean to suggest is that there is possibly 'more than.'"

Yes, but did they kiss?

Hard to tell. *Almost.*

"We were *almost* naked" says we weren't quite without clothes but couldn't wait to be, which might easily mean "we couldn't believe we were *almost* naked." *Almost naked* is more charged, more erotic, more prurient than *totally naked.*

Almost is all about gradations and nuance, about suggestion and shades. Not quite a red wine, but not crimson, not purple either, or maroon; come to think of it, *almost* Bordeaux. *Almost* can be a polite, understated way of screening definitive certainties. It withholds the obvious and dangles it just long enough. *Almost* is about uncertainty soon to be dismissed but not quite dispelled. *Almost* is about revelation to come but not entirely promised—i.e., *almost* promised.

Almost mollifies certainty. In butchers' language, it tenderizes

certainty. It is anti-conviction and—by definition, therefore—anti-omniscience. Fiction authors use *almost* to avoid stating an outright fact, as though there were something blunt, crass, too direct in qualifying anything as definitely this or that. It is how novelists—as well as their characters—open up a space for speculation or retraction or for suggesting something that may not be but that poisons the mind of the jury.

Almost reminds the fiction writer that he is just that: writing fiction, not journalism. How can he know for certain whether X was really in love with Y? One could *almost* guess that he was. But who is to know? "That night, X caught himself *almost* thinking of Y without her clothes on." Did he actually think of her naked, or is the writer trying to make the reader consider something that may never have been thought of at all? *Almost* speaks a writer's reluctance vis-à-vis here-and-now, hard-and-fast, nuts-and-bolts, tooth-and-nail, bare-bones, in-your-face factoids.

Almost teases. It is not a yes or a no; it is *almost* always a maybe. *Almost* withholds definitive knowledge of things and suggests the provisional nature of everything found in a narrative, including, of course, the narrator's own knowledge of the facts he's been narrating. A cautious narrator uses *almost* almost as a way of vouchsafing his honest attempt to capture a particular essence on paper. *Almost* guarantees him an out. *Almost* not only allows an author to suggest that he might at any moment withdraw or revoke anything he's put on paper, but it is also an elusive loophole that doesn't always want to be noticed.

Almost is not the favorite word of all authors. One can imagine—though no one's counting—that Hemingway was not

a friend of *almost*. It's not a word alpha males are disposed to use. It suggests timidity, not assertion; recession, not dominance.

But then there are writers who with an *almost*, or a *presque* in French, can suddenly illuminate a reader's universe. Here is a sentence from *La Princesse de Clèves*: "She asked herself why she had done something so perilous, and she concluded that she had embarked on it almost without thinking."

Had she really not thought of it, or had she thought of it but didn't want to admit it? The author, Madame de La Fayette, herself doesn't seem to know or want to know. She wants her character to seem a touch more guileless than might seem appropriate. After all, the Princesse de Clèves is a model of virtue.

But there is something else happening with the use of the word. It reflects a worldview where nothing is certain and where all things written can be rescinded or taken to mean the very opposite, or *almost* the very opposite.

I am an *almost* writer. I like the ambiguity, I like the fluidity between hard fact and speculation, and I may like interpretation more than action, which might explain why I prefer a psychological novel to a straightforward page-turner. One leaves things perpetually insoluble; the other is an open-and-shut case. Think of Stendhal, Dostoyevsky, Austen, Ovid, Svevo, Proust. I turn to the word *almost* because it allows me to think more, to open more doors, to steer boldly and yet safely, to keep excavating and interpreting, to fathom the very recesses of the human mind, of the human heart, and of human desire. It gives me an out in case I have strayed too far.

There is not a page I write where the word *almost* doesn't slip in to mollify and mitigate anything I say. It is my way of undoing

what I write, of casting doubt on anything I write, of remaining uncertain, untethered, unmoored, unaligned, because I have no boundaries. Sometimes I think I am all shadow.

And perhaps I almost don't know what the word *almost* really means.

COROT'S *VILLE-D'AVRAY*

On a late November morning years ago, we crossed Central Park. I remember the bare trees along the way and the glacial air and the sodden earth underfoot, and I remember unleashed dogs scampering about in the mist with steam rising from their snouts while their owners stood jittering, rubbing their palms. When we reached Fifth Avenue, we scraped the mud off our shoes, entered the Frick Collection, and, before we knew it, were facing Corot's *Ville-d'Avray* and moments later Corot's *Boatman of Mortefontaine*, followed by Corot's *Pond*. I had seen the paintings several times before, but this time, perhaps because of the weather, I realized something I'd never considered. I was about to tell my friend that Corot had captured Central Park perfectly, that looking at the boatman in the paintings reminded me of the scene we'd just left behind by the deserted boathouse on Seventy-Second Street, when I realized that I had gotten things entirely in reverse. It was not that Corot reminded me of the park, but that if the park meant anything to me now, it was because it bore the inflection of Corot's

subdued melancholy. Central Park suddenly felt more real to me and was more stirring, more lyrical, and more beautiful because of a French painter who'd never even set foot in Manhattan. I liked the cold weather more now, the dogs, the scrawny trees, the damp and barren landscape that no longer felt late autumnal but that was starting to glow with peculiar reminders of early spring. New York as I'd never seen it before.

But just as I was about to explain this reversal, I began to see something else. I remembered the Ville-d'Avray I had visited as a young man, years earlier, in France, and how I'd been struck by its beauty, not because of the town and its natural environs but because of Serge Bourguignon's depiction of it in his 1962 film *Les dimanches de la Ville-D'Avray* (a.k.a. *Sundays and Cybele*). Now the film too was imposing itself on Corot and on New York, and Corot himself was being projected back onto the film. Only then did I realize that what truly attracted me to the paintings was something I'd never observed before. It explained why—despite all these mirrorings and reversals and despite the sky verging on the gray and the untended landscape over which hovered Corot's muted lyricism—what I loved in each painting and what had suddenly buoyed my mood was a mirthful spot of red on the boatman's hat. That hat caught my attention like an epiphany on a gloomy day in the country. Now it's what I come to see each time I'm at the Frick, and it's why I love Corot. It's the tiny baby in the king cake, like a subtle hint of lipstick on a stunning face, like an unforeseen afterthought, the mark of genius that reminds me each time that I like to see other than what I see until I notice what's right before me.

UNFINISHED THOUGHTS ON FERNANDO PESSOA

The story exists in countless versions. A painter is hired to portray the life of Christ. So he roams the country in search of the most angelic-looking boy. Eventually he finds him, paints him, and then for years plods through countless towns and villages in search of models for each of the disciples. And, one by one, he finds them: James, Peter, John, Thomas, Matthew, Philip, Andrew, et al. Finally the last one remains to be painted: Judas. But he can't find anyone who looks as awful as the Judas he has in mind. By now the painter is quite aged and doesn't even remember who had commissioned the painting or if that person is still alive to pay him for his work. But the painter is headstrong, and one day, outside a tavern, he spots the most debauched, seedy-looking, bedraggled vagabond who is clearly given to drinking, lechery, and thieving, if not worse. The painter offers him a few coins and asks if he would sit for him. "I will," replies the man with a sinister smirk on his face. "But give me the coins first," he says, proffering a filthy hand. The painter does as he's told and pays the man. The hours pass. "Whom are you painting?"

the vagabond asks. "Judas," replies the painter. After hearing the painter's answer, the would-be Judas begins to weep. "Why are you crying?" asks the painter. "Years ago you painted me as Jesus," says the man. "Now look and see what's become of me."

Some versions of the story say the vagabond's name was Pietro Bandinelli and that he sat for Leonardo's *Last Supper*, first as Jesus and a while later as Judas. Others maintain that his name was Marsoleni and that Michelangelo painted him as the innocent-looking child Jesus and years later as Judas.

I was thirteen or so at the time my father told me the story, and I remember that it made a powerful impression on me, leaving me feeling even stunned, as though my father had told me a tale not just about Jesus and Judas or about how time can totally undo who we think we are, but that the story was also about me in ways that I couldn't begin to put into words. Yes, time happens to all of us, but the Jesus-Judas story struck me as a cautionary tale, almost an admonition, that I, like the boy Jesus, had a dissolute Judas inside me who could any moment slip out, take over, and lead me down an irreversible path. I was a boy, but I had Judas in me—I knew it, and, what made things worse, my father seemed to know it too.

What moved me, and will continue to move anyone who hears this story, is that the passage of time could transform a person from an unsullied, uncorrupted, godlike boy into a thorough degenerate steeped in sin and damnation. Something about this tale clearly suggested a truth about an aspect of myself that I had never considered before: that I could easily *turn*, or that I was already turning and didn't see it. I was already feeling guilty for acts I knew not a thing about, much less how to commit them.

The man is no longer the person he used to be once, and

yet he is still the same person. *I was born to be this, but now I've become that,* he says. The distance between Jesus the boy and Judas the traitor remains forever unbridgeable: past and present couldn't be more different. That the man weeps in front of the painter implies that, however dissolute, he is not without guilt or shame. *I could have continued being the boy I once was, but that was not to be. I can no longer become what I was meant to be.* The question he means to ask is: *Is there redemption for me?* Which is another way of asking: *How can I buy myself back?* And the terrible answer lies in the painter's silence: *You were the unsullied boy Jesus, and you committed the worst act of murder ever recorded in man's history: you've killed Jesus, you've killed the Son of God, you've killed the innocent boy you once were, you've killed yourself. Marsoleni, you've been dead for years.*

The boy who sat for the portrait had no idea who he'd become one day; he might even have been looking forward to his future adult years. The adult, however, wishes nothing more than to be taken back to a time in his life when he had no notion of who he'd turn into, when he was incapable of even thinking of the future. *I'd rather go back to the darkness of unknowing,* he says, *than be who I've become. I'd rather go back, back, back to be nothing than be the child who'd be me one day.*

I want to be out of time.

"I am nothing," writes the poet Fernando Pessoa. "I'll always be nothing."

<div align="center">→>–<←</div>

I am looking at a picture of myself at age fourteen. I am standing in the sun. I have a sense that a big change is about to occur

in my family's life, but I have no idea what the future holds—
where will I be? who will I be? what hardships lie ahead? But
today I envy the boy in the photograph. He is young, and there
are many discoveries and joys ahead of him, especially those
of the body, whose pleasures he seems to know nothing of yet.
But there are also sorrows and defeats awaiting, and, worse yet,
there will always be that swamp of boredom whose shores he'll
grow to know and even find comfort in when things fall apart.
Perhaps he already knows—though I can't be sure he does—
that one day he'll want to look back at the time when this photo
was taken. Perhaps he is already rehearsing a ritual that may
not quite be in place yet.

Ritual, I wrote earlier, is when we look back and repeat what
has already happened, either because the past can bring solace
or because we're still trying to repair something and can do so
only by repeating it. Rehearsal, on the other hand, is when we
repeat what has yet to happen. Behind these two terms skulk
their two shadow partners: regret and remorse. Remorse is when
we desperately wish to undo what we've already done; regret,
when we wish we had done or said something that we feared
might cause remorse. Nostalgia for what never happened.

This is an irrealis moment, and I find it everywhere in the ge-
nius of Pessoa. "Regret, right now, for the regret I'll have tomor-
row for having felt regret today," which is a form of anticipated
nostalgia, but a "nostalgia for what never was," "for things that
never existed," hence, "false nostalgias." In Richard Zenith's
translation of Pessoa,

The leaves' tattered shadows, the birds' tremulous song,
the river's long arms shimmering coolly in the sun, the

greenery, the poppies, and the simplicity of sensations—
even while feeling all this, I'm nostalgic for it, as if in
feeling it I didn't feel it.

Writing further in *The Book of Disquiet*: "I love you the way I
love the sunset or the moonlight: I want the moment to remain,
but all I want to possess in it is the sensation of possessing it."
Almost Proustian.

As if he were the victim of a blockage, Fernando Pessoa's
narrator is always searching for something other, for some-
thing more, for the sensation of sensation, for thinking about
thinking, for that sense of time that time never grants anyone.
"There's a thin sheet of glass between me and life. However
clearly I see and understand life, I can't touch it." The shadow
of the shadow, the echo of the echo, the essence of time and
experience that always seems to elude us each time we wish to
savor it.

I've always belonged to what isn't where I am and to
what I could never be . . . I'm never where I feel I am, and
if I seek myself, I don't know who's seeking me. My bore-
dom with everything has numbed me. I feel banished
from my soul [*Sinto-me expulso da minha alma*] . . .

To realize that who we are is not ours to know, that
what we think or feel is always a translation, that what
we want is not what we wanted, nor perhaps what any-
one wanted—to realize all this at every moment, to feel
all this in every feeling—isn't this to be foreign in one's
own soul, exiled in one's own sensations [*Estraneiro na
própria alma, exilado nas próprias sensações*]?

From dealing so much with shadows, I myself have become a shadow in what I think and feel and am. My being's substance amounts to a nostalgia for the normal person I never was. That, and only that, is what I feel. I don't really feel sorry for my friend who's going to be operated on . . . I only feel sorry for not being a person who can feel sorrow . . . I try to feel, but I no longer know how. I've become my own shadow, as if I'd surrendered my being to it . . . I suffer from not suffering, from not knowing how to suffer. Am I alive or do I just pretend to be? Am I asleep or awake? A slight breeze that coolly emerges from the daytime heat makes me forget everything. My eyelids are pleasantly heavy . . . It occurs to me that this same sun is shining on fields where I neither am nor wish to be . . . From the midst of the city's din a vast silence emerges . . . How soft it is! But how much softer, perhaps, if I could feel!

Sensation or, better yet, the consciousness of sensation is what is absent. Elsewhere Pessoa writes:

In this moment I feel strangely far away. I'm on the balcony of life, yes, but not exactly in this life. I'm above it, looking down on it. It lies before me, descending in a varied landscape of dips and terraces towards the smoke from the white houses of the villages in the valley. If I close my eyes, I keep seeing, because I'm not really seeing. If I open them I see no more, because I wasn't seeing in the first place. I'm nothing but a vague

nostalgia, not for the past nor for the future but for the present—anonymous, unending, and unintelligible.

What he craves is a surplus of consciousness that arrests and supplements experience and time, but at the price of overriding and therefore of inhibiting time and experience. We want to be conscious of consciousness, to have more than what experience yields, to be *in* time, not before or after time—and to know it. But this is not possible. The twilight of consciousness is the price for overreaching the limits of consciousness. As La Rochefoucauld writes, "The biggest fault of insight [*pénétration*] is not to get to the point, but to bypass it."

To be cast away from a place is not difficult to narrate, but to be adrift in time is a curse few writers have ever dwelled on. "I miss the future when I'll be able to look back and miss all of this, however absurdly," writes Pessoa. Elsewhere in the same book, he adds:

I feel banished from my soul. Whatever I feel is felt (against my will) so that I can write that I felt it. Whatever I think is promptly put into words, mixed with images that undo it, cast into rhythms that are something else altogether. From so much self-revising, I've destroyed myself. From so much self-thinking, I'm now my thoughts and not I.

How much I've lived without having lived! How much I've thought without having thought! I'm exhausted from worlds of static violence, from adventures I've experienced without moving a muscle. I'm surfeited

with what I've never had and never will, jaded by gods
that so far don't exist. I bear the wounds of all the battles
I avoided. My muscles are sore from all the effort I never
even thought of making.

All critics who have written about Pessoa's *Book of Disquiet*
feel obligated to examine the author's heteronyms, the multiple
identities he assumed as a writer by giving each voice in his
work a different author. This subject has never interested me,
and I am pushing it aside. I am interested in his conscious in-
ability to set his feet in one time zone. Instead, he inhabits and
is inhabited by an irrealis mood.

It was hard to remember yesterday or to believe that the
self who lives in me day after day really belongs to me.
 The feelings that hurt most, the emotions that sting
most, are those that are absurd: the longing for impos-
sible things, precisely because they are impossible;
nostalgia for what never was; the desire for what could
have been; regret over not being someone else; dissatis-
faction with the world's existence. All these half-tones
[*meios tons da consciência*] of the soul's consciousness
create in us a painful landscape, an eternal sunset [*um
eterno sol-pôr*] of what we are. We feel ourselves to be
a deserted field at dusk, sad with reeds next to a river
without boats, its glistening waters blackening between
wide banks.
 I imagine myself living for a moment in each house
I pass, each chalet, each isolated cottage whitewashed

with lime and silence—happy at first, then bored, then fed up. And as soon as I've abandoned one of these homes, I'm filled with nostalgia for the time I lived there. And so every trip I make is a painful and happy harvest of great joys, great boredoms, and countless false nostalgias.

If one day they happen to look at these pages, I think they will recognize what they never said and will be grateful to me for so accurately interpreting not only what they really are but also what they never wished to be nor ever knew they were.

The tendency to paradox is none other than the attempt to bridge two undefinable aspects, two intangible folds of identity, two irreconcilable tenses: never what is, but "the desire for what could have been." In the space between two eternities, there is the gap, no less unreal than are the extremes on either side:

I don't want to have my soul and don't want to renounce it. I want what I don't want and renounce what I don't have. I can't be nothing nor be everything: I'm the bridge between what I don't have and what I don't want.

I exist without knowing it and will die without wanting to. I'm the gap between what I am and am not, between what I dream and what life has made of me.

In the gap between Paul Celan's "always and never" (*zwischen Immer und Nie*), between leaving and lingering, be-

ing and not being, between blindness and seeing double (*voir double dans le temps*) in Proust, his space will always be the irrealis domain: the might-have-been that never happened but isn't unreal for not happening and might still happen, though we fear it never will and sometimes wish it won't happen or not quite yet.

ACKNOWLEDGMENTS

I would like to thank Sigrid Rausing at *Granta*, Sudip Bose at *The American Scholar*, the editors of *The Paris Review*, Andrew Chan at the Criterion Collection, PEN America for hosting me at the Cavafy evening, Laura Martineau at *Coda Quarterly*, Robert Martin for including my piece in *The Place of Music* (Bard College), Whitney Dangerfield at *The New York Times*, my former student Leah Anderst for including me in *The Films of Eric Rohmer: French New Wave to Old Master*, Michaelyn Mitchell at the Frick Collection, Robert Garlitz for introducing me to the work of Fernando Pessoa, Youssef Nabil for allowing me to reprint his stunning picture on the jacket of this book, and the Corporation of Yaddo for a wonderful and productive stay. I particularly want to thank Jonathan Galassi and Katharine Liptak at Farrar, Straus and Giroux, and last but certainly not least, my agent, Lynn Nesbit.